D0538619

# BASEBALL

*Fantography*

★ ★ ★

## A Celebration in Snapshots
and Stories from the Fans

**ANDY STRASBERG**

WITH A FOREWORD BY
**BOB COSTAS**

ABRAMS IMAGE, NEW YORK

# Contents

# Foreword

BY BOB COSTAS

In 1991, HBO debuted its acclaimed series *When It Was a Game*. Many of the evocative images at the heart of the production were home movies: personal, often poignant glimpses of players and ballparks, fondly recalled but seldom so vividly captured. Babe Ruth and Lou Gehrig in color?? Jackie Robinson and Ebbets Field not in grainy black and white, but in the kind of bold, vibrant dimension that seemed to bring them back to life—familiar and yet fresh at the same time.

This treasure trove of visuals was supplemented by personal recollections: some from those with connections to the game as writers and broadcasters, some from those prominent in other fields. But many were from just regular fans, unknown to most of us, yet each a genuine representation of what the game meant, and still means, to millions. On its own terms, *When It Was a Game* could scarcely be improved upon. But what if the sensibilities behind it were applied in a different way? That's where *Baseball Fantography* comes in.

Here is a collection of fan photos and the memories they prompt, because sometimes the most compelling photographs are not those of game action, or even those taken by a professional photographer. Sometimes it is the personal snapshot a fan takes that best demonstrates what the game can mean to those who care about it. The photograph could have been taken as a player walked into the ballpark, or during batting practice, a relaxed moment in spring training, or maybe a chance meeting with a fan away from the ballpark. It could be of a father and child in an empty stadium after a game was over in the 1930s, the 1980s, or last week.

While *Baseball Fantography* is for fans and by fans, it doesn't hurt to have the perspectives of a couple of players from different points on the spectrum. So here we have Hall of Famer Ozzie Smith, as well as Dave Baldwin, who now holds a PhD in genetics, but who, for six big league seasons, held forth in the bullpens of three American League clubs.

As you leaf through the book, you may find yourself thinking, Boy, there must be a lot more where this came from, and you'd be right. The hope is that additional volumes will follow—volumes that will be both nostalgic and current, and that will include the faded photograph from 1922 you discovered in your grandpa's attic, or the crystal clear digital photo you might take this season or next.

In the meantime, enjoy *Baseball Fantography*.

# Preface

BY MARTY APPEL

New technologies and social media continue to expand the ways in which we can root, root, root for the home team, but one thing still connects all generations of baseball fans: photography.

Unlike many other sports, the varied pace of a professional baseball game allows for a synergy with its fans that encourages them to bring their cameras to games, a practice that became more regular in the late 1940s and early 1950s. Teams would designate a specific day when fans would be invited to photograph their favorite players. This promotion became known widely as "Photo Day" or "Camera Day" and remains popular today. The rhythms of the game day experience provide fans with the opportunity to snap a photo prior to that first pitch, during the action, and then after the last out of the game is recorded. The subject matter could be that of a ballpark, a player entering the facility, a player signing autographs during batting practice, or perhaps long after the game's conclusion when a fan engages a player quite by accident at a restaurant or hotel near the park. These snapshots create a timeless record of a fan's baseball experience.

The images in this book have been taken by fans who are amateur—not professional—photographers. The photos are not always the most artistic, composed, or focused images, but they represent a uniquely personal and poignant moment for the photographer and provide an insight into what *was* and *is* important to the fan.

This book features never-before-seen pictures of players great and not quite, in ballparks long gone or vaguely familiar, in settings major and minor, in black-and-white and color, on the field and in civilian clothing—a feast for the eyes of fans who think they've seen it all.

Many teams and eras are represented, and among the finds is a snapshot of intense Roberto Clemente looking up for the photo, the Washington Senators' Nick Altrock striking a pose for a fan on the 1939 Fenway Park dugout steps, Eddie Mathews stepping out of a shower, a spectacular sunset at the Mets' Citi Field, and Babe Ruth hurrying out of Yankee Stadium with his daughter.

Published for the first time (and generally seen for the first time), this is the ultimate collection of undiscovered baseball imagery as captured by adoring fans. And in truth, the finished project is really about the fans, by the fans, and, ultimately, for the fans.

What a gift to baseball.

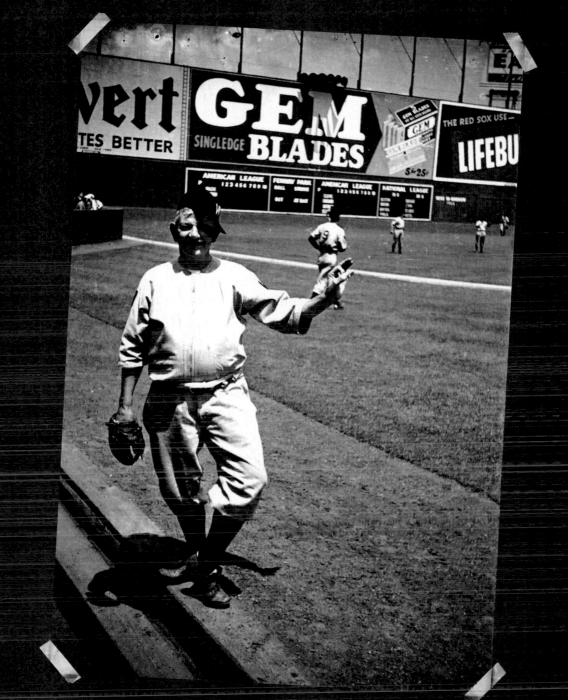

★ MAKE MIME

Nick Altrock was a former big league pitcher who coached for forty-two years with the Senators. One of his talents he often demonstrated after his playing days was as a mime on the field, which would evoke laughter from the fans. —*Don McNeish*

# Introduction

BY ANDY STRASBERG

Because of my father, the support of my mother, and the tolerance of my sister, I was obsessed with the game of baseball while growing up in the 1950s in New York City. I read about it, played it, listened to it, watched it, collected it, dreamt about it, thought about it. And I photographed it. My mother wished that I paid as much attention to my schoolwork because "Baseball," she said, "will not help you later on in life."

I was nine when my father took me on my first trip to the National Baseball Hall of Fame in Cooperstown, New York. He brought a camera, and from then on, when I attended a major league baseball game I frequently brought my own camera and snapped photos of ballparks, ballplayers, and friends. In college, I acquired a 35 mm camera and enrolled in a photography course taught by Arthur Leipzig. Through the lens finder, this great American photographer showed me a world that I never knew existed. Afterward, I crisscrossed the country three times looking for a baseball job—and taking photos. Once I was settled, I worked at three different camera stores to support myself.

Starting in 1975—and against my mother's predictions—I have made my living in and around baseball, the first twenty-two years working for the San Diego Padres. And many of my baseball memories have been captured on film.

Ten years ago, I rediscovered an old snapshot taken by my best friend Arnie Cardillo, from the summer of 1966. There I am, a gangly teenager in thick-rimmed glasses, posing with Roger Maris against the iconic backdrop of Yankee Stadium. Emulating my idol, I'm wearing a pin-striped shirt, and I've got my sleeves rolled up in his trademark style. My arm is draped across Maris's back as if we're close friends. In a few seconds, he's going to dash back to pregame warm-ups, and I'll return to my seat in a pinch-me dream state and with my heart pounding. But for this one brief shining moment in front of the camera, nothing else exists. No past, no future. There is only Roger and me—a home run hero and a starstruck fan, frozen in time together with the incredible Yankee Stadium as a backdrop.

When I came across this photo again as a grown man, a flashbulb went off in my head: *I'm not the only person with a one-of-a-kind amateur shot socked away in some long-forgotten shoebox. There are thousands of pictures like this gathering dust across the nation!* After all, baseball is a numbers game. That's when I started asking around. First, I contacted family, friends, and colleagues. Before long, I went online to seek out images from everyday fans and shutterbugs around the country and, eventually, around the world. What I learned was that not only did such pictures abound, not only did they capture amazing never-before-seen encounters, but each one had its own compelling backstory, just like mine.

This book is the first published collection of snapshots of professional baseball taken by fans who are amateur photographers. It is their story. And these are their photos.

Enjoy them.

**1 ★ ROGER THAT**
This was a photo booth shot of me after the 1960 season was over. Pathetically, I wanted to see what I would look like having my picture taken with my idol Roger Maris. —Andy Strasberg

**2 ★ STEP UP TO GREATNESS**
My first visit to the Baseball Hall of Fame and Museum. —Andy Strasberg

**3 ★ YANKEE STADIUM FRIEZE FRAME**
Finally, I got a shot at the real thing. And when I put my arm around Roger as if we were pals, I vividly recall touching his wool jersey which was hot from perspiration. At the time I didn't realize that summer would be Roger's last as a Yankee. In December, he was traded to St. Louis and I was devastated. —Andy Strasberg

3

# 1 Spring Training

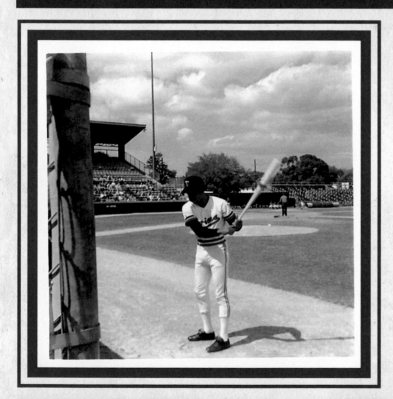

★ **SWING BREAK**
Rod Carew takes a practice swing in front of me at spring training.
—*Tom Stannard*

# Cactus and Grapefruit

Ah spring training in the Florida—or Arizona—sunshine! It is one of baseball's most civilized and satisfying rituals, and baseball fans have been enjoying it just about as long as the players themselves. There is a relaxed air to the small ballparks of the spring, and an openness and accessibility to the teams and players that is just not found in big league stadiums. The tickets are exponentially cheaper and, for the common fan, exponentially better—closer to the game itself. In the spring, the world's best ballplayers play in tiny little ballparks, most comparable to the minor league and even college and high school baseball fields. Getting good photographs of the players and the game is certainly easier here than in the bigs.

No one knows who first thought of the idea of taking a preseason training trip to sunnier climes, but some form of this rite of spring predates even the organized formation of Major League Baseball, which was founded in either 1876 or 1871, depending upon which historians you listen to. But in April 1870, two teams which still exist took a spring sabbatical in New Orleans to get in shape and play exhibition games. The teams? The Cincinnati Red Stockings, now known as the Atlanta Braves (you could look it up), and the Chicago White Stockings, now known as the Cubs. The following season the New York Mutuals prepped themselves in sunny Savannah.

In 1877, the Indianapolis club embarked on the first successful Southern tour (though the Brooklyn Atlantics had tried to do the same nine years earlier), playing from Texas to New Orleans to Memphis to St. Louis. By the 1890s, a trip south was almost required, according to author Peter Morris in his excellent book *A Game of Inches: The Stories Behind the Innovations That Shaped Baseball*. Some clubs remained behind, however, in favor of gymnasium workouts.

The first team to head to Florida for spring training was the Washington Nationals of 1888, who trained in Jacksonville. The business of spring training was born soon after in Ocala, Florida, where John Montgomery Ward convinced city fathers to provide free use of their ball grounds for his Brooklyn club and to pay some of the team's expenses. The practice grew slowly, but by 1913, the Cubs had an arrangement with Tampa, Florida, whereby the Cubs got nearly $5,000 in cash up front for bringing the team, and the local businessmen got the gate receipts.

BY TIM WILES

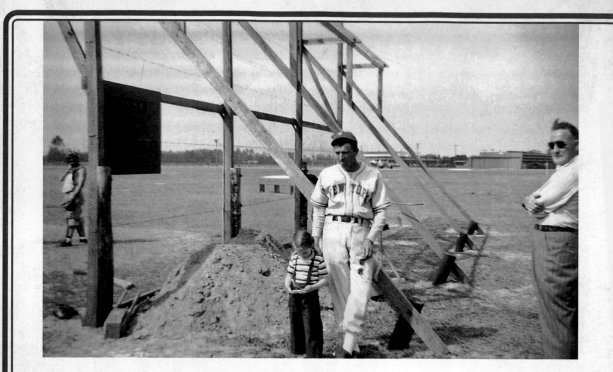

★ **MEAL TICKET**
My sister wouldn't look up for this once-in-a-lifetime photo with Giants' pitching great Carl Hubbell, who was known as "The Meal Ticket," at spring training.
—*Jerry Fallenstein*

The first club to go west was again the Cubs, who lit out for New Mexico in 1899. The Tigers pioneered Arizona training in 1929, and the first club to establish a permanent base there was the Cleveland Indians, in 1947. By then, the Cubs had long been on Catalina Island in California, where owner William Wrigley, Jr., promoted the island, where he had significant real estate holdings, as a tourist destination. The Cubs trained on the island from 1921 to 1951, except for the World War II years, when they reduced expenses by training in the future birthplace of Larry Bird, French Lick, Indiana. The Cubs had a history in the area, having trained during the "Tinker to Evers to Chance" era in nearby West Baden, the site of a luxury hotel and famous springwater.

The westward expansion of major league baseball in the 1950s and beyond was closely followed by a great growth in Arizona spring training bases. The "Cactus League" was born in 1954 with the arrival of the Baltimore Orioles, the fourth Arizona club after the Indians, the Giants, and the Cubs.

Sometime in the 1990s, perhaps spring training grew up a bit, as fans of large-market teams like the Cubs and the Yankees began making the team's spring training sites a spring break destination in themselves. No longer could you just amble over to the ballpark and buy a choice seat at the ticket window—you might find that the game had sold out. Many clubs relocated their spring sites or rebuilt their complexes, often with help from the state or the city. While ticket prices remain much lower than in the regular season, spring training games are bigger business than ever.

But that hasn't changed the essence of spring training. Even at sold-out games, there are still long quiet pauses, you can still hear the players' chatter on the infield, and you can still hear the ball "thwap!" into the catcher's or first baseman's mitt much better than you can in the majors. And you can still get right up close to players at the field's edge to get those precious pictures!

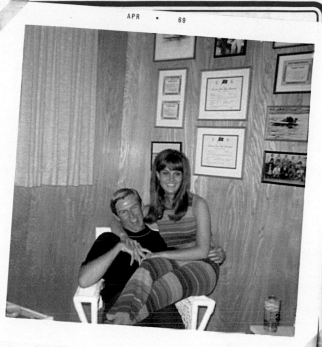

> "Watching a spring training game is as exciting as watching a tree form its annual ring."
>
> ## JERRY IZENBERG

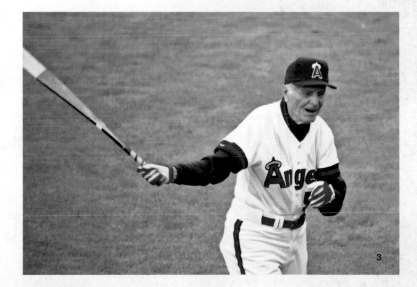

**1 ★ DARK DAZE**
Cleveland Indian manager Alvin Dark appears to be relaxed and in a daze during spring training in 1971. —*Julie Markakis*

**2 ★ A COUPLE**
Pitcher Jerry Stephenson and his wife Yvonne at Winter Haven, Florida, during spring training in 1969.
—*Julie Markakis*

**3 ★ HE CAN FLAT OUT HIT**
Angels coach Jimmie Reese, during 1991 Palm Springs spring training, using his flat fungo bat to hit flies and grounders.
—*Doug Heron*

# Sweat Equity

*The following stories are excerpted from an article authored by John B. Foster and published in the* New York Herald *in 1912:*

Loping awkwardly along the dusty yellow surface of a clay road in Mississippi, a huge figure, queerly clad, with cumbersome strides pushed his way forward under a broiling sun.

He wore two old sweaters, three pairs of baseball stockings, one pair of knickerbockers over another, the second pair unfastened at the knees and flapping clumsily around his legs. With mouth agape and head swinging wearily from side to side, he was urged on by some ballplayers of the Chicago Cubs who were seated in a wagon driven by one of the natives who encouraged him from time to time in words of approval.

Perspiration streamed from his face, the drops blinding him now and then. At intervals one of the players in the wagon would tumble over, convulsed with laughter, to the bottom of the wagon and give vent to his hilarity but not so that the struggling athlete could see him.

But he hadn't. He was an unsophisticated busher who had been recommended this treatment by the jokers on his team to reduce his weight and get him into condition.

The day came, though, when he repaid his tormentors by arising in the night in a sleeping car after a particularly trying day and singing "The Larboard Watch," accompanying himself dexterously if not noisily on the bottom of a pie tin.

———

In 1908, after the Cubs beat the Detroit Tigers in the 1907 World Series, the city of Houston paid the Chicago club to train and play there, as this popular team drew tourists.

———

Conducting his first spring training in New Orleans in 1904, White Sox manager Fielder Jones found that many players couldn't face morning workouts after full nights enjoying the city's bright lights and other attractions. Jones responded by personally checking each player's room at 7:30 a.m. Those still in bed after a night of carousing received a ticket back to Chicago.

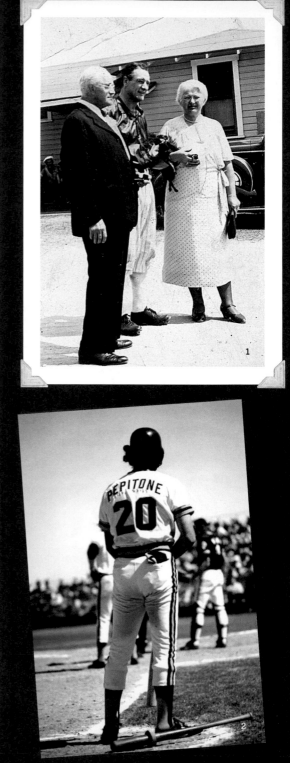

## Frank "Babe" Ruth

The first time Babe Ruth's name appeared in a national publication was in the *Sporting News* issue of March 19, 1914. George Herman Ruth, a member of the Orioles, showed up for spring training in Fayetteville, North Carolina. E. L. Schanberger, the *News* reporter, got half of this player's name correct.

"Reports from this camp indicate that he [manager Jack Dunn] has some good prospects among his rookies. For one there is a youngster named Frank Ruth, a Baltimore boy, who has been the pitching mainstay of a local industrial school team for years. He has shown Dunn so much that the manager makes the bold statement that he will stick with the team this season, both on account of his hitting and his port-side flinging."

3

**1 ★ MA & PA**
Legend Lou Gehrig with his parents at spring training.
—*Josh Evans*

**2 ★ HAIR DRYER**
Joe Pepitone as a San Diego Padre in spring training, Yuma, Arizona.
—*Roger Morse*

**3 ★ GOOSE LEGS**
I shot this during spring training in 1985. My daughter Blake Tucker is looking up at Goose Gossage, waiting to ask him to sign her program.
—*Kerry Tucker*

**4 ★ HEY, BUDDY**
A very young Bud Harrelson was playing short for the Mets, four years before they were world champs.
—*Al Prince*

4

## Babe Gets an A

Imagine the sort of havoc this lineup could have accomplished: Mickey Cochrane, Lefty Grove, Jimmie Foxx, Al Simmons, and Babe Ruth. You don't have to imagine, because it happened. During a spring training game on March 24, 1925, the Babe played for Connie Mack's A's, swapping Bronx Bomber pinstripes for White Elephant flannels. In this Fort Myers, Florida, exhibition game, the A's beat the Milwaukee Brewers, 5–4. Ruth went hitless in three trips to the plate. It is unclear why Yankee manager Miller Huggins permitted Babe to play for another team. But that 1925 season was a flop for the "Sultan of Swat," as suspensions limited him to only ninety-eight games. A footnote to the 1925 A's lineup: first baseman Joe Hauser went on to hit more than sixty homers twice in the minor leagues. In 1930, he clouted sixty-three round-trippers for the Baltimore Orioles of the International League; and in 1933, sixty-nine for the Minneapolis Millers of the American Association.

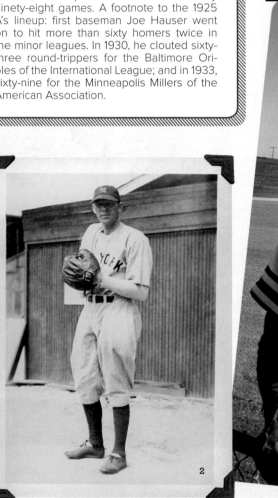

2

3

# Dust the Plate

Doug Harvey, a National League umpire and future Baseball Hall of Famer, enjoyed spring training closer to his San Diego home once the Padres entered the league in 1969. The San Diego team trained in Yuma, Arizona, just a few hours east of San Diego and the Harvey family's winter home. In the latter part of his career, Harvey only worked those Yuma games and often engaged fans in conversation.

Always congenial and sometimes mischievous, Harvey teased the crowd by never taking out his whisk broom to dust off home plate, no matter how much dirt piled up on the plate. Fans chanted "Dust the plate!" and occasionally Harvey would remove his whisk broom as if to comply. But that was just a tease—he never followed through.

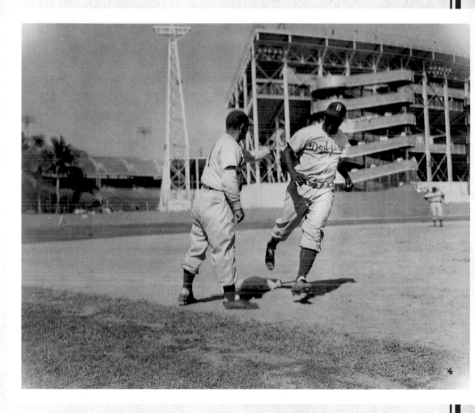

4

"Spring training is mostly hard work, demanding as much of the aching veteran as the scared bonus boy."

**LEE ALLEN,** *in the April 4, 1962,* Sporting News

## A Change of Scenery

"A trade that helps both teams"—this cliché has been used by every team since baseball's first trade. Over the years, the Yankees and the Giants have conducted many of these trades, but only one included a change of scenery for every member of both clubs. Before the 1951 season, the Yankees and the Giants swapped spring training facilities. As a result, the New York Yankees spent their first and only spring preparing for the season in Arizona, while the New York Giants became the first team other than the Yankees to utilize Miller Huggins Park. The exchange was a one-year agreement by the Giants as a courtesy to Yankees co-owner and vice president Del Webb, whose hometown was Phoenix. That 1951 spring training was an eventful one. Joe DiMaggio announced his retirement, and both Mickey Mantle and Willie Mays broke into the big leagues. A continent apart that spring, these teams would meet in the fall classic, competing in the World Series.

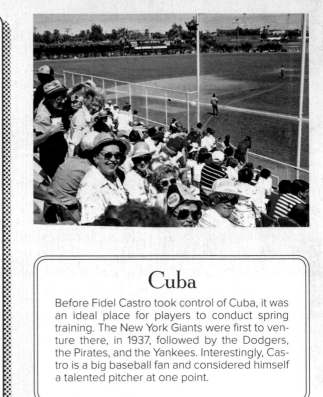

## Cuba

Before Fidel Castro took control of Cuba, it was an ideal place for players to conduct spring training. The New York Giants were first to venture there, in 1937, followed by the Dodgers, the Pirates, and the Yankees. Interestingly, Castro is a big baseball fan and considered himself a talented pitcher at one point.

### 1 ★ PALM SUNDAY
A group of San Diego Madres, a Padres booster group, attend a 1984 Sunday spring training game (Padres vs Angels) in Palm Springs, California. —Madres

### 2 ★ HOT DOG
This was taken with my iPhone at spring training 2009 in Maryvale, Arizona, spring home of the Milwaukee Brewers. The first hot dog of the season is like communion. I'll confess a sin, it was the first of several hot dogs that day. —Todd Little

### 3 ★ GOOD HANS
Hans Lobert was sixty and became one of the oldest rookie managers at the time he managed the Phillies in 1942. He was very good friends with my grandparents, who were also German American. —Jonathan Hashagan

## Go South

In 1897, "Scrappy Bill" Joyce, an infielder with the Giants, persuaded the team to train in Lakewood, New Jersey, rather than a southern city. Thanks to reduced travel costs, the New York team saved $4,000.

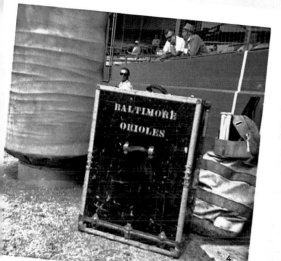

**4 ★ CAMP TRUNK**
A Baltimore Orioles equipment trunk at spring training camp  —Al Prince

**5 ★ GRAPEFRUIT LEAGUE**
Sammy Sosa signing a grapefruit during a spring training game at the Maryvale Baseball Park in spring of 2007. Since its signing, the grapefruit has been freeze-dried and has made two cross-country trips back and forth from Arizona to Cooperstown, where it has been on display in a memorabilia shop and as part of a museum exhibit on Arizona's Cactus League. —Charlie Vascellaro

**6 ★ A GAME OF CHANCE**
Leave it to Chance to screw things up for the Cubs at spring training. —Tim Wiles

# 2 Parades

★ **A BIG BOY**
Iconic Big Boy Restaurant. Big Boy rides
atop a fire engine during the Reds' Opening
Day parade. —*Joan Capehart*

# Baseball Floaters

New York has its Macy's Thanksgiving Day Parade. Pasadena has the Rose Bowl Parade. And New Orleans has a series of colorful parades during Mardi Gras. But if you grew up in Cincinnati and followed the Cincinnati Reds through thick and thin, no parade can compare to the Findlay Market Opening Day Parade.

In the early spring of 1971 I attended my first meeting of Major League Baseball public relations and promotion directors in Tampa, and one of the agenda items was about promoting Opening Day. I was startled to learn that Opening Day was not a sellout everywhere, like it was in Cincinnati.

For well over a century, the Reds have always played their opening game at home. Most people presume this is a privilege for baseball's oldest franchise, but Reds historian Greg Rhodes and *Cincinnati Enquirer* sportswriter John Erardi set the record straight in their book *Opening Day: Celebrating Cincinnati's Baseball Holiday*, the definitive work on the subject and a source of information for these words. As the southernmost major league city in the late 1800s, Cincinnati was viewed as a warm weather alternative to Boston, New York, Philadelphia, and Chicago. By the 1930s, when the tradition was challenged by another ball club, the oldest franchise rationale was advanced successfully to thwart the challenge.

As a result of the team opening at home annually, Opening Day took on a special significance in the city. Tired of winter, Cincinnatians devoured news accounts of spring training and its warm weather, knowing their day in the sun was only weeks away. Anticipation built in the weeks and then days leading up to the start of the baseball season. And when the magical day finally came, the festivities started with an annual parade.

Early marchers were members of rooters clubs, but eventually the rooters club from Findlay Market grew so much larger than the others that its members, with their large white hats and canes, came to dominate the parade.

Findlay Market, located about fifteen blocks north of the city's central Fountain Square, has evolved into a covered open-air collection of shops and vendors selling meats, poultry, fish, produce, dairy products, flowers, and other staples for the family table. It dates to 1852, when Cincinnati's Over-the-Rhine neighborhood bustled with

BY ROGER RHUL

immigrants and the city was the sixth largest in the United States thanks to Ohio River commerce. A National Historic Register designation was conferred in 1972.

Over-the-Rhine has presented challenges for the city over the years. Decades of flight to the suburbs left the area with the city's poorest residents. Now government and civic groups are once again working to find a compatible blend of urban poor, longtime residents and merchants, and suburban transplants seeking a gentrified lifestyle in renovated lofts, new condos, and apartments. Arts venues run the gamut from storied Music Hall with symphony, opera, and ballet, to small theaters with edgy productions. Trendy shops and eateries are opening. Unperturbed by generations of development starts and stops, Findlay Market has survived quite nicely.

Findlay Market's pre-1971 parade contingent was mostly merchants and their friends walking the eight-tenths of a mile from the marketplace west to Crosley Field, known earlier as League Park, Palace of the Fans, and Redland Field.

Since 1971, the destination has been downtown Cincinnati near Riverfront Stadium and now Great American Ball Park. Live television coverage sparked increased and broader participation, but the parade itself remains no slick extravaganza. A horse-drawn carriage. A flatbed truck. Several high school bands. A police color guard. Some Boy Scouts. An old fire engine. Shrine clowns in their minicars. Unicyclists. Former Reds players. Findlay Market businesses with their names on the side of convertibles, sedans, or trucks. Peanut Jim, until his death in 1982. When Marge Schott owned the Reds, she and her St. Bernard, Schotzie, were mainstays, as was a larger Schotzie, an elephant from the Cincinnati Zoo. Marge loved the parade.

Many fans lining the parade route have tickets to the ball game, but most spectators do not. This is as close to Opening Day as they can get. They are there to be a

★ **LEGENDS**
The 1939 Baseball Parade in Cooperstown was led by Honus Wagner (Pirates uniform), Cy Young (white suit), and Eddie Collins (Boston uniform).
—*Homer Osterhoudt*

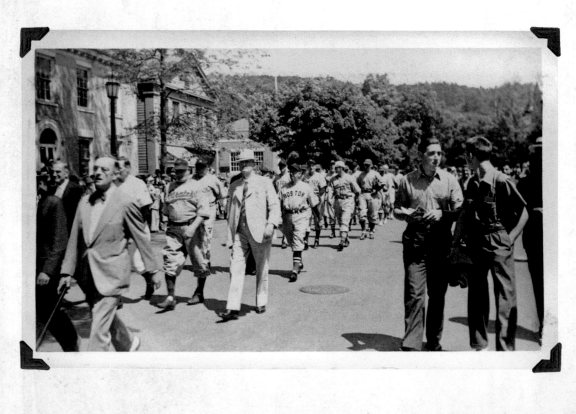

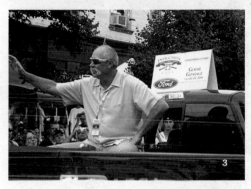

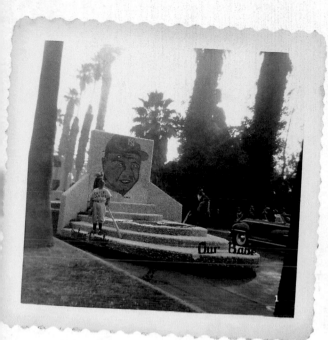

part of the happening, to soak up the atmosphere and get in the baseball spirit. The demographic mix is across the board.

Businesses generally recognize the day as a holiday and expect and understand there will be a drop in worker productivity. Televising the game has been a long tradition, so fans without tickets gather at watering holes for business meetings or in company lunchrooms. Many workers simply go to lunch from one to four o'clock. Game broadcasts can be heard in many classrooms.

My first Opening Day was in the early 1960s when someone gave four tickets to a friend's dad, and my buddy invited me to go along. It was so special. I've never seen greener grass than the blades at Crosley Field that Opening Day. A ticket to Opening Day was an excused absence from school. It still is, with only tacit apologies to No Child Left Behind.

My thirteen years in the Reds front office provided plenty of memories. Some of my favorite ones are from Opening Day. My daughter got to take a friend and be part of the hoopla and enjoy the parade. My late parents were lifelong Cincinnatians and baseball fans. They met on the softball fields of Northside and South Cumminsville. The idea that their son worked for the Reds was hard for them to imagine. They had near-perfect attendance at the Reds games, and I am very grateful for having been able to give them this gift in their healthy retirement years. Opening Day was one of their favorite days.

Cincinnati Reds president Bob Howsam, architect of the Big Red Machine, told his staff to take time to smell the roses. Writing these words helps me realize that the Findlay Market Parade rose is one whose bouquet I never really took in to the fullest. Next year, I'll be there.

**1 ★ NOT FORGOTTEN**
The Rose Parade acknowledged the passing of Babe Ruth in August of 1948 with a float titled "Our Babe," and dedicated it to his memory. Standing on the float is a player from the Ventura Yankees youth baseball team.
—*Debbie Chou*

**2 ★ PINSTRIPE PRIDE RIDE**
The 2008 All-Star Game held a parade in New York City. Here's Whitey Ford and Yogi Berra as they pass by Radio City Music Hall.
—*Andy Strasberg*

**3 ★ SMILING GOOSE**
The 2010 Cooperstown Parade featured all attending Hall of Famers. Here's Goose Gossage.
—*Louise and Dave Cavallin*

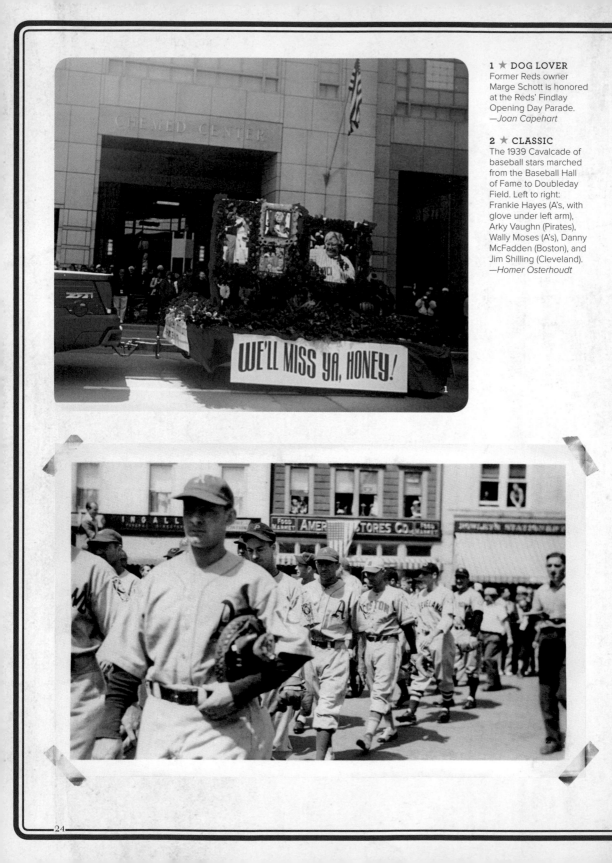

**1 ★ DOG LOVER**
Former Reds owner Marge Schott is honored at the Reds' Findlay Opening Day Parade.
—*Joan Capehart*

**2 ★ CLASSIC**
The 1939 Cavalcade of baseball stars marched from the Baseball Hall of Fame to Doubleday Field. Left to right: Frankie Hayes (A's, with glove under left arm), Arky Vaughn (Pirates), Wally Moses (A's), Danny McFadden (Boston), and Jim Shilling (Cleveland).
—*Homer Osterhoudt*

WE'LL MISS YA, HONEY!

## Opening Day, Nineteenth-Century Style

A parade started at the boarding places and hotels of the two teams. Players in uniform would be transported via horse-drawn carriages to the ballpark. This was the main body of the parade.

The procession took about two hours, winding through the streets of the host city. Players were accompanied by brass bands, either marching or riding in large flat-bed coaches. In Baltimore, uniformed amateur teams on foot would swell the columns.

As the years went by, other dignitaries began to join the baseball parades, riding with the players and sharing in the limelight—community leaders, newspaper moguls, prominent baseball figures, and politicians.

By 1906, though, the Opening Day parade was a dying tradition. Players skipped them because prolonged exposure to the chilly April weather caused many to catch cold or stiffened their pitching and throwing arms.

**3 ★ NO. 3 FOR #2**
Derek Jeter enjoys his third World Series Parade for the Yankees in 1999.
—*Joel Oks*

**4 ★ BAD HENRY LOOKING GOOD**
Hank Aaron travels down Main Street in Cooperstown during the 2010 parade.
—*Louise and Dave Cavallin*

**5 ★ A SLOW ROLLER**
A snapshot of a baseball float taken during the Motor City Cavalcade parade on June 1, 1946, from a location just about half a block south of John R Street, looking northwest up Woodward Avenue, in Detroit.
—*Unknown*

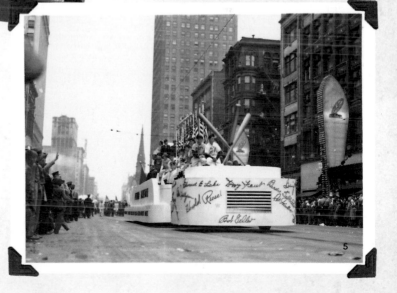

# 3 Mascots

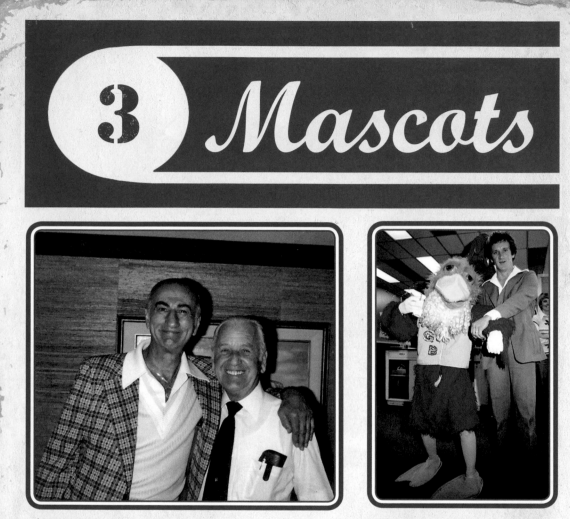

★ A PRINCE
Max Patkin, in the sport coat, was known as the Clown Prince of
Baseball. He is all smiles around my dad, Dennis. —*Tom Walsh*

★ WING MAN
Radio station mascot the KGB Chicken put
on a Santa beard for a Christmas party and
compared left wings with Padres pitcher
Randy Jones, who had just won the 1976
Cy Young Award. Note that the Chicken's
"barn door" is open. —*Andy Strasberg*

# Baseball's Characters

From Fredbird, to Bernie Brewer, to Slider, to the Phillie Phanatic, mascots are a relatively new and entertaining innovation to Major League Baseball.

Although Max Patkin, the "Clown Prince of Baseball," a former minor league player, was not an "official" mascot, he entertained fans from 1944 to 1993. How Patkin got started is a story in itself. While he was pitching for a military team in Hawaii in 1944, Joe DiMaggio hit a home run off of him. Patkin threw his glove down and mockingly followed DiMaggio around the bases. He later played himself in the movie *Bull Durham*.

Of course, probably the most famous of all mascots is the San Diego Chicken. In 1974, a representative of a San Diego radio station went to the radio studio at San Diego State University, looking for someone to fit into a chicken costume and represent his station at the San Diego Zoo for an Easter promotion. Ted Giannoulas just happened to be in the studio at the time, fit into the costume, and agreed to do it. After a day at the zoo, he wanted to quit, but he needed the money. He stayed on as the San Diego Chicken, and the rest is history. Even though he has never been the official mascot of the San Diego Padres, the San Diego Chicken has been the kingpin of the mascot revolution in Major League Baseball. The Chicken once had his little chicks follow him around the base paths between innings of a game. The *Sporting News* has named the San Diego Chicken as one of the top 100 most powerful people in sports of the twentieth century.

Love them or not, you can't help but adore, and cannot forget, mascots. Take the Phillie Phanatic. When Los Angeles Dodger manager Tommy Lasorda went toe-to-toe with the Phillie Phanatic, broadcaster Joe Garagiola was quick to quip that the Muppets were invading baseball. Baseball is meant to be entertainment, and fans of all ages have come to expect their hometown mascot to rally their local team. Once, the Phillie Phanatic uniform was misplaced, and it became a national story. It was found several days later, and peace was restored.

Mascots, such as Mr. Met, have appeared in commercials. Who cares if the costumes are hot and heavy, kids will line up for pictures with their local mascot. And if you bring the kids to a major league baseball game, the adults will be there with them.

How about some of the innovative names of mascots for major league baseball teams: Southpaw (Chicago White Sox), Sluggerrr (Kansas City Royals), Pirate Parrot (Pittsburgh Pirates), Paws (Detroit Tigers), Fredbird (St. Louis Cardinals), Gapper (Cincinnati Reds), Lou Seal (San Francisco Giants), Mariner Moose (Seattle Mariners), Stomper (Oakland Athletics), Ace (Toronto Blue Jays), Bernie Brewer (Milwaukee Brewers), and Slider (Cleveland Indians).

What can beat eating hot dogs and popcorn and enjoying a mascot at a baseball game?

Sure, Major League Baseball has become a big business, but no one can ever question that mascots help preserve the wonderful thrill of being at the old ball yard and enjoying our national pastime.

BY JEFF FIGLER

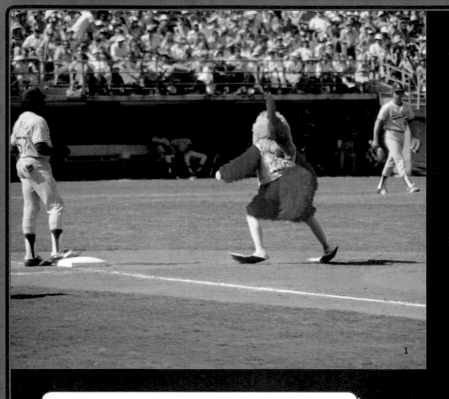

1

## 1 ★ CHICKEN LEGS

The San Diego Chicken is sizing up Dodgers pitcher Don Sutton as he attempts to steal second base in between innings of a Padres-Dodgers game in 1977. —*Tom Larwin*

## 2 ★ BROOKLYN BUM

World-class clown Emmett Kelly, known as the "Tramp Clown," was hired by the Brooklyn Dodgers as their unofficial mascot during the 1956 season, and made frequent appearances at Ebbets Field. —*Lew Lipset*

## 3 ★ THE CHIEF

In the late 1970s, during a less PC time, Chief Noc-A-Homa is praying to the baseball gods before an Atlanta Braves game. This was during football season, when he was allowed to do his "thing" on the mound instead of the stands. —*Rob Johnson*

## 4 ★ HOMER

In 1962, the New York Mets played their home games at the Polo Grounds. The stands behind home plate were prowled by the Mets' official mascot, Homer the Beagle. Legend has it that Homer lived in Manhattan's Waldorf Astoria hotel. Homer was sponsored by Rheingold Beer, which may have helped ease the pain of being a Mets fan in 1962. —*Anonymous*

## Deal with the Devil?

In the beginning, baseball mascots were a combination of batboys, good luck charms, and baseball retrievers. Perhaps the most famous mascot in the early days was Charlie "Victory" Faust. He was thirty years old when he approached New York Giants manager John McGraw in 1911 with a whopper of a story. Faust told McGraw that a fortune-teller predicted that the Giants would win the pennant if Faust joined the team and pitched for it. It was well known that McGraw was very superstitious and decided to keep Faust and put him on the roster. He was on the team but served as a "good luck" charm and nothing more. When the Giants were losing, McGraw sent Faust down to the bullpen to warm up, but that's where he stayed. Faust never got into a game during the pennant race. But once the Giants' pennant was clinched, Faust had his moment on October 7, 1911. "Victory," as he was known, pitched two innings and gave up two hits.

The Giants didn't win the World Series in 1911 against the Philadelphia Athletics. And although the Giants won the National League pennant in 1912 and 1913, they never scored a World Series, and McGraw decided that the "Faust Luck" was running out and he released him.

## Applause Sign

In 1892, a fleet-footed groundskeeper for the Washington Senators, known as "Charlie," was adept at both chasing trespassers who went on the field and chasing foul balls. A fan favorite, Charlie quickly became a local institution. And the ultimate compliment came on Opening Day, when Charlie received more applause than many of the players.

3

2

## Good Luck Charms

In 1905, a little frail-legged, hunchbacked old man drifted into the Philadelphia Athletics ballpark one morning. Without saying a word, he began minding the team's bats. He stared in awestruck fascination as the players took long swings at the plate and raced around the bases. His name was Louis Van Zelst. Connie Mack, a manager with a heart of gold under his cold, businesslike exterior, immediately took a liking to the poor old guy and let him stay. "Little Van," the team members called him. He was placed on Mack's payroll, where he remained for years, as the club's indispensable mascot and lucky charm. It worked. During the five years that Van Zelst was with the A's, they won four pennants and three World Series.

4

## The Dog Days of Baseball

In the early 1900s, on the Baltimore grounds, "General" Jim Jackson, who later became a hitting star in the Pacific Coast League, was playing right field for the Orioles. A long fly ball was hit between him and the center fielder. As both men started after the ball, a big bulldog reached it first, grabbed it in his teeth, and dashed across the field with his prize. Three runs were scored as a result. Jimmy said later that the dog was the greatest outfielder he had ever seen. As it turned out, the canine was the opponents' mascot.

# Homegrown Cheerleaders

Henry Thobe was a bricklayer from Oxford, Ohio, who loved the Cincinnati Redlegs. Nattily dressed, he led fans in cheers at hundreds of Reds games. A big part of the ballpark experience in Crosley Field, Thobe was so beloved that the Reds granted him full access to all areas of the park. When he died just before Opening Day 1950, a local newspaper headline read REDS LOSE GREATEST FAN.

Practically every ballpark has had fans who are local legends. Today, the Yankees Bleacher Creatures sit in section 209 of Yankee Stadium. They start every game with their "roll call" and shout out every Yankee starter's name until the player acknowledges them with a wave. But there are other famous fans. They include Michael T. "Nuf Ced" McGreevey, a Red Sox fan in the early 1900s; Hilda "Cow Bell" Chester, a Dodger fan beginning in the 1920s; Karl "Sign Man" Ehrhardt, a Mets fan in the 1960s; Jim "Tuba Man" Eakle, who paraded in the stands during Padres games of the 1970s and '80s; William "Wild Bill" Hagy, who in the 1970s and '80s led the crowd in spelling out O-R-I-O-L-E-S; and Ronnie "Woo Woo" Wickers, who now haunts Wrigley Field wearing a Cubs uniform and yelling "Woo woo."

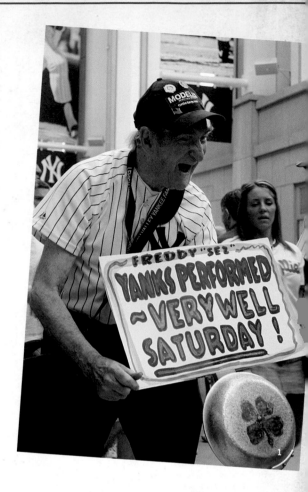

1

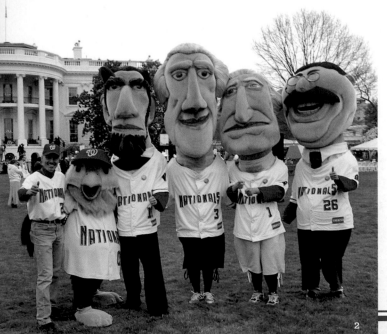

**1 ★ FREDDY SEZ**
This photo, taken on Sunday, May 24, 2009, is of legendary Yankee fan Freddy Schuman. Freddy, adored by all for his colorful Freddy "Sez" placards and metallic shamrock pan, could often be found circulating throughout the stadium during home games, offering fans the chance to "motivate" the Yanks by banging a spoon on his plate. The distinctive sound cut through crowd noise and became every bit as important to the atmosphere of the stadium as Eddie Layton's organ or the Bleacher Creature's roll call. Freddy passed away in October of 2010 and was honored by the team in a ceremony prior to Game 3 of the ALCS. —*Wyatt Smith*

**2 ★ GOOD EGGS**
Nationals Mascot Screech. Nationals Racing Presidents Abe, George, Tom, and Teddy pose on the back lawn of the White House in Washington, D.C., on March 24th, 2008, during the White House Easter Egg Roll. —*Sohna Sallah-Saffelle*

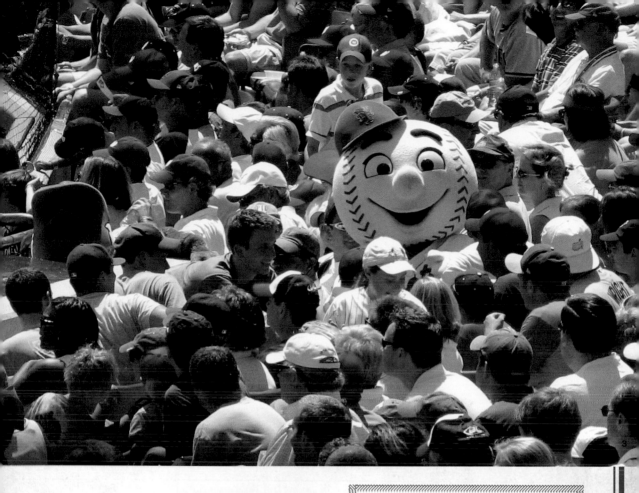

**3 ★ SEAM HEAD**
The Mets' mascot, Mr. Met, in the crowd at RFK Stadium on August 13, 2006. That day, Michael Tucker hit a solo shot in the eighth inning to lift the Mets to a 3–1 win over the Nationals.
—*Tom Conklin*

**4 ★ A GIANT MASCOT**
New York Giant mascot Willie Breslin appeared on Old Judge baseball cards in the 1880s.
—*Unknown*

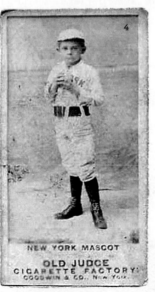

NEW YORK MASCOT
OLD JUDGE
CIGARETTE FACTORY.
GOODWIN & CO. NEW YORK.

## And the Rest

Only four MLB teams lack mascots: the Chicago Cubs, the Los Angeles Dodgers, the New York Yankees, and the Los Angeles Angels of Anaheim. The Angels, though, have a mascot of sorts—the Rally Monkey. While this creature does not roam the ballpark, it is unique, argues Angels executive Tim Mead: "We are fortunate to have the only baseball team mascot not produced by a mascot costume character company. Our Rally Monkey is real. Our Rally Monkey never complains, never gets sick, and always shows up on our video board in our time of need. He remains an integral part of our organization and the ballpark!"

# 4

# The Journeyman Player POV

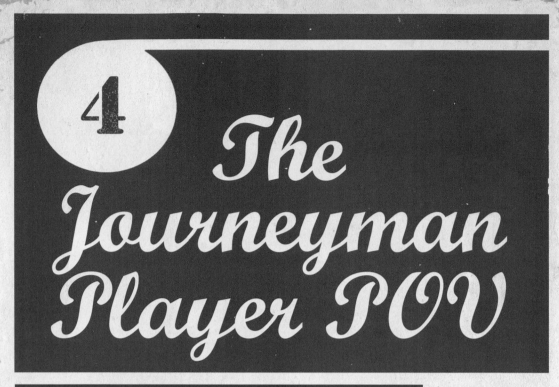

★ Greg Howell and Dave

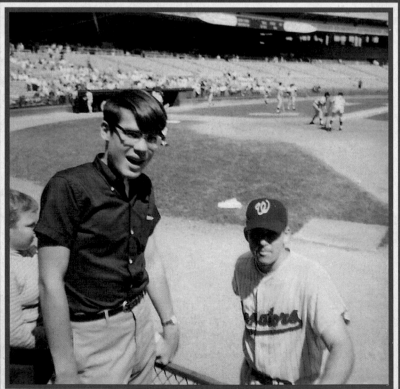

# Snake Jazz Author

Baseball players are accustomed to being photographed—sports photographers clicking away are a common part of an athlete's life—but the player is in an unfamiliar situation when the person holding the camera is a fan. This is all the more true when the photo is to include one or more other fans standing next to the player.

I've seen ballplayers refuse to sign autographs, but I don't recall ever seeing a player refuse to have his photo taken. Most players find this request to be disarming and irresistible. The autograph is merely a name scribbled automatically, but the photo illustrates that a real person is attached to the name. The photo is more personal; thus most players can't help but be intrigued and flattered by the camera-wielding fan's request.

In the 1960s and '70s, fans were less hindered in getting photos of players than they are today, I believe. Of course, even then players were not available when they had pregame activities to attend to (like batting practice) or during the game, but when players didn't have these constraints, they tried to be cooperative. During that era, minor league players were more readily accessible than major leaguers, but even the major leaguers could sometimes pose quickly for a snapshot before a game. Spring training offered an especially good opportunity for fans to photograph major or minor leaguers because of the relaxed atmosphere of the training camps.

Usually when players seemed uncooperative it was because management and the league had strict rules in place, and players carefully avoided being hit with a fine. If a player merely waved at the camera-bearing fan and trotted past him or her, it meant "I'd like to come over there, but my boss is watching me."

One of the most popular players I knew was Frank "Hondo" Howard, who was my teammate for several seasons with the Washington Senators. Hondo towered over the fans (and all his teammates, as well), and many wanted to have their picture taken standing next to him. Hondo was very outgoing and cooperated whenever he

BY DAVE BALDWIN

★ Jim French and Dave                    ★ Dave and Chief Medrano

could. And he was the master of small talk with the fans, who were convinced they had held a real discourse with him, even though Hondo's remarks were usually the same for each "conversation." That made the photo with Hondo even more enjoyable, I'm sure.

My most pleasurable memories of fans' photography occurred while playing for the Hawaii Islanders of the Pacific Coast League in the late sixties and early seventies. Prior to our opening game in Honolulu we had a kind of "camera day," although I think it was advertised as something like "Meet the Islanders Day." The Islanders fans would swarm over the field asking each of us to pose with friends, relatives, and in some cases whole extended families. The fans made the players feel like they were part of those families, and the event seemed like a big party. It was a great way to kick off the season—a wonderful experience for the players and the fans.

At that time, instant-printing cameras were becoming popular, and many fans favored them because they made it possible to take the photo and get the player's autograph on it right after it was taken. Players came to expect to sign the print whenever they saw that a Polaroid camera was being used.

Sometimes a fan would give a player a copy of a picture. I still have several of these, although in most cases I don't know who took the photos. I have included here two pictures. One was taken of me in 1960 when I was just beginning my pro career, playing for the Williamsport (Pennsylvania) Grays. This was taken during a Camera Day at Bowman Field, a ballpark that is still being used today.

The second photo was taken in 1968 before a Senators game at RFK Stadium in D.C. The young man in the foreground is Greg Howell, who is one of my best friends to this day.

In my collection of baseball memorabilia I have two photos taken in Hawaii by unknown fans. One was taken in the Islanders' bullpen (an area where fans had ready access). It shows me with Carlos "Chief" Medrano, another relief pitcher. The second photo shows me with our catcher, Jim French. We had just gotten off a plane at the airport and were being greeted by enthusiastic Islander fans. Jim and I are both bedecked in numerous plumeria leis. These photos are so blurry one can hardly tell who resides in them, yet I've kept them for more than forty years as reminders of those great baseball days and those great fans.

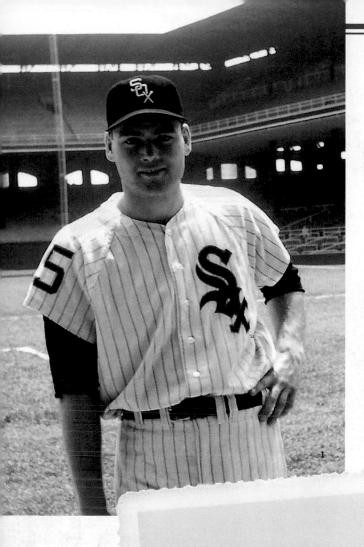

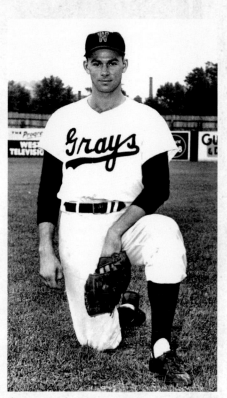

★ Dave Baldwin

**1 ★ SHAW ENOUGH**
White Sox pitcher Bob Shaw takes a break before a game on a hot humid day in Comiskey Park in late 1959.
—*Tom Larwin*

**2 ★ BABY FACE**
Davey Williams was a second baseman for the New York Giants in the 1950s who appeared in 517 games. One of Davey's claims to fame for baseball card collectors was the fact that he was card number 1 in the 1953 Bowman card set. The back of his card referred to him as the baby-faced Texan.
—*Craig Kellerman*

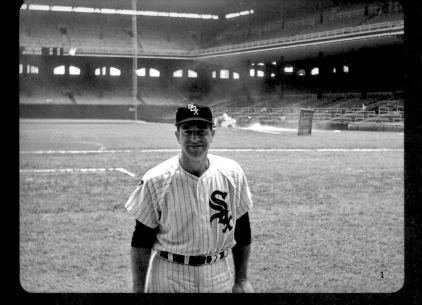

### 1 ★ JUNGLE LOVE

Every kid who was a White Sox fan in the 1950s loved Jungle Jim Rivera. A smart and fast runner, he ran the bases with abandon, sliding into bases on his belly before it was fashionable, and made many a game-saving catch in the right field. He was a ground ball hitter, and used his speed to full advantage. He was much tougher in clutch situations.
—Tom Larwin

### 2 ★ A B&W OF GRAY OF THE BROWNS

One-armed outfielder Pete Gray played 77 games in the 1945 St. Louis Browns outfield and made 7 errors. He batted .218 in 234 at bats and collected 51 hits that included 6 doubles and 2 triples.
—Don McNeish

### 3 ★ A WHIZ KID

Curt Simmons, a left-handed pitcher, teamed up with Robin Roberts to lead the Phillies to their 1950 National League pennant. He was only twenty-one years old at the time.
—Pete Wagner

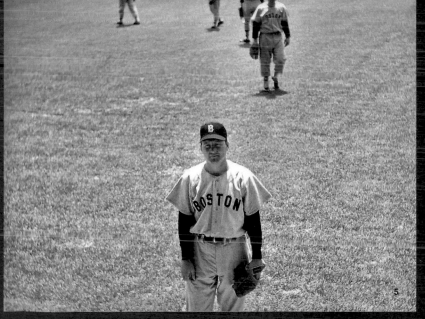

**4 ★ OH MY GWOSDZ**
The Padres' Doug
Gwosdz attends a
1980s picnic in the
stands for fans. His
teammates nicknamed
him "Eyechart" because
of the unusual spelling of
his name. —*Madres*

**5 ★ I LIKE IKE**
In eleven seasons
(1952–1965) pitching for
the Red Sox and Orioles,
Ike Delock won 84
and lost 75 and hit one
homer. —*Tom Larwin*

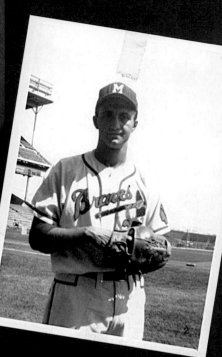

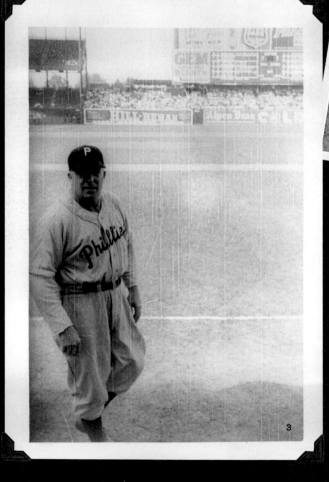

### 1 ★ STARE MASTER
Padres catcher Terry Kennedy "poses" for a fan during a 1983 Padres Saturday afternoon booster-club lunch after playing a long extra-inning game the night before. —*Madres*

### 2 ★ BIG BROTHER
Frank Torre is the older brother of Joe Torre. Frank played 714 games for the Braves and Phillies as a first baseman in the late 1950s and early 1960s. —*Frances Morgan*

### 3 ★ A PORTLY RIGHT-HANDER
Freddie Fitzsimmons, a right-handed pitcher who won 217 games during his 1925–1943 pitching career and then became the Phillies manager, is "snapped" at Braves field. —*Don McNeish*

**4 ★ IT'S THE LAW**
I "caught" this picture as Vern Law waved to a fan in 1956.
—*Peter Wagner*

**5 ★ GLOVE MAN**
My first Giants game was Fan Photo Day! I took this candid photo of Edgar Rentaria signing my oversized glove (that I carry to games for laughs) on May 2, 2009, at AT&T Park. —*Chris Wood*

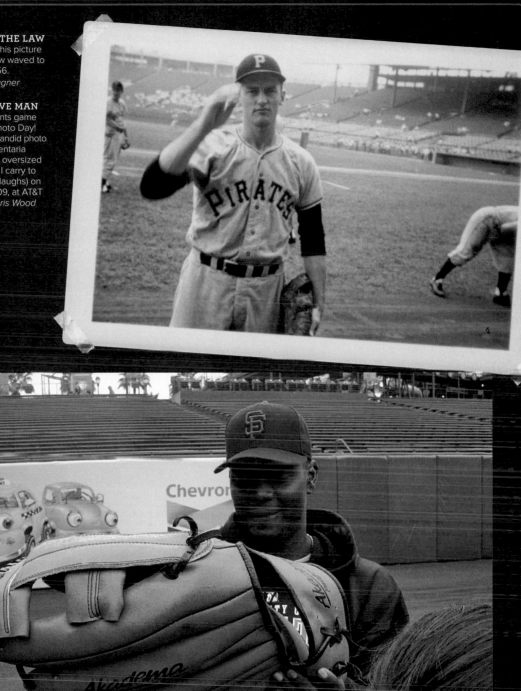

# 5 Camera Day

★ **A GAMER**
Ethan Allen of the Phillies grabs a camera to show the proper technique in shooting pictures. Allen would end his baseball career after the 1938 season and then start another one as the inventor of the popular baseball board game Cadaco All-Star Baseball.
—*Hunter Daniels*

# Take a Shot

A cherished stadium tradition since the 1940s, "Camera Day" is that annual golden opportunity when fans are given carte blanche to descend from the stands, mingle with their heroes on their own turf, and take snapshots to their heart's content. It's a heady, almost surreal experience that many awestruck fantographers—especially the youngest ones—always seem to remember as sheer perfection, as if all the stars were momentarily aligned.

But how much do any of us know about the behind-the-scenes details of Camera Day and the logistics of what it takes to organize and stage such an event?

Well, as a longtime marketing executive with the San Diego Padres, I've been there and done that, and let me tell you, the ear-to-ear smiles don't come out until the big day. Before that, it's gritted teeth and pursed lips as all the myriad details get ironed out (hopefully).

Some considerations:

*Timing*—The first step is to strategically select a date that meets the approval of the home team's GM and manager, both of whom may consult with the visiting team's GM and manager, since time constraints dictate that batting practice for both squads must be canceled. Ideally, Camera Day is scheduled on a fan-friendly Sunday that, if possible, also coincides with the climactic last day of a home stand.

*Sponsors*—Of course, any financial underwriters of the promotion will also want the date to coordinate with their marketing plans, and their scheduling ebbs and flows. Professional photography studios, for example, may not want their Camera Day involvement to impede the high season for graduations or weddings. Also, sponsorships may likely involve some kind of free "swag" handout, which requires a concrete plan for development, production, and distribution. And all of that comes *after* the process of attracting sponsors in the first place, usually by assembling a marketing package that promises a dramatic return on their investment. *Pssst*: the key is to under-promise and over-deliver.

BY ANDY STRASBERG

## 1 ★ SHOOTING THE READING RIFLE

This snapshot was taken during the 1955 World Series at Ebbets Field. The player swinging the bat is Carl Furillo. The reason why all the motion picture photographers are on the ground is because they were taking a close-up of his swing so they could edit it into the World Series highlight film. —*Bruce Greer*

## 2 ★ FUNNY NOSE & GLASSES

During the Padres 1992 Camera Day, Bruce Hurst and Larry Andersen reveal that boys are boys no matter how old or how talented. —*Larry Carpa*

## 3 ★ PICTURE PERFECT

My mother, Dorothy C. Klink, took this photo of me during the Giants 1963 Camera Day. The day was a special one for many reasons, including the fact that we got an official photo pass. —*Bill Klink*

## 4 ★ DUKE OF CANDLESTICK

It was Camera Day in 1964 at "The Stick," and Duke Snider was making the rounds for fans to snap his photo. After all these years Duke still doesn't look right in a Giants uniform. —*Ted Canter*

*Players*—Many hate Camera Day. These sourpusses either won't cooperate at all or just grin and bear it. They count the seconds until it's over, ruing whoever in world history ever invented the cruel come-on "Say cheese." Regardless, however, each member of the home team must receive advance written notice with explicit instructions on time, location, uniform dress, and guidelines regarding fan interaction. (One potential problem is that fans often think Camera Day means Autograph Day—which it does not. Hence, if one player accommodates a fan's request and another player doesn't, then the player actually following the rules winds up the villain.) The visiting team also must be reminded of the event, typically two weeks before they arrive and then again on their first day in town. Finally, come Camera Day, players must be led out onto the pastime's grand pasture in an orderly fashion and at the appointed time. Organizers must anticipate hesitancy, excuses, tardiness, and attempts—both feeble and bold—to sneak back to the locker room.

Sound complicated so far? It gets worse.

*Grounds Crew*—For the sake of appearance, the field must be especially finely manicured either the night before or earlier in the day—or, better yet, both. Reminding groundskeepers not to water that morning is always a smart measure to ward against muddy cleats and sneakers.

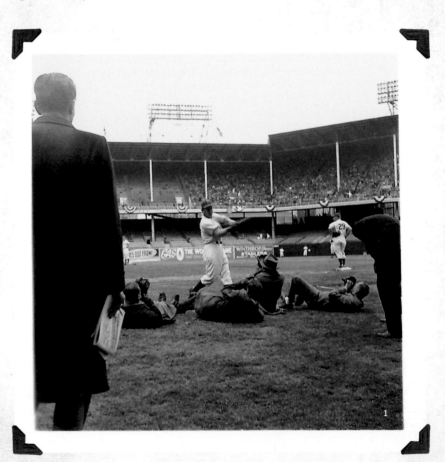

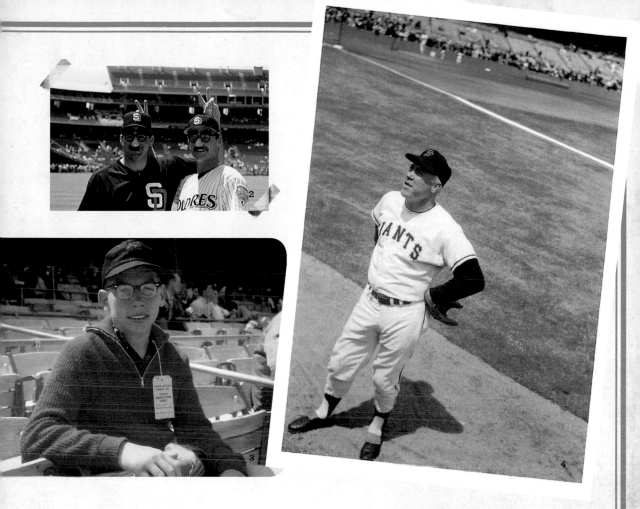

**Security**—Somebody has to make sure no fans get overzealously stalkerish during the event! Plus, nobody wants to see a stampede, so arrangements must be made for a safe flow of traffic onto and off of the field.

**First Aid**—Sunburn, dehydration, injuries, swooning—you get the idea.

**Public Relations**—Press releases and advertisements must be created for print and electronic media. Promotional scripts must be written weeks in advance for the TV/radio broadcasters and the public address announcer. Hyped-up scoreboard messages must be displayed at preceding games to heighten awareness of Camera Day. This all takes forethought and time, people!

**Weather**—Contingency plan, anyone?

Once the event is over, every fan, player, coach, manager, stadium personnel member, security guard, and groundskeeper needs to return to standard ball game operating procedure. And, last but not least, *everyone* needs to be thanked for participation and cooperation.

Play ball!

## 1 ★ HAIL CESAR
Cesar Tovar played every position in one game (1968). He also played in 164 games in 1967. —*Shorty Allison*

## 2 ★ FAN FAVORITE
Popular Dodger first baseman Gil Hodges returns to New York as a member of the Mets in 1962 and accommodates the fans on Camera Day at the Polo Grounds. —*Lew Lipset*

## 3 ★ PIRATE OF THE MONONGAHELA
I am with Pirate shortstop Tim Foli on Photo Day in 1980. I'm ecstatic and terrified at the same time. — *Matthew Ruben*

JUL · 68

6

## It's Not a Small World After All

In 1974, while Yankee Stadium was being refurbished, the Yanks' home games were at Shea Stadium. That year, for one pregame Camera Day promotion, the Yankees had forty ushers with Polaroid SX70 cameras stationed around the ballpark who were instructed to take pictures of as many fans as possible alongside a Yankee player or coach. As you can imagine, there were too many fans and not enough time, players, or cameras to make this work, and it was never tried again.

**4 ★ EXPOSED**
The Orioles' Jim Palmer signs autographs for fans at a 1975 Baltimore Memorial Stadium event. Palmer would gain additional exposure as a model for Jockey underwear.
—*Greg Howell*

**5 ★ UP CLOSE**
Sandy Vance was the only player we could get close to on Dodgers' Camera Day.
—*Alan Shroeder*

**6 ★ A WYNNER**
My dad let me take his camera onto the field. I was about twelve years old and not very tall so I had to stand as tall as I could to take pictures over adults' heads. Sometimes I was lucky and they all moved away and that's when I got a good picture like this one of Jim Wynn at Bush Stadium in 1968.
—*Gary Holdinghausen*

**7 ★ BIG "D"**
For Brooklyn fans "Big D" didn't mean Dallas, it meant Don Drysdale. —*Lew Lipset*

5

7

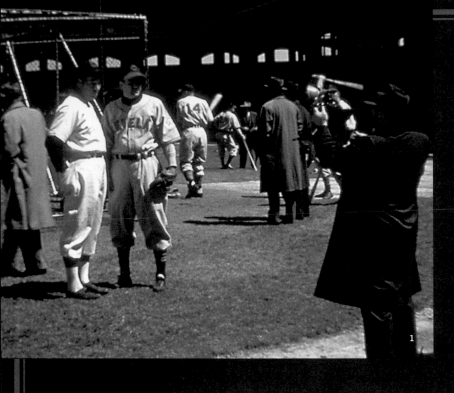

### 1 ★ HANDSOME & MULE
Lou Boudreau, who was known as "Handsome Lou," poses for a photographer with George Haas, who was known as "Mule," at Comiskey Park in 1946. —*George Case*

### 2 ★ BAG MAN
According to the 1951 Cleveland Indians Sketch Book, Harry Simpson was called "Suitcase" by sportswriters after Suitcase Simpson, a character in the "Toonerville Trolley" comic strip. This is years before the player's many trades. His real nickname was "Goody," which came from his willingness to run errands and help neighbors in his hometown of Dalton, Georgia. —*Kay E. Scozzafava*

### 3 ★ STOP ACTION
Tony Oliva of the Twins smiles for the camera, while the kids for the next photo get in place. —*Shorty Allison*

Harry Simpson

Lane Field - Year "49"

Tony Oliva

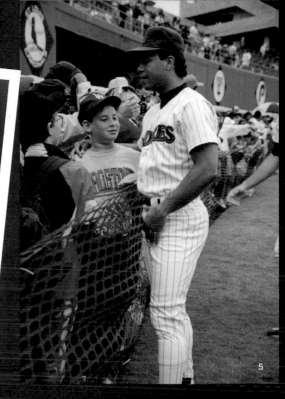

**4 ★ HUGS & MUGS**
Unidentified Angels player
mugs for the camera while
hugging a fan during
Camera Day. —*Unknown*

**5 ★ OH BROTHER**
Robby Alomar greets fans
on Padres Camera Day
early in his career. Robby
and his brother, Sandy
Jr., played briefly for the
Padres at the same time.
—*Madres*

**6 ★ A GREAT BARBER**
Atlanta Braves pitcher
Steve Barber walking to
the dugout at Atlanta-
Fulton County Stadium on
August 10th, 1971 (my 12th
birthday), before a game
with the Chicago Cubs.
Upon taking this picture
Barber commented: "Why
in the hell would you want
a picture of me?"
—*Jeffrey Saffelle*

# 6
# Transportation

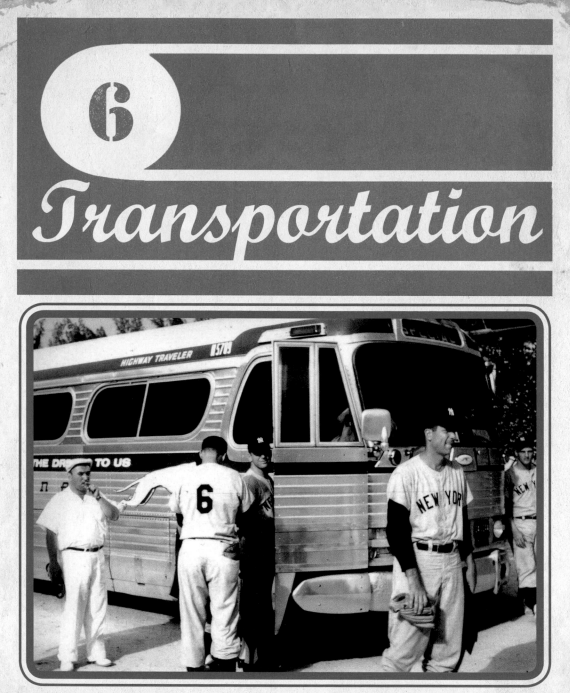

★ **ALL ABOARD**
The Yankees board their bus at Vero Beach after playing the Dodgers in a spring training game in the early 1960s. The person in the white pants, shirt, and cap who is smoking is Dodger employee John Mattei. That's Mickey Mantle about to board, looking at the camera; number 6 is Clete Boyer; and Roger Maris is coming around the bus from the other side.
—*John Mattei*

# Short Hops, High Flies, and Long Drives

Ever since professional baseball leagues were formed in the 1850s, transportation and baseball have been intertwined in many ways. America's favorite baseball song—"Take Me Out to the Ballgame"—was inspired on a train ride somewhere in New York City in 1908. And in the 1970s, "Baseball, hot dogs, apple pie, and Chevrolet" was an advertising jingle that became a mini-anthem.

The most concrete linkage between transportation and baseball comes from travel—the use of transportation for teams to get to their next city on schedule and for fans to get to and from a game.

Teams were organized to represent cities, and thus, it was necessary for the players to travel between the league's cities in order to play the scheduled games. Over time, in going from one city to another, a team's primary modes of transport included trains, automobiles, buses, and airplanes. There were even professional leagues called "trolley leagues" because the ball clubs from each of the league's cities were reached by an interurban system of trolley routes.

In the late nineteenth and early twentieth century, players already in uniform would be carried to and from ballparks in carriages and were occasionally subjected to jeers, trash, and fruit missiles, depending on their record or the allegiance of the spectators along the way. But through the 1950s major league baseball teams got around mainly by train. For the minor leagues and Negro leagues, team buses were the most cost-efficient mode of transportation. The first major league team to travel by air was the Boston Red Sox in 1936, and then ten years later the Yankees began flying exclusively to their games. And with the relocation of the Dodgers and the Giants to the West Coast in 1958, air travel became the predominant way for teams to go from city to city.

For fans wanting to attend ball games, the early major league ballparks were generally built in areas accessible by streetcars or trolleys. In the 1880s, Staten Island Ferry riders could buy tickets that included free boat rides to and from the games. The Los Angeles Dodgers' nickname is transportation-related: it was derived from a common term used in Brooklyn in the 1880s, the "trolley dodgers." There were

BY TOM LARWIN

1 ★ THE EYES
OF THE A'S
I still can't believe that
my father jumped on the
A's bus as a kid and took
this photo just before
they pulled away from
the field during spring
training. The only player
I can identify is Wally
Moses, who is seated in
the front seat with his arms
folded. —*Kevin Flitcraft*

2 ★ BUS STOP
Baseball fan Gary
Heron leans against the
Brewers team bus in
1992 at Palm Springs—
a bus that he hopes
he will ride when he
becomes a major
leaguer. —*Doug Heron*

3 ★ BLUE BY YOU
During the 1970s, MLB
teams used golf carts
that were decorated
in a baseball motif to
transport relief pitchers
from the bullpen to
the mound. This is the
Dodgers version, parked
on the warning track at
Dodger Stadium near
Billy Grabarkewitz.
Fortunately, this
baseball-transportation
tradition lasted only a
few years as pitchers
opted to enter the game
on their own.
—*Alan Schroder*

nine busy trolley lines that passed by Brooklyn's ballpark, Ebbets Field, and back then, the maze of tracks surrounding the ballpark required fans to be careful crossing the streets and "dodge" the streams of trolleys.

However, by the late 1950s, automobiles had become a more common option for access to games. Major league ballparks of that era were outside of the central, more populous areas where more land was available for large parking lots. Starting in the early 1990s, new ballparks have been built in central areas where a combination of automobile and public transportation access has allowed fans to more easily make it to games.

Transportation access has also served to describe World Series. New York City hosted the 2000 "Subway Series" between the Mets and the Yankees. The first Subway Series took place in 1923 between the Giants and the Yankees when the Giants used to play at the Polo Grounds in Harlem and the Yankees were based in the Bronx at Yankee Stadium. In 1989, the Oakland Athletics played the San Francisco Giants in the World Series, which was called the "BART Series," named after the Bay Area Rapid Transit network.

Not too long ago transportation was also a ceremonial component of a major league game. Relief pitchers would be carried from the bullpen to the pitching mound by vehicles such as automobiles, hearses, trucks, fire engines, scooters, and golf carts.

Automobiles have also been associated with baseball awards. In 1910 the "Chalmers Touring Car Award" was presented by the Chalmers Automobile Company, a Detroit-based automobile manufacturer, to each league's batting champion. Then, from 1911 through 1914, the Chalmers award was given to each league's most valuable player (MVP).

2

3

## A Player of Notes

Phil Linz was playing the harmonica in the back of the Yankee team bus after an August 1964 loss. From the front of the bus, manager Yogi Berra ordered him to stop. "What did Yogi say?" Linz asked Mickey Mantle. Mantle's reply: "Yogi wants you to play it louder!"

# 13

For centuries, baseball players have been superstitious. Volumes could be written about the strange beliefs and omens that guided these men in their everyday lives on and off the diamond. The "thirteen" superstition was universal. No player ever rode on a team bus carrying thirteen men—they were sure to count noses before boarding. The same practice applied to taking a seat at the team dining table. If the player was the thirteenth diner, he sat elsewhere. And when teams traveled by rail, berth number 13 on the train, even a lower, was shunned by those with superstitions. The exception was Frank Chance, who insisted on occupying berth number 13 on the sleeper car or, lacking that, a stateroom by the same number. If he couldn't find one, he chalked the number on the door. The jinx killer worked. Chance proudly proclaimed that he was never involved in a train wreck.

Legend has it that Roger Bresnahan, the New York Giants catcher, suffered mental anguish unless he got to sleep in an end berth on the train.

## 1 ★ CHALK TALK
In a "behind the scenes" tour of the Padres clubhouse during the 1980 season. Everyone was fascinated with the travel instructions for the players on the chalk board.  —*Madres*

## 2 ★ ON THE MOVE
During the 1998 World Series Game 2 at Yankee Stadium, I noticed through the glass doors of the old Yankee offices the Roger Maris family getting into the elevator to take them to the field. I opened the door and yelled, "Hey Maris family . . . smile!" and captured this awesome candid shot of a great family on a great night. Left to right: Richard, Sandra, Roger Jr. in back, Kevin in front, unidentified man in sweater, Susan in back, Randy, and elevator operator. —*Craig Jackowski*

## 3 ★ ON THE WAY
The idea was to stage the 1979 Padres team photo at a local San Diego landmark rather than an empty stadium. The site was the San Diego Zoo and the players were not thrilled for this bus ride. Left to right: Ray Peralta, Kraig Heye, James Piotrowski, Randy Jones, and Dick Dent. —*Andy Strasberg*

**4 ★ HEADING NORTH**
In 1942, it was getaway day at spring training and my father waited for the Boston Bees to get on their bus and take them north. In the picture you can see, from left to right, Nanny Fernandez, Mrs. Max West, Max West, Tommy Helms, Tony Cuccinello, and Mrs. Holmes, with her back to camera.
—*Gerald Hampton*

**5 ★ A CLEAR STATION**
The New York underground subway train became an elevated train and went right by Yankee Stadium. You could watch the game from the platform and you could see the train go by from inside Yankee Stadium. —*Don McNeish*

# Pie in the Sky

Hughie Jennings once told this tale about a busher who came to the Tigers with a prodigious appetite for pie. Apple, custard, lemon meringue, peach, or berry—they all looked good to him, morning, noon, and night. It did not take long for the players to discover his failing. The Tigers were on a long and tiresome train ride that made many stops along the way. At the first stop, one of the regulars who sat behind the pie fancier, opened the train car door and shouted, "Five minutes for refreshments!" trying to get a reaction from the busher. Out bolted the rookie, who rushed into a small train station looking for the lunch counter, but there was none. Frantic yells from the train brought him back just in time. At the next stop, the joke was repeated, and once again the young player rushed out from the train car, this time finding nothing in sight but a water tank.

All morning long, at every stop, the cry ran through the car, "Five minutes for refreshments!" and the rookie ran to the car platform and leaped to the ground, looking in vain for the pie counter. When noon came and there was the real stop for lunch, he was tired and assumed that it was another practical joke so he kept his seat. So, with huge slabs of pie in hand, the Detroit players returned to their coach from the lunch counter and gathered around the youngster, making sure that he watched every mouthwatering bite being devoured.

### 1 ★ SOCK IT TO ME

Max West grew up in Southern California and made his big league debut in 1938. He went to high school with my mom and they remained good friends over the years. My mom had this great picture of Max with one foot on his car. I don't know what the circumstances were but this is a treasured family heirloom. After his playing career ended, he owned a sporting goods store in Alhambra, California. West died of brain cancer at age 87 in 2003.   —*Phil Galvin*

### 2 ★ PICTURE PERFECT

The year before Tony Conigliaro made it to the Red Sox he played minor league baseball in Wellsville, New York.
—*Julie Markakis*

SEP    63

## Baseball Voodoo

In the early days of baseball it was not uncommon for a player to be superstitious about his surroundings as he traveled to the ballpark, as it could affect his play at the ball game. There were numerous fears.

★ Passing a wagonload of empty wooden barrels was one of the worst omens that could befall a bus full of players.
★ A funeral was just as ominous. The team bus was ordered to pass well out of its way to avoid certain danger.
★ Meeting a cross-eyed woman on the street required that a player spit through his fingers three times, twice for a man.
★ Passing a person who was handicapped was bad luck—unless he or she was tossed a coin.
★ A few baseball players picked up pins they found on the sidewalk, because each one represented a hit.

Some journalists at the time had fun with players who had the dreaded superstition disease. The following lighthearted spoof was published in 1908 in the *New York Times*, targeting a high-profile member of the hometown team:

"Clark Griffith of the Yanks has an aversion to being run over by a six-cylinder automobile, and it is said by those who know him well, the same dread extends to cars of only four-cylinder construction."

## Pillow Talk

At the turn of the century, train officials were reluctant to place baseball teams in their best Pullman sleepers because of the players' predictable acts of rough horseplay and destructive vandalism. In 1901, a Washington baseball writer witnessed a trouble-making ballplayer who was determined to relieve the boredom of the journey by daring another player to throw a pillow out the window. The words were hardly out of the instigator's mouth before the car's entire pillow supply was jettisoned out the moving train, littering the train tracks. (On another occasion a different player took a bat to one of the seats and deliberately smashed off the arm.)

**3 ★ SIGN HERE**
Babe Ruth's "autograph" appears on a San Francisco Municipal Railway station wall map. —*Brandon Burke*

**4 ★ HIT MAN**
Wally Moses would occasionally ride his bike to spring training. One of the more interesting stats about Moses is that during his career (1935–1951) he had more hits (2,138) than games played (2,012). He was also the Yankees batting coach in 1961, when Roger Maris hit 61 homers and Mickey Mantle hit 54 round-trippers. —*Kevin Flitcroft*

# Trains and Homers

How far did the longest home run travel? Perhaps 500 feet? 550 feet? More than 600 feet? Not even close. The longest home run on record traveled over 500 *miles*.

Roger Connor hit the longest home run ever. A Hall of Famer, Connor began his eighteen-year professional career in 1880. Once, he hit a home run in Fort Wayne, Indiana. Legend has it the ball landed in a train car while the train was moving and traveled over 500 miles before it came to a stop.

Don't believe Connor's tale? Try this one: Bob Montag hit the longest home run ever.

In World War II, Robert Edward Montag earned the Bronze Star and Purple Heart, suffering so many wounds that doctors thought he'd never walk again, let alone play baseball. But in 1946, he played for Ogden in the C League and continued on in the game for the next fourteen years. He may have been one of the greatest players *never* to play in the major leagues. In the 1950s, he spent seven years with the Atlanta Crackers of the Southern Association and was the most popular player at the time. During a 1954 game, Montag hit a round-tripper that traveled an estimated 450 feet over the right field wall of the Crackers' Ponce de Leon ballpark. Reports had the ball landing in a coal car of a passing train and traveling out of sight. A few days later, a train employee appeared in Atlanta. He presented the ball to Bob and told him he had recovered it from the coal car. The employee explained that the train had traveled from Atlanta to Nashville and back, a 518-mile round-trip. That would mean Montag's blast was 518 miles and 450 feet! Clearly the *longest* home run in baseball history!

1

2

## Name Game Doctor

Rod Carew was born on a train on October 1, 1945. When his mother went into labor, another passenger, Dr. Rodney Cline, delivered the baby. To show their appreciation, the parents named the infant Rodney Cline Carew.

## Backseat Baby

Rickey Henderson was born in the backseat of a 1956 Chevy. His father was driving his mom to the hospital but didn't make it in time.

**1 ★ IT'S VERY CHALMERS**
A snapshot of the Chalmers automobile that was awarded each season to the player with the highest average in the Major Leagues during the 1911–1914 seasons. —*Anonymous*

**2 ★ EASY RIDER**
Biker dudes Mickey Lolich and Joe Torre take a trip around the Shea Stadium warning track. It is Photo Day 1976. The black arm patch is in memory of Casey Stengel and Joan Payson. —*Andrew Pomeranz*

**3 ★ HE PARKED IT**
This snapshot was taken for the purpose of documenting for Roanoke city officials that this ROSOX baseball bus had been parked alongside this building without the proper permit on two occasions in 1953. —*Anonymous*

**4 ★ SUBWAY SPECIAL**
Roger Maris arrives at Yankee Stadium in 1960 after getting off the subway. That's Bob Cerv to Maris's left. —*Dick Mathis*

# 7
# Scoreboards and Signage

★ **DENTED**
This is the famous Fenway Park left field manual scoreboard in 2001. Look
closely at how many dents are in the wall from the many years of abuse.
—*Paul Stanish*

# Off the Wall

The concept of informing those in attendance at a baseball game of the score had its origin practically when baseball began. Originally, the scoreboard was placed in an area so that everyone at the game could see it. There was a person who was in charge of writing the appropriate number in chalk or hanging a painted number for the runs scored each inning.

Eventually there were scoreboards located away from ballparks that could satisfy baseball fans who couldn't attend games. Telegraphy made possible the invention of the mechanical street scoreboard in the 1880s. It was a clumsy but highly visible monstrosity set up on scaffolding outside the building of a local newspaper. Wired messages of a game in progress a thousand miles away were received and transferred to the boards by two men. One moved metal pieces representing players around the simulated diamond; the other explained what was going on with a megaphone in his hand. It was crude but it worked. The scoreboard attracted large audiences in the streets in front of those newspaper buildings.

Scoreboards on the inside of ballparks underwent similar changes. In 1902, the first electrically operated unit was erected on the St. Louis Browns' ball grounds. The primitive mechanical contraption was worked by the official scorer and registered inning, outs, balls, and strikes. This came as a blessing to those fans seated too far away from home plate to hear the umpires' calls.

Electrical technology was eventually applied to the street scoreboard. One result was the amazing Rodier Electric Baseball Game Reproducer. It not only displayed vital game information such as outs, innings, and the score, but could reproduce action by means of electric lights, "in a manner so realistic as to be startling," a newspaper ad boasted.

It was a momentous day indeed when the *Washington Post* newspaper purchased a Rodier unit and installed it outside their offices. It roared to life in July of 1909 and was an immediate success, a wonder of its day. The device allowed local fans to follow the Senators on the road, in action yet. It drew immense crowds.

BY ANDY STRASBERG

On July 16 of that year, Washington was playing a close game in Detroit. As the contest ran into extra innings, a small group of spectators began to gather in front of the scoreboard. More trickled in as the game wore on. It was long after 7 P.M. when the contest was finally called because of darkness. By that time, more than two thousand fans had jammed the street, much to the delight of local saloon keepers and delicatessen owners.

The Rodier machine in Washington, D.C., was improved in 1910 when two boards were erected to accommodate larger crowds. They were set at angles to allow for easy viewing from any point on the street and operated with every away game.

Meanwhile, baseball team owners were hesitant to provide information about the boards for fear that it would cut into the sale of scorecards, but the electric scoreboard signaled an eventual shift in the in-game experience at stadiums and arenas as well. Over the next two decades, manually operated scoreboards evolved to feature more information than the score. Lineups with players' names and numbers were displayed, along with scores and pitchers' numbers from games around the league.

Beginning in the 1970s, scoreboards provided more than just information to fans attending ball games. Scoreboards were able to display animation as a result of multicolored lights.

The next step in the scoreboard evolution happened in 1980 when the Los Angeles Dodgers unveiled a $3 million, 875-square-foot video board at the All-Star Game. Mitsubishi's Diamond Vision, which enabled operators to show replays using a VCR, was the first video board of its kind. Similar video boards soon became standard in ballparks around the world. Eventually the resolution and functionality of the screens improved when Sony entered the market with its popular JumboTron.

# SIGNAGE—*NO* PEPPER

In 1858, the Fashion Race Course baseball games were the first to charge an admission fee. (That revenue went to defray costs, with the surplus going to a fund to help widows and children of New York and Brooklyn firemen.) For my money, the moment a baseball team decided to enclose a baseball field and charge admission was when baseball became a business. And shortly after those walls went up, team owners realized that they had a captive audience of "baseball bugs" or "baseball cranks," the names for the fans in those early days, who were facing some blank outfield walls. They quickly saw an opportunity to sell advertising space on those walls that were going to be seen over the course of a game. History hasn't recorded who came up with the idea or what the first ad was, but once it started there was no stopping it. Some of the earliest outfield ads were for Bull Durham tobacco. They were painted on the outfield walls in most ballparks and usually situated in foul territory where pitchers would warm up before entering the game, hence the name "bull pen."

The primary target market of the outfield ads was the men who attended the games. Gillette razors led the list of candidates for an outfield sign, and after Prohibition was repealed in 1933, beer ads rolled into the ballparks, and they haven't left since.

The early ballpark signs were hand-painted and were almost works of art. The most notable and effective of all outfield signs had to be the sign just below the scoreboard at Ebbets Field. The last time that sign was seen at a major league game was 1957, and yet many baseball fans still talk about it as if it was seen last July. It was for Abe Stark Clothiers, and the sign played a role in every game because it

plainly stated that Abe would give a suit to any player who was able to hit the sign on a fly. Abe wasn't, however, the first interactive sign. In the 1912 and 1913 seasons, the makers of Bull Durham smoking and rolling tobacco created the "Hit the Bull" advertising campaign. Large wooden signs of the "Bull" were erected on the outfield grass in several major and minor league parks. Players who hit the sign won cash—this was a costly advertising stunt. In 1913 alone, $10,550 was paid for direct hits scored on the bull. The lucky batters included pitcher Walter Johnson.

Once signs had electricity, the incorporation into the outfield advertising sign of scoring a batted ball as a hit or an error was ideal. The play was indicated by illuminating a sign that said "It's a Hit" in the bigger beer sign, or the *h* or the *e* would light up in the name of the product (Rheingold Beer).

When Dodger Stadium opened in 1962, the ballpark signage approach changed dramatically. It was the first privately financed major league ballpark to open since the original Yankee Stadium opened in 1923. The Dodgers decided that rather than have a clutter of outfield signs competing for eyeballs, they would turn the supply-and-demand equation around. They reduced the number of signs and probably charged for one billboard what was equal to the cost of six. Union 76 was the only ballpark signage that could be seen if you were sitting in the stands.

Sometime in the mid 1980s television was added as an ingredient to the formula. Consider first the broadcasting of the game to the television audience of the visiting team. Immediately, the target audience for outfield ads is expanded to viewers in another city, county, and state. Depending on the location of the signs within the park, the ads will receive "TV airtime," a factor so important that there are now companies who specialize in calculating the amount of time an ad will be given by those viewers watching the game in the visiting team broadcast market. Now add to the mix the replays of games and selected shots on sports networks

★ **PROOF POSITIVE**
This is proof that my brother Mitch was at the first-ever Padres World Series game in 1984.
—*Gary Holdinghausen*

and news shows around the country, and quickly there are a few more zeroes in the pricing. Such ads became baseball's version of "product placement" at its best or worst. Camera angles are now planned strategically to not only cover the game but also determine which background areas can provide prime inventory signs to sell in ballparks.

More recently, baseball games that are televised have incorporated signage that is seen behind the batter, the catcher, and the home plate umpire. But if you are at that ballpark, there is no actual signage. Technology provides whatever sign is sold using green screen, the kind that provides digital backgrounds for big budget sci-fi films, as well as the weather map on your local news.

And if you have attended a ball game in the last few years and visited the restrooms, you quickly realized that there is no limit to where signage can appear. Even cup holders have mini ads on them.

The experience of attending a baseball game might not be enhanced by outfield signage and advertising, but it does provide a revenue stream for a team that in turn can offer more money to players and hopefully get the best ones. That business model is still in effect today.

**1 ★ POWER OUTAGE**
A Joe Mauer fan holds up a sign during the 2010 All-Star Game at Anaheim. Mauer went hitless in two at bats as the National League beat the American League, 3-1.
*Paula Davis*

**2 ★ YES PEPPER**
The 1969 Padres players are enjoying a game of pepper before a game at San Diego Stadium.
*—Bruce Rowe*

## Men of Cloth

At Ebbets Field in Brooklyn, a sign under the right field scoreboard used to proclaim that a player hitting the sign would win a suit, a practice that was copied by other haberdasheries around the country. For years at Crosley Field in Cincinnati, the Superior Laundry building could be seen over the left field fence. (Broadcasters measured home runs for listeners by using the laundry building as a reference. A home run was either "in front of the laundry," "off the laundry," or "on top of the laundry"!) During the 1950s, a billboard atop the laundry read "Hit this sign and win a Seibler suit." The Reds' Wally Post reportedly hit that sign a record eleven times!

1

2

**1 ★ BRAVE OLD FIELD**
The Boston Braves Field outfield fence ad for Carstairs Whiskey provides the backdrop for the Cardinals' Kurt Davis.
—*Don McNeish*

**2 ★ MY PORCH**
Andy Strasberg standing next to the Yankee Stadium "344 Feet" sign in right field at Yankee Stadium. —*Gary Baker*

**3 ★ FAREWELL**
The message on the Connie Mack Stadium scoreboard remained for months, maybe years, after the final game was played. —*Andy Strasberg*

**4 ★ BEHIND THE NUMBERS**
In a surprise meeting, Red Sox fan Carol Rautenberg is shown the inside of Fenway's Green Monster and in walks Aubrey Huff. This snapshot records the chance meeting.
—*Carol Rautenberg*

**5 ★ NO PEPPER**
Tony Gwynn was in Riverside, California, at UCR, shooting a baseball video, and I had full access to shoot pictures. Note the "No Pepper" sign in the upper left corner. —*Doug Heron*

## A Sign of Reverence

In the March 28, 1878, edition of the *Milwaukee Sentinel*, an article noted that the local baseball club was taking bids for advertising on the outfield fences. According to the National Baseball Hall of Fame, this is the earliest mention of an outfield fence ad in recorded baseball history.

## Push Button Baseball

When Yankee Stadium opened in 1923, it featured a large manually operated scoreboard in right field that was visible to every spectator in the park. In 1950, the Yankees unveiled an electric scoreboard that the team called "the most efficient scoreboard ever built and, in general, a big stride forward." The Yankees' new scoreboard was operated by two men as opposed to five and featured a nonglare enamel covering.

Before the 1959 season, the Yankees made another upgrade, installing the first scoreboard to feature a changeable message display. The *New York Times*, which dubbed the new scoreboard the "electronic miracle," provided the specifics: "The board will contain 11,210 lamps with a wattage of 115,000, and 619,000 feet of electric cable, will weigh 25 tons (not including the steel supporting structure), will have more than 4,860 push buttons on the master control console and will have a total face area of 4,782 square feet."

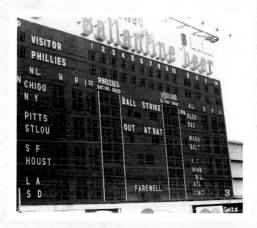

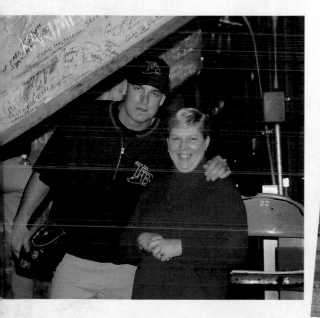

## Something Old, Something New

Wrigley Field's iconic eighty-nine-foot scoreboard was built in 1937 under the direction of flamboyant club treasurer and future White Sox and Indians owner Bill Veeck, whose father was team president until he died in 1933. Most of the original Wrigley Field scoreboard, which still stands today, is manually operated, and the original control panel is still in use, but the batter's number, balls, strikes, and outs are now displayed electronically in the center portion of the board.

## 1 ★ LOOKING UP

Here's what the center field Wrigley Field scoreboard looks like from the bleacher seats directly underneath.
—*Don Dewolf*

## 2 ★ SUIT SIGN

The Braves were in Ebbets Field to play the Dodgers on July 14, 1957, and Joe Adcock was in the on deck circle. The scoreboard, the design, coloring, and lettering were a work of art. —*Lew Lipset*

## 3 ★ *H* OR *E*

Two former Brooklyn Dodgers, Roger Craig and Charlie Neal, strike a pose during the 1962 Mets Camera Day promotion at the Polo Grounds. Note the Rheingold Beer sign in dead center. The *h* and *e* in the sign are not as white as the other letters because they would light up, indicating to the fans if a ball was a hit or an error. That sign was 500 feet from home plate. —*Lew Lipset*

## 4 ★ MEMORY LANE FIELD

Unidentified Pacific Coast League Padres player is about to sign an autograph for a young fan. Note the advertising signs above the left field bleachers in Lane Field.
—*Jack and Susie Nopal*

## 5 ★ A GEM OF A PHOTO

An unidentified Detroit Tigers player poses for a picture before a game with Fenway Park's left field "Gem Singledge Blades" and "Lifebuoy" ads in the background.
—*Don McNeish*

## Fireworks

The current scoreboard in Chicago's U.S. Cellular Field, which opened in 1991, pays tribute to the old Comiskey Park version, which, beginning in 1960, featured multicolored pinwheels and shot off fireworks after every home run by a Chicago player. "All I know is that if I was a pitcher whose home run ball had started that Fourth of July celebration, I'd fire my next pitch at the head of the next hitter," Indians manager Jimmy Dykes told a reporter in 1961.

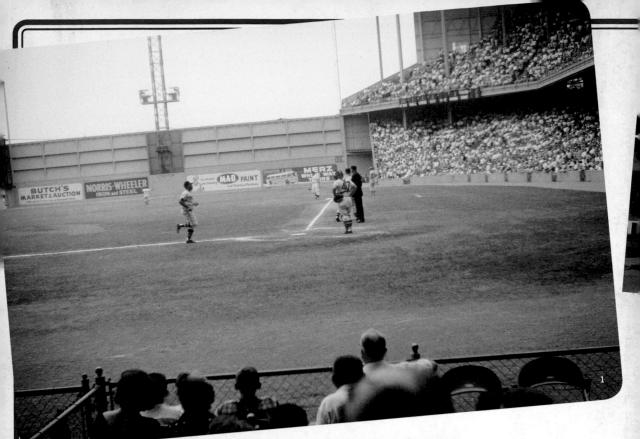

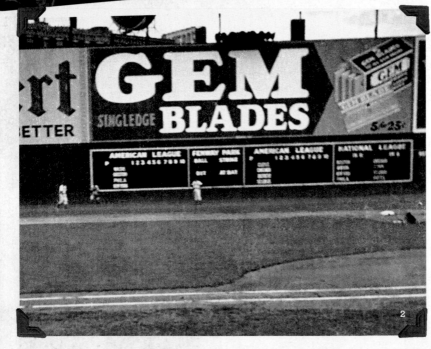

### 1 ★ PLATE CROSSING
Looking down Connie Mack Stadium's right field foul line as a Milwaukee Brave crosses the plate.
—Don McNeish

### 2 ★ A GEM
Fenway Park's left field fence in the late 1930s displayed an ad for Gem razor blades.
—Don McNeish

### 3 ★ AN OLD SCORE
While visiting the Astrodome in 1971, I noticed that in the parking lot was the remains of the old Colt .45 ballpark. This is the center field scoreboard from that outdoor ballpark.
—Andy Strasberg

3

# Morse Code Scoreboard

Originally installed in 1934, the manually operated scoreboard at the base of Fenway Park's Green Monster in left field features a hidden and little known message. Those with training in Morse code can discern the initials TAY and JRY in the vertical stripes of the scoreboard, a dotted tribute to former Red Sox owner Tom Austin Yawkey and his wife Jean Remington Yawkey. The letters were installed at the request of Tom in 1947. According to longtime Red Sox executive Jim Healey, it was Mr. Yawkey's idea to surprise Jean and a way of publicly displaying his affection for all to see . . . but only if they knew Morse code and where to look.

Another Morse entry in Fenway that never really appeared for public viewing occurred when Nike honored the 2004 Red Sox championship with a television ad. Nike invoked its corporate slogan "Just Do It" in Morse code in the margins surrounding the scoreboard.

# Everything's Bigger in Texas

When the Houston Astrodome opened in 1965, its 474-foot-wide scoreboard was the largest in all of sports. The scoreboard featured fifty thousand lights that erupted in a forty-five-second animated display of cowboys, ricocheting bullets, flags, steers, and fireworks after every Astros home run or victory. The display was set to a soundtrack that included "The Eyes of Texas."

4

### 4 ★ COMISKEY A GO GO
The 1959 Chicago White Sox were known as the "Go Go" team because of their emphasis on running the bases. Team owner Bill Veeck knew that the baseball game experience was more than just W's and L's so he enhanced the fans' experience with a scoreboard that would "explode" with fireworks every time a member of the team hit a home run.
—Gary Holdinghausen

### 5 ★ ATTENTION GETTER
Some of the Chicago Cubs turn toward the camera before a game at Braves Field. Note the left field advertising signs.
—Don McNeish

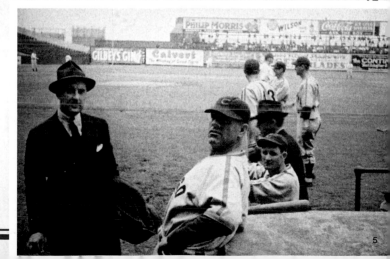

# 8 Moonlighting

1

2

**1 ★ YANK IT**
New York Yankees great Roger Maris found time to fish and pulled this one in. —*the Surprise Family*

**2 ★ GUITAR MAN**
Bronson Arroyo loves to play the guitar when he's not pitching or sleeping. Note the official MLB tattoo on his shoulder. —*Angela Parker*

# It Splits the Alley

I became a baseball fan in 1955 while living in Sacramento, California. That was the year the Brooklyn Dodgers defeated the New York Yankees in the World Series. I didn't understand that much about the game then, but I quickly learned.

My favorite player at that time was Duke Snider. The reason for that was because my next-door neighbors on 60th Street in the Fruitridge (no jokes, please) area of town were originally from Brooklyn and vacationed there every summer. The youngest of their two boys, Billy—who was my age—was a Snider fan and used to brag to everyone about seeing him hit home runs at the games he and his family attended while in Brooklyn. Since I had never been to a major league game, I wanted to punch him out of pure jealousy.

The very next year my family relocated to Oceanside, California, where we lived for six months before moving into a brand-new home in Fallbrook. My stepfather, a Marine, was stationed at Camp Pendleton, which is between Oceanside and Fallbrook. Anyway, even though I wasn't very happy about leaving my friends and relatives, I vowed to make the best of it.

Soon after moving to Fallbrook, I learned something that made me very happy: Duke Snider owned a home just outside of town and spent the majority of the off-season there. Furthermore, after signing up for Little League in early 1957, I got to meet the "Duke of Flatbush" in person. And boy was I thrilled! Being the great guy he was, Duke came out to Potter Field and held clinics for all the kids in the community before he left for spring training in Florida. In fact, I learned how to properly field a ball in the outfield from the man himself. And, dig this: Duke would step up to the plate against Fallbrook High's best pitchers at the Babe Ruth League field and hit drives that appeared to sail five hundred feet or more. Boy, did I have some stories for little Billy up in Sacramento the next time I saw him, which wasn't until the summer of 1959.

BY DEAN WHITNEY

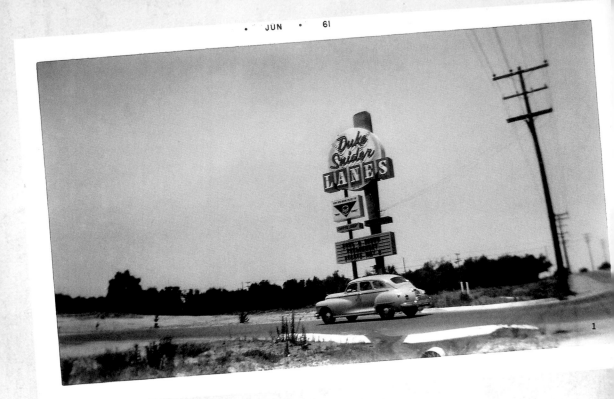

Of course, the Dodgers moved to Los Angeles in 1958, and I finally got to see my first major league game at the L.A. Coliseum during the summer of 1959. And, with the games being broadcast out of L.A., I was able to catch most of them on my transistor radio. The Dodgers won the World Series that year, defeating the Chicago White Sox in six games. During the '58 and '59 seasons, I became a huge fan of two young, up-and-coming Dodger pitchers—Don Drysdale and Sandy Koufax.

Sometime between the end of the '59 season and spring training the following year, Duke Snider opened a bowling alley—which was aptly named Duke Snider Lanes—on Mission Road, just outside of town. That was a big deal back then because other than one movie theater in the village, there wasn't a whole lot to do in Fallbrook in those days. Now, I don't remember if the grand opening was in late '59 or early '60, but I do recall that it was a huge event. On hand for the event were Duke and several L.A. Dodger players, including pitcher Roger Craig, outfielder Chuck Essegian (who hit two pinch-hit home runs in the '59 series), and big Don Drysdale.

I don't know exactly how many people were there for the grand opening, but I can tell you that there were a lot of kids around my age. And, after introducing the players, Duke had his people break the kids up into groups. Each group was then assigned a player. We were going to get bowling lessons from major league ballplayers.

As luck would have it, I was in Don Drysdale's group. Big "D," who was only twenty-three at that time, was listed at six-foot-six (although some claim he was actually six-foot-five) and more than 220 pounds. I gotta tell ya' . . . he looked like a giant to me. And when he spoke, everybody listened.

The first thing he did was pick up a bowling ball and demonstrate the proper grip. And then, almost in slow motion, he displayed the proper technique for the approach and release of the ball. He then turned and walked back toward us while emphasizing the importance of not stepping over the line. Even though most of us kids had already bowled a few games prior to the grand opening and knew how it was done, we acted as if we were learning about it for the first time.

After he was done with the lessons, Drysdale asked if there were any questions. We all looked around at one another, but no one said a word. He then asked if we were ready to see how it's done for real. Of course, we all started yelling, "Yeah, yeah!" So, the big guy got into position, held the ball up, focused on the pins, and then took a couple of strides toward the line. That's when it happened. To this day, I don't know if one of his shoes stuck to the floor or he actually tripped over his own feet . . . but the gigantic pitcher went down like a falling tree and landed on his face. And to think that none of us thought to holler *Timber!* as he took the header. Although I'm not exactly sure where the ball went, I seem to recall that it landed in the gutter.

Of course, all of us kids were shocked and just sat there with our mouths agape. I could see the headline in one of the L.A. papers the next day—DRYSDALE'S CAREER OVER AT 23 DUE TO A BOWLING ACCIDENT. But, happily for the Dodgers and their fans, Big D got up, dusted himself off, and with his face a little red, said, "OK, let's try that again." His next attempt was successful.

**1 ★ MEMORY LANES** This was the sign for Duke Snider Lanes in Escondido, California. It was a very cool place, literally, because it had great air-conditioning during the summer when the temperature constantly reached over 100 degrees. *—Jack and Susie Nopal*

**2 ★** A program from the grand opening of Duke Snider Lanes in 1960. *—Dean Whitney*

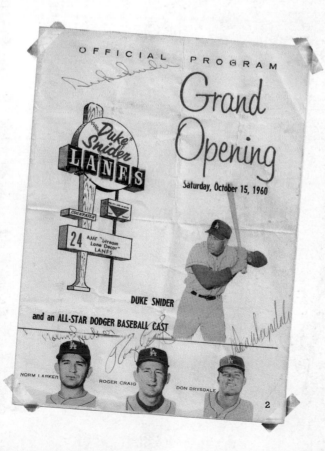

# Going, Going, Gone

Jack Lynch, a pitcher for the "original" Mets from 1883 to 1887, took a side job as gatekeeper at the National Cemetery in Washington, D.C. One day while he was working there, a large party of sightseers toured the establishment and someone, wondering whether Confederate or Union soldiers were buried there, asked Lynch, "What kind of soldiers are buried here?" Jack, according to legend, glowered at the tourist and replied, "Dead soldiers."

**1 ★ FISHY**
My husband, Eddie Mathews, in retirement, attempting to "catch" something. —*Judy Mathews*

**2 ★ CAUGHT FISHING**
The story in our family is that my father went fishing on a Sunday and ran into Ernie Lombardi fishing with a friend. Luckily, Dad had his camera and snapped this photo, which has been passed down for generations. —*David Warner*

**3 ★ BLACK ACE**
Jim "Mudcat" Grant was a pitching ace for a number of teams but he also had a singing career. His group was called "Mudcat Grant and the Kittens," and they recorded several records. —*Al Prince*

**4 ★ COUNTRY HARDBALL**
Garth Brooks loved baseball so much that for a period of time he would participate in spring training with major league teams. Here he is when he "played" for the Padres in Peoria. —*Larry Carpa*

## 5 ★ THE EAGLE AND THE RABBIT

Cleveland Indians centerfielder Tris Speaker, who was known as the "Grey Eagle," chats with Walter "Rabbit" Maranville, the shortstop of the Boston Braves, prior to a game at the Polo Grounds against the Yankees. Maranville enlisted in the navy that season and was at the ballpark to sell Liberty Bonds. He took an enormous amount of pride in selling more than $250,000 worth that summer.
—Phillip Martin

## 6 ★ ROUND BALL

While growing up in Racine, Wisconsin, I was always amazed that many of the baseball players had jobs during the off season. Gene Conley, who stood 6' 7", had to have the best off-season job of any major leaguer. While he was an effective pitcher in the summer for eleven seasons from 1952 to 1963 for four different teams, he also played professional basketball for six seasons (1952–1953 and again from 1958–1964) for two teams in the NBA. He is best known for winning championships in two different sports, one with the Milwaukee Braves in the 1957 World Series and three for the Boston Celtics in the championships from 1959–61. This photo was taken right after he was the winning pitcher in the 1955 All Star Game. —Roland Arthur

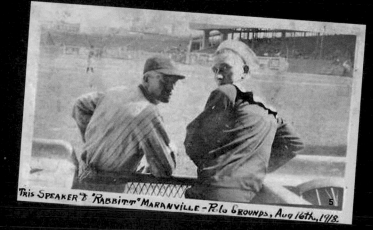

Tris Speaker & "Rabbitt" Maranville - Polo Grounds, Aug 16th, 1918.

5

6

## Odd Jobs

For years, major league players held other jobs, between seasons or after they retired from baseball. Some acted on the vaudeville stage (Ty Cobb) or in the movies (Babe Ruth, Lou Gehrig); some were recording artists (Tony Conigliaro, Jim "Mudcat" Grant, Don Drysdale, Lee Maye); some played instruments (organist Denny McLain, banjo player Maury Wills, guitarist Bronson Arroyo); some ran bowling alleys (Phil Rizzuto, Yogi Berra, Gil Hodges—still in operation—and Duke Snider). Others licensed their names to hotels (Mickey Mantle); ran sporting goods stores (Honus Wagner, Jim Konstanty); opened restaurants (Al Schacht, Don Mattingly, Tommy Lasorda, George Brett, Mike Shannon, and Ozzie Smith); and one operated a car wash (Randy Jones). Joe Morgan, who was the Boston Red Sox manager from 1988 to 1991, would work for the Massachusetts Turnpike Authority and plow snow in the off season.

And then there were players like Burleigh Grimes, who threw a legal spitball for fifteen years after it was banned in 1920. He worked at a lumber camp from dawn until after dusk, earning $1 a day.

# 9 Hero Worship

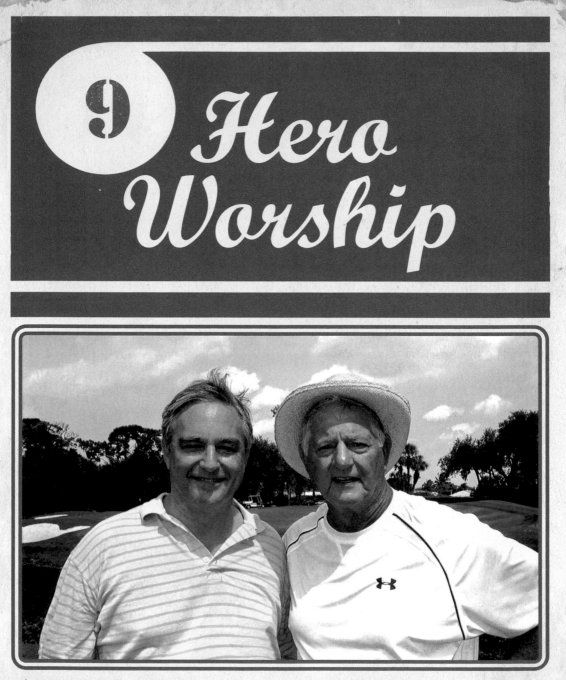

★ CARDBOARD IDOL
My passion for Carl "Yaz" Yastrzemski started with his rookie baseball card, and never ended. On April 6, 2009, the stars aligned and I finally met him. —*Talmage Boston*

# From First Card to First Encounter: My Forty-Nine-Year Journey with Carl Yastrzemski

In May 1960, my frugal parents sacrificed a dime and bought me two packs of baseball cards as a kindergarten graduation present. Since my last name was Boston, choosing a favorite team was easy. I opened each pack with the question, "Any Red Sox cards in here?"

In my first pack, searching in earnest for Bosox players, I came upon the smiling face of a Boston rookie named Carl Yastrzemski, whom Topps listed as a second baseman. Since he would play for my favorite team, this card was a keeper, though Yaz was still a year away from making the majors. The next year, I again opened a pack and found another "rookie" card of Carl Yastrzemski, this time with him properly identified as an outfielder. Unlike the year before, fans knew Yaz would definitely be playing in Fenway Park during 1961, since the Red Sox had chosen him to replace the just retired Ted Williams.

My connection with Yaz started with his rookie cards and never ended. In 1963, as I entered the fourth grade, he won his first batting title. In my eighth-grade year, he won the Triple Crown and led the Impossible Dream Bosox to the World Series. In law school, I saw him star in the 1975 World Series against the Big Red Machine. As a "rookie" lawyer, my heart broke as Bucky Dent's homer sailed over his head in the 1978 playoff game. As a law firm partner, I traveled from my Dallas home to see him inducted at Cooperstown in 1989, and the magic of that day caused me to start writing about baseball, culminating with my new book, which devotes its second chapter to him and has his 1967 *Life* magazine cover photo on the dust jacket. Carl Yastrzemski and I had collaborated on a lifetime of memories, but never met. Then, the stars aligned.

— BY TALMAGE BOSTON —

Through circumstances engineered by Mike Weinberg, Harvey Kaplan, and Chip Allard, on April 6, 2009, I got to spend four hours with Yaz at his Florida country club. What happened in our time together exceeded my wildest hopes. After being introduced by Harvey Kaplan in the locker room at 9:00 A.M., me with gray and Yaz with white hair, we shook hands and looked in each other's eyes. His opening words met with my approval: "You wrote a good book. I liked it."

As the morning unfolded, it became apparent Yaz's life these days has a driving rhythm, with no pauses. His first practice swing brought back memories. Though a pure left-handed hitter in baseball, Yaz said he tried it both ways and settled on being a right-handed golfer. The deliberate placement of his feet and the pulling of his hands all the way up to his right ear during his backswing took me back to 1967, when his poised hands held the bat high, next to his left ear, waiting for each pitch.

A fluid swing, an intense focus on the ball, and perfect hand-eye coordination are as essential to a golfer as to a baseball batter, and it soon became clear that for a man about to enter his seventh decade, Yaz had fully recovered from his 2008 heart surgery and was primed for a fast-paced, well-executed round of golf.

Yaz's closest confidant, Chip Allard, facilitated our conversation. "He likes to walk many holes even though we have a cart, so don't hesitate to go along with him." So we walked and talked as Yaz attacked his course with the same fervor he had shown over twenty-three American League seasons.

His stories and viewpoints pulled no punches:

♦ On his competitive relationship with Ted Williams, he confirmed the story of Williams's refusal to let him bring beer onto Ted's boat, which ended the fishing trip before it started. He also told of how at spring training every year, Williams obsessed over talking about the art of hitting. Yaz refused to join the conversation, believing Ted's dissection of batting techniques produced confusion, while Yaz's instincts and adjustments to his swing

★ CLASSIC ROCK OF THE 1950s
In 1959, I was twelve and thought Rocky Colavito was gorgeous. My girlfriend Iris (in the picture) and I went to the stadium to see if she and I could get Rocky's autograph and picture. Iris got the autograph and I snapped this picture. —*April Butler*

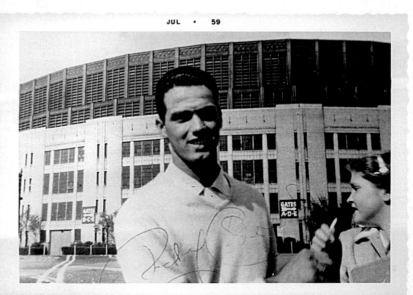

JUL • 59

under hitting coach Walt Hriniak produced clarity. "At my size, if I'd done what Ted said, I'd have hit only one hundred homers in my career." He also laughed about how Williams once fancied himself a decent tennis player, and enlisted a writer to line up a match with Yaz, who had once acknowledged, "I play a little." After Yaz drubbed Ted, 6–0, in the first set, Williams stormed off the court refusing to speak not only to Yaz but also to the writer who had followed Ted's orders and set up the match.

◆ On the degree of difficulty associated with hitting a pitched baseball with a bat compared to hitting a stationary golf ball with a club, he told the story of a fellow attending Red Sox spring training who had once insisted golf was harder, causing Yaz to walk the guy onto the field, give him a bat and helmet, and order him into the batter's box. "I then walked out to the pitcher and told him to throw the ball as hard as he could under the guy's chin, which he did. I told the guy, 'A golfer never has to play his game with the element of fear,' and never saw him again."

◆ On the pre-2004 Curse of the Bambino, "I never believed in it. If Jim Lonborg had had four days' instead of two days' rest in Game 7 of the '67 Series, there might have been a different result. And if Jim Rice hadn't been injured and missed the entire '75 Series, which went seven games against the Reds without him, probably a different result there, too."

◆ On achieving a balance in athletic competition between maintaining intensity while staying relaxed: "I always thought of it as the intensity part was a mental thing while the relaxing part was physical. It's a fine line between the two, but at the big league level, everyone will tell you that 90 percent of what separates players is the mental part."

1 ★ STRAW MAN
A 1995 shot in the Palm Springs Suns (of the Western League) clubhouse during spring training: L–R: R.C. Stolpe, Chad Ponegalek [seated], Duane Page [seated], and Darryl Strawberry. Darryl had the locker right next to mine. This was following his season with the San Francisco Giants and just a month before the Yankees signed him and sent him to Columbus for additional seasoning prior to call-up. —R. C. Stolpe

2 ★ ON TOP OF THE WORLD
Jackie Robinson appearing at the 1964 World's Fair. I am on Jackie's right. I asked him for an autograph; I still have it. —Eric Cirlin

★ GREATS
Hank Aaron, Muhammad
Ali, and Bill Cosby were
all honorees at the first
annual Civil Rights Game
on June 29, 2009, at
Great American Ballpark
in Cincinnati, Ohio.
—Brian Herberth

I reached three conclusions on what it's like to play golf with Carl Yastrzemski. First, the round moves quickly, with no stops taken. Club selections and putting reads get made instantly, and no one loses self-control. Yaz commented, "The biggest difference for me between baseball and golf is I don't get mad at myself in golf the way I did in baseball; although my favorite competition in sports is the head-to-head battle between batter and pitcher. Nothing can top that."

Second, the needle is always out for gigging a friend in the foursome, one of whom was a delightful guy named Marty Kogen, who's good tee to green but not a stellar putter. On the twelfth green, Marty miraculously knocked in a long putt to break par on the hole, and Yaz zapped him: "This game is too [blankin'] easy if a guy like you can make a birdie."

Finally, as Chip and Marty commented, Yaz's intensity elevates his foursome. He stays zoned in and grinds through eighteen holes, and his sustained energy and concentration are contagious. After watching him play, it required little imagination to understand how he lifted the Red Sox out of their perennial second division doldrums and transformed the team into Impossible Dream glory in 1967, followed by sixteen consecutive winning seasons. Carl Yastrzemski was the straw who stirred that drink.

After the round (in which Yaz shot a 79), I asked him if he would sign the copy of my new book I use when speaking to groups. He sat down, thought a second, and then wrote on the title page, "To Talmage—A Hall of Fame Book—Carl Yastrzemski, HOF 1989, TC 1967."

We said our good-byes, and then he showered and left the club. Thanks to Mike, Harvey, and Chip, after forty-nine years of being his fan, I had had my time of engagement with Yaz, the circle of life had connected, and now this very private man returned to his home.

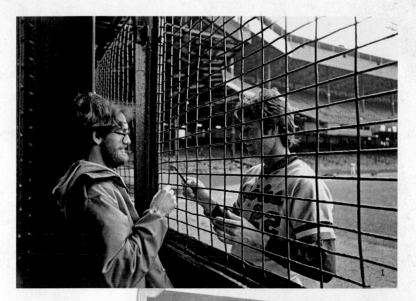

## 1 ★ SCREEN GEM
Baseball fan Jim Diehl gets his pen returned after obtaining an autograph from Jim Palmer on April 22, 1977, at Tiger Stadium.
—*Thomas Hagerty*

## 2 ★ GIVE ME YOUR WALLET
Early in the Chicago Cubs season in 1956, I was able to have my picture taken with my hero, Ernie Banks. Later on that season, I had a copy of this photo and before the game I saw Ernie near the dugout. I asked him if he would autograph the picture and he immediately asked me for my wallet, which I gave to him. My friend who was with me asked why I handed over my wallet, I explained that it was because Ernie Banks asked me. He used my wallet as a backing and signed the photo. He returned my wallet and my prized autographed photo.
—*Howard Frank*

# Hero Selection

## BY ANDY STRASBERG

One of the most frequent questions I am asked regarding my well-documented hero worship of Roger Maris is, why did I choose him?

Candidly, the response to that question is a combination of several factors. At the outset, I must confess I am not good at sharing. When I was growing up, it seemed that every baseball fan in my age group idolized Mickey Mantle. I understood it. Mickey was good-looking, could run like a deer, and could hit the ball a mile (or at least 565 feet???). There was something about The Mick that just did not do "it" for me, and I think having to share him with others was a major component of my not being among his staunch devotees.

When Roger Maris was traded from Kansas City to the Yanks in the winter of 1959, he was projected by baseball writers to be the player who would rejuvenate the Yankees. I was twelve and had no idea what the word "rejuvenate" meant. When I checked my dictionary and learned it meant that he could energize, invigorate, and revitalize the team . . . now that did catch my attention in a big way.

I devoured all the newspaper reports about Maris and noted that he was often labeled a family man. I thought that was a curious way to describe a baseball player, because it seemed to have nothing to do with playing the game. Another word often used to describe Maris was "brisk," something apparently derived from his typical responses to the questions of reporters and a trait that very much appealed to me. Maris spoke frankly and without hesitancy. I was twelve and did not realize I was searching for a role model. Roger Maris became that man.

Maris played the game with intensity, and it was evident when he ran the bases and in the fearless way he broke up double plays when running to second. The eyes of most fans follow the relay throw to first, but I always watch what happens as the runner barrels into second base and the middle infielder tries to avoid the sliding man. It is an integral part of the game that most fans miss.

Maris was quickly labeled by his teammates as a team player, another appealing attribute to his newest fan. It meant he was unselfish, and having once attained that reputation, Maris was followed by it throughout his career.

Maris also had an extraordinary throwing arm. He was a savvy player who consistently threw to the right base or relay man. I grew to appreciate this aspect of his game when Maris daily practiced fielding and throwing an hour before the game, during batting practice. Maris could scoop a grounder or snag a fly and throw the ball on a straight line, and I swear it maintained the same height for more than 250 feet, dropping only as it reached the intended player.

A more dramatic reason why I liked Roger Maris arose from the way he would catch "would-be" tonks in right field at Yankee Stadium. In 1961 Maris and Mantle referred to homers as "tonks" because according to them that was the unmistakable sound made when the bat met a pitch and headed for the seats. During the years Maris was a Yankee, the right field fence was a mere 296 feet down the right field line and radically jutted out to 344 feet. It was a concrete wall and only forty inches high. If memory serves me well, at least once a week, an opposing player would smack a ball toward the short right field seats, only to have Maris run back to the wall, turn, and time his jump perfectly to deprive the other team of a tonk. Such catches by Maris saved dozens of runs every summer he was stationed in right. My all-time favorite of those grabs came on June 11, 1961, when in the top of the seventh inning of the first game of a doubleheader, Ken Hunt of the Los Angeles Angels drilled a 0–1 pitch off Ralph Terry toward that right field bullpen. Maris was off running with the crack of the bat, and when he did his patented turn and leap, his momentum carried him into the first row of seats. As he held his glove aloft with the ball snug inside it, the stands erupted. But that was Maris. He risked injury, seemingly without forethought, every time he went back for a ball.

One time in my thirties I shared briefly my childhood idol worship of Maris with the man himself. He politely explained it made him uncomfortable to hear people talk that way. When asked, Maris shared that he too had a favorite baseball player, in Ted Williams. For Maris, that meant checking the box scores only, not collecting everything about Ted Williams as I have done with Maris since 1960. As years passed, I realized how fortunate I was to know that fine, brisk team player and family man. At twelve, I had indeed picked the right guy.

★ STAR POWER
Mickey Mantle was known as the Commerce Comet. He was good-looking, had a great smile, and could hit the ball a country mile.
—*Sandy Ketterer*

"Lou Gehrig was a favorite of mine ever since I watched *Pride of the Yankees* with Gary Cooper when I was twelve. . . . But my all-time favorite player had to be Phil Rizzuto. He was my size and also an infielder. In my high school yearbook they asked what I wanted to do the rest of my life and I said play shortstop for the Yankees. It came true. Then when I got to the big leagues, Rizzuto was my roommate . . . and later his son played ball under me as a coach."

BOBBY RICHARDSON

## Baseball Players and *Their* Favorite Players

| PLAYER | FAVORITE |
| --- | --- |
| Ozzie Smith | Roberto Clemente |
| Tony Gwynn | Willie Davis |
| Aramis Ramirez | Jorge Bell |
| Roger Maris | Ted Williams |
| Jay Bell | Steve Garvey |
| Brian McRae | Pete Rose |
| Nate McLouth | Alan Trammell |
| John Lackey | Nolan Ryan |
| Nick Swisher | Steve Swisher |
| Hunter Pence | Pete Rose |
| Bronson Arroyo | Ozzie Smith |
| Cole Hamels | Tony Gwynn |
| Johnny Estrada | Carlton Fisk |
| Dustin Moseley | Ken Griffey, Jr. |
| Scott Kazmir | Nolan Ryan |
| Brian McCann | Tony Gwynn |
| Roy Oswalt | Nolan Ryan |
| Carl Crawford | Craig Biggio |

"Growing up I tried to emulate the pitching style of Bobby Shantz because he was always ready to field his position even as a little guy."

—JIM KAAT—

**1 ★ REUNITED**
During spring training in 1987, my neighbor Roger Whitley poses with Rick Sutcliffe before a game in Mesa, Arizona. Roger (Portland Mavericks) and Rick (Bellingham Dodgers) were minor league pitchers in 1974 when they faced each other in their first professional game. —*Bill Klink*

**2 ★ SIDEWAYS**
Josh Hamilton, spring training 2009. We asked Josh to pose and he obliged us. —*Mike Egan*

**3 ★ VERY TOUCHING**
When Cal Ripken broke Lou Gehrig's record of consecutive games played, he walked around the stadium and tried to shake the hands of as many fans as possible. —*Marsh Adams*

**4 ★ INSIDE BASEBALL**
Ted Williams explains to Tony Gwynn that on inside pitches he should hit them out of the park.
—*Andy Strasberg*

4

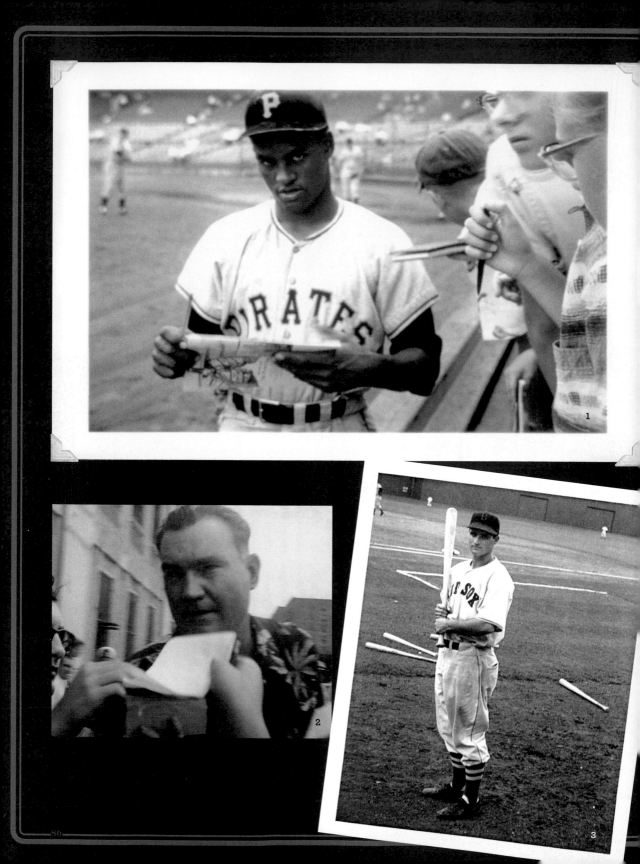

### 1 ★ SIGNATURE STARE

When Roberto Clemente first arrived in Pittsburgh, the Pirates announcer Bob Prince called him "Bobby," although his name was Roberto. A few years later, in 1957, I was at a game when Roberto was signing autographs near the dugout. I had my camera and wanted him to look up at me and so I called out his name, Roberto. It worked. He didn't move his head, only his eyes turned to me when I snapped his picture. What I remember most from that day was the skin on his face; it looked like he didn't need to shave, it was so smooth. —*Peter Wagner*

### 2 ★ MEOW

Johnny "Big Cat" Mize getting besieged for autographs outside of Yankee Stadium, 1950.
*Paul Phillips*

### 3 ★ A SWINGING DOERR

The popular Boston Red Sox second baseman, and future baseball Hall of Famer, takes a moment to strike a pose during batting practice at Fenway Park in 1939. Bobby Doerr would hit .318 for the Bosox that season.
—*Don McNeish*

### 4 ★ KID COMES HOME

Ken Griffey Jr. returning to the Seattle Mariners in the home opener of the 2009 season. The crowd was applauding forever! There were even people crying! My husband and I have taken our son Alek, who is almost eight, to every home opening day Seattle Mariners game since he was born. This particular game is his eighth home opener. He now understands the love Seattle feels for the "Kid."
—*Catrina Rioux*

### 5 ★ BUILDING DESIGNER EXITS

This photo was taken by my father's brother Ed, when he was thirteen years old. It is of Babe Ruth and his daughter as they leave Yankee Stadium in the 1940s.
—*Larry Colella*

4

5

**1 ★ PERFECT SHOT**
I was in the middle of all the fans trying to get Sandy Koufax's autograph after he was done playing golf and I took this snapshot.
—*Paul Joba*

**2 ★ SEVENTH HEAVEN**
At a special Yankee open house in 1967, I was given access to the Yankee clubhouse and allowed to hold Mickey Mantle's jersey. It was an incredible Yankee moment that I'll never forget. —*Andy Weiner*

1

"Without question my favorite player growing up was Tom Seaver. He was the big guy that would get low to the ground and dirt on his knees. I tried to pitch like him and that's also why I wore jersey number 41 often during my career. . . . Jim Lonborg was also a favorite of mine because I was a big Red Sox fan."

JEFF REARDON

# 49 Walters

While pitching for the Washington Senators, Walter Johnson had several twenty-win seasons in the mid 1920s. In 1924, he won twenty-three games and lost seven. A year later, Johnson was 20–7. During those two seasons, forty-nine fans wrote to let him know that they had named a son after him and included a snapshot of their newborn, Walter.

3

**3 ★ MANTLE OF GREATNESS**
I had heard that Mickey Mantle was playing golf with some of his buddies in Ft. Lauderdale, Florida. Having grown up idolizing "The Mick," I thought this would be my best chance to get to see him in person. I waited patiently on the eighteenth green and after about an hour there was number 7, I couldn't believe my eyes. He was shorter than I thought he'd be. He finished playing golf and for some reason laughed out loud so everyone could hear him. As he was walking off the course, I snapped this picture to prove that I saw the greatest Yankee ever.
— *Gary Baker*

**4 ★ IF I HAD A HAMMER**
Hank Aaron walks into Milwaukee County Stadium on a sunny summer afternoon in 1956. That was the season he collected 200 hits. My favorite Aaron stat is that if you subtracted his 755 homers from his career totals he still would have 3,016 hits.
—*Johnny Trianno*

# 10
# *Cooperstown*

★ BRICK BY BRICK
The Baseball Hall of Fame
was built in 1939, and I was
one of the bricklayers who
built that building.
—*Homer Osterhoudt*

# Baseball Mecca

ooperstown is the spiritual and intellectual home of baseball. It also happens to be located in one of the most picturesque settings in America—a small village of 2,300 on the shores of crystal clear Otsego Lake, nestled in the rolling hills of upstate New York. What more could a photographer—especially a baseball photographer—ask for?

For nearly nine years, I was privileged to serve as president of the National Baseball Hall of Fame and Museum. And every day I was in Cooperstown, I enjoyed watching fans take photographs—of Hall of Famers and other recognizable players, artifacts in the museum, historic Doubleday Field—of anyone or anything that would help them capture the essence of our national pastime and why it has such a hold on us.

Two-thirds of the Hall's visitors come in the summer months of June, July, and August. That's when the weather is spectacular—usually in the seventies and eighties—and when the grass is emerald green and the flowers seem painted with extra-vibrant hues. Often, excited first-time visitors arrive at the Hall even before the doors open, line up in front, and ask a passerby to snap a photo to commemorate their baseball pilgrimage to Cooperstown.

The centerpiece of the year is Induction Weekend, which also presents the best opportunity for keepsake photos. The vast majority of Hall of Famers—usually fifty or more—return to Cooperstown the last weekend of July for a joyful reunion and to welcome their newly elected baseball brothers into their ultra-exclusive club. Only about 1 percent of those privileged to play major league baseball have a plaque in Cooperstown, so Hall of Famers are a special group at the very peak of the baseball pyramid.

Hall of Famers play golf on that Saturday morning, on the challenging Leatherstocking Golf Course, which is associated with the elegant Otesaga Hotel. Fans with cameras and items to autograph wait for them along the beautiful gray stone wall that separates the course from the road. As they putt on the Number 3 green before moving on to tee Number 4, some Hall of Famers mug for the camera and others walk over to chat and sign autographs.

BY DALE PETROSKEY

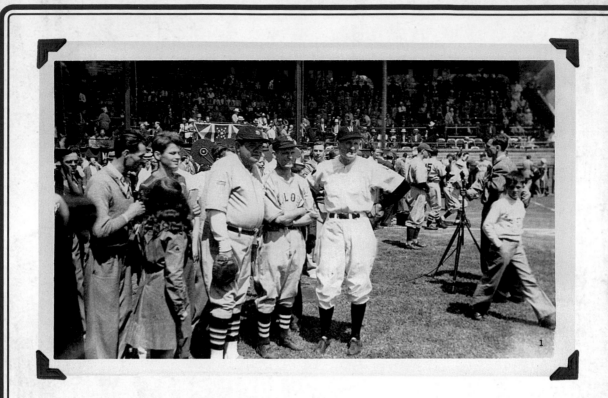

1 ★ IMMORTALS
In 1939 during the opening of the Baseball Hall of Fame, there was a special ball game played on Doubleday Field. Some of the players surveying the field are (left to right) Babe Ruth, George Sisler, and Walter Johnson.
—*Homer Osterhoudt*

2 ★ LOCKER LOOT
Babe Ruth's locker and uniform as seen on the third floor of the National Baseball Hall of Fame and Museum in 1961. That was the summer Mantle and Maris were challenging his single season homer record.
—*David Cowan*

Many Hall of Famers and other retired players spend Saturday afternoon signing autographs in front of Main Street shops and restaurants, which is a great opportunity to photograph—or be photographed with—a favorite player from a different time.

Saturday evening, the Hall of Famers and their families arrive at the Hall in a parade of trolleys and are announced to the crowd one by one before heading in to enjoy a private reception. This twilight event offers the photographer the weekend's best light.

Sunday is the big day—the Induction Ceremony takes place in the early afternoon outside the Clark Sports Center. And while most people who attend are not close to the stage, it is possible to squeeze some frames of the greatest living players who ever played baseball sitting together on one stage. There's also a good chance other celebrities will be in the crowd to celebrate a friend's induction—Texas governor and future president George W. Bush attended Nolan Ryan's induction; his father, former president George Bush, enjoyed Gary Carter's; and John Travolta was there for Cal Ripken's.

The fall is my favorite time of year in Cooperstown, as cooler temperatures and the brilliant red, yellow, and orange leaves of the northern hardwoods turn the village into a spectacularly colorful and peaceful retreat. September means exciting pennant races, and with the summer crowds thinned, many fans choose to be in Cooperstown at this time. A favorite photo is of the standings—changed daily by the Hall staff—in a glass-enclosed case facing Main Street, especially if your favorite team happens to be in first place and headed to the playoffs.

These are just a few of a treasure trove of opportunities for baseball photographers in Cooperstown. Truthfully, every day is special in Cooperstown—with a chance to capture baseball images you can't find anywhere else on earth.

## The Odds

What does it take for a baseball player to be enshrined in the Baseball Hall of Fame? Here's the breakdown:

★ This year, 3 million kids will play Little League baseball.
★ A small percentage of those will be good enough to play in high school.
★ A smaller percentage will be good enough to play in college.
★ An even smaller percentage—1,500 a year—will be drafted to play in the minor leagues.
★ Of those very talented players, 5 percent will ever play a single major league game.
★ Those who make it to the major leagues are the best of the best.
★ And only one out of one hundred of those players 1 percent of the best of the best—are inducted into the Baseball Hall of Fame.

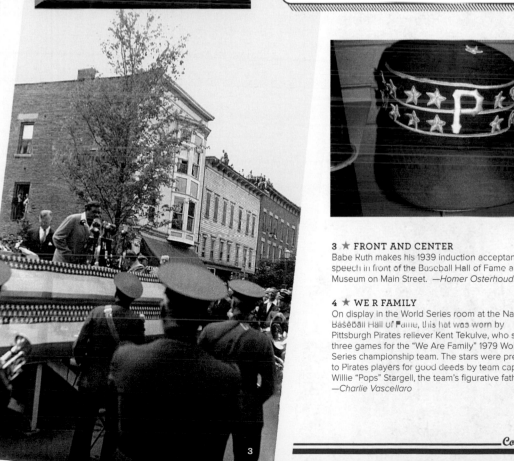

### 3 ★ FRONT AND CENTER
Babe Ruth makes his 1939 induction acceptance speech in front of the Baseball Hall of Fame and Museum on Main Street. —*Homer Osterhoudt*

### 4 ★ WE R FAMILY
On display in the World Series room at the National Baseball Hall of Fame, this hat was worn by Pittsburgh Pirates reliever Kent Tekulve, who saved three games for the "We Are Family" 1979 World Series championship team. The stars were presented to Pirates players for good deeds by team captain Willie "Pops" Stargell, the team's figurative father. —*Charlie Vascellaro*

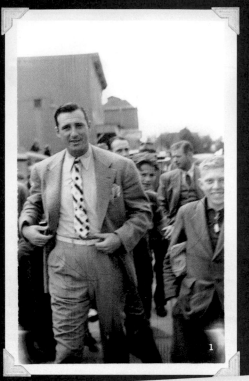

1

## Home Base

Major league players who were born the closest to Cooperstown are Clay Bellinger (Yankees) in 1968, Ken Chase (Senators, Red Sox, and Giants) in 1913, and Tim Christman (Rockies) in 1975, all natives of nearby Oneonta.

## At Rest

The first African-American to umpire in the major leagues was American League umpire Emmett Ashford. He's buried in the Lakewood Cemetery of Cooperstown.

The only professional baseball player buried in Lakewood Cemetery is Vernon Sprague Wilshire. Known as Whitey, he was a southpaw pitcher for the Athletics from 1934–1936.

2

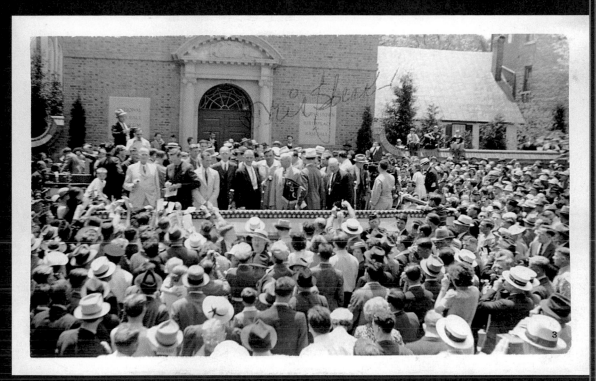

### 1 ★ VERY SUITABLE
Hank Greenberg walks down Cooperstown's Main Street to attend the 1939 Baseball Museum opening ceremonies. —*Homer Osterhoudt*

### 2 ★ HERE'S THE CATCH
Dizzy Dean warms up before the Doubleday baseball game in 1939. —*Homer Osterhoudt*

### 3 ★ ICONIC LINEUP
Look closely and you will see, from left to right, Cy Young (white suit), Walter Johnson (autographing a program), George Sisler (white suit), Connie Mack, Nap Lajoie, Babe Ruth, Tris Speaker, and Honus Wagner. —*Homer Osterhoudt*

### 4 ★ BUCK SHOT
During Hall of Fame Induction Weekend 2005, a free clinic was held at Doubleday Field. Buck O'Neil participated, but not in the skills department. He sat and waited for the next group of children and spoke to them about togetherness and had them sing a song. My son Joey was on the field. I was in the grandstand. This behind-the-scenes shot of Buck through the mesh is one of my favorites. —*Jeff Katz*

# 11 *Weather*

★ **COVERED**
The Milwaukee Braves, formerly of Boston, visited Boston's Fenway Park for an exhibition game in the late 1950s. Waiting for the tarp to be removed after a rain shower are Ray Shearer number 56 and coach Connie Ryan number 8.
—*Don McNeish*

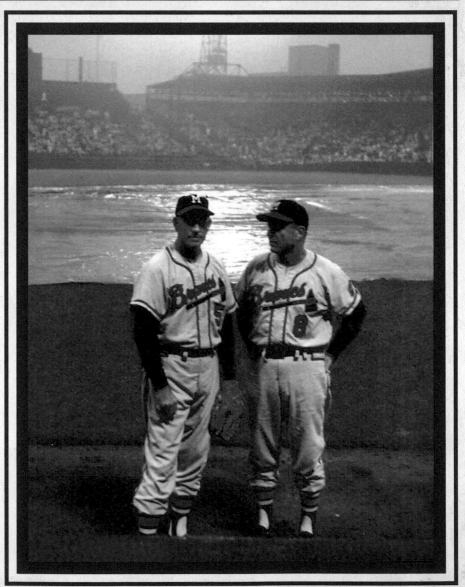

# Rainouts, Heaters, and Frozen Ropes

On July 22, 1991, the San Francisco Giants met the Minnesota Twins in the annual Hall of Fame Game in Cooperstown, New York. The contest was only an exhibition (the Twins won, 6–4) and in many ways no different than 99 percent of all baseball games ever played. But it represented the true essence of baseball. The best players in the world were playing the national pastime before ten thousand enthusiastic fans in a small, pastoral village in upstate New York. Any baseball fan there that day could not imagine being anywhere else. The setting was perfect. And perhaps most importantly, unlike the previous year, the sun was shining and the game was not rained out.

Baseball and Mother Nature have an odd marriage. Is there another sport that depends on it as much as baseball? The game was originally meant to be played in warm, sunny conditions, and later in warm, lighted conditions, once night baseball was introduced to the major leagues in 1935. But circumstances have arisen over the years to fight back against weather conditions. Domed stadiums, retractable roofs, and artificial turf have challenged Mother Nature in an attempt to keep games going that should have been rained out (or even snowed out).

Who can forget the fifth game of the 2008 World Series between the Philadelphia Phillies and the Tampa Bay Rays? It was played in some of the worst conditions ever seen for a baseball game. It was cold and rainy at the start, and just got worse as the game progressed. The Phillies were ahead in the series three games to one, and had a chance to clinch the title with a win. They led, 2–1, after four-and-a-half innings, which would constitute an official game if called by rain. However, no World Series contest in history had been stopped short of nine innings, so play continued. When the Rays finally tied the score in the top of the sixth, the umpires immediately stopped play. The game was suspended and resumed two days later. The Phillies ended up winning anyway, 4–3, but at least their World Series victory wasn't tainted. Baseball commissioner Bud Selig later said he would never have let the game become "official" before nine innings, even if the Rays had not tied the score. But the umpires and players didn't know that.

BY DAVID KENT

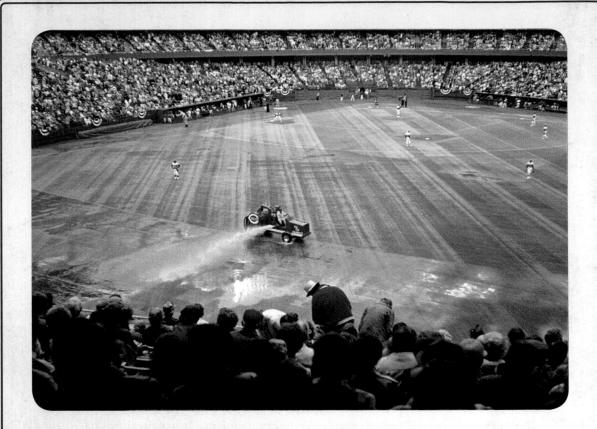

★ BIG RED MACHINE
The Reds played on synthetic grass at Riverfront Stadium and only needed a short time for a big red machine to remove the water from the outfield.
—Peter Nunez

It wasn't the first time that a commissioner faced such a dilemma. Bowie Kuhn faced a similar situation in 1982 when the Milwaukee Brewers played the St. Louis Cardinals in the sixth game of the World Series. The host Cardinals trailed the series, 3–2, but were up in the game, 8–0, in the sixth inning when the skies unloaded for the second time (a rain delay of more than two hours). The Cardinals eventually won, 13–1. Kuhn was vilified by the press for not simply calling the game since it was a blowout. But he had not wanted to establish a precedent where a World Series game, no matter what the score, was called short of completion. By sticking to his guns, he established a line of reasoning for Selig to follow twenty-six years later.

One of the most storied parks in baseball today is Wrigley Field, home of the Chicago Cubs. It is well known as the last major league stadium to install lights. The first night game occurred on August 8, 1988. Naturally, it was rained out after three-and-a-half innings. Wrigley Field is also notorious for shifting wind patterns. Chicago is known as the Windy City, but that's actually due to the political winds that encompass it. On May 17, 1979, the wind was blowing out. The Phillies beat the Cubs by the football-like score of 23–22 in ten innings. Your first instinct is to think the Cubs lost because they failed to convert a two-point conversion, or that the wind, which they call Maria, is a baseball fan and was pulling for the Phillies that day.

One advance in keeping weather from being a factor was the invention of the domed stadium. Today we not only have domed stadiums but ones with retractable

roofs. The first enclosed venture was the Astrodome in Houston, Texas. Built in 1965, it was called the "Eighth Wonder of the World." Originally it had special grass developed at Texas A&M that would grow indoors. But after it was discovered that the clear dome made it impossible to see fly balls, the roof was painted black and the grass died. Thus came the invention of artificial turf, or Astroturf.

The interesting thing about the Astrodome is that it didn't stop rainouts. On July 15, 1976, the Astros actually had an official "rainout" due to heavy rains and severe flooding in Houston. The players made it there, but the umpires and fans (except for a presumably insane twenty) didn't.

With all the zany weather-related events that have affected different venues, there is one ballpark that stands alone when it comes to the elements. Candlestick Park in San Francisco, home to the Giants from 1960 to 1999, may be considered the biggest disaster in urban planning in the history of sports. If the original Yankee Stadium was known as the "House That Ruth Built," then Candlestick Park, or more simply the "Stick," should be known as the "Epitome of Stupidity." The blame here goes straight to Giants owner Horace Stoneham. He didn't want to build a second deck on the team's temporary home, former minor league park Seals Stadium, because it lacked parking. He also wanted to beat the rival Dodgers in building a new stadium. Situated by the San Francisco Bay, the site was chosen simply because the land was cheap and it provided ample parking. Nobody bothered to consider the horrible wind, fog, cold, and generally un-baseball-like conditions of the locale.

The Giants gave new meaning to the concept of "open air" stadium. The first year the team drew 1.7 million fans because it was a novelty. It was eighteen years before they came close to that mark again. One game in 1974 drew six hundred fans to a 60,000-seat stadium. In 1971, when the NFL 49ers moved there, the "City That Knows How" thought that adding 20,000 seats and enclosing the stadium would fix the problem. It only made it worse. Instead of wind blowing through the place, it just swirled, kicking up dirt and making hot dog wrappers as conspicuous as seagulls. In other cities, fans could go to games on warm summer nights in T-shirts, shorts, and flip-flops. In San Francisco, fans preparing for night games had to dress as if they were heading to the North Pole.

Also, the swirling winds would cause foul balls to become windblown doubles (or outs at first base if the batter stood at home plate thinking the "foul" ball was going to land in the stands). Routine fly balls turned into home runs, or vice versa, depending on where they were hit. Willie Mays adjusted his swing to hit to right-center field because that's where the ball carried.

To avoid the rougher elements, the Giants even tried scheduling nothing but day games except for Friday nights. Their marketing slogan, "Real grass, real sunshine, real baseball," caused one coach of the slumping team to quip, "Well, two out of three ain't bad."

The one saving grace for Candlestick was demonstrated when Mother Nature hit hardest on October 17, 1989. A 6.9 magnitude earthquake struck the Bay Area during the World Series and shook the park to its foundations. But it survived intact with little damage, proving that it literally could withstand everything that Mother Nature could throw at it.

# Rain Checks

The evolutionary process of issuing rain checks was a stormy one. Ball clubs did not embrace the concept of refunding ticket money or providing tickets for another game if a game was called because of rain. Case in point: in 1876 St. Louis had its home opener rained out and the team elected not to refund any of the money. In an editorial, the *St. Louis Globe Dispatch* denounced the club: "Such a policy may be penny wise, but it is pound foolish, as well as dishonest."

Shortly after, the team posted its policy for all patrons to see: "After one inning has been played no tickets will be returned. If the game is called tickets will be returned, good for any game played on the grounds, but in no case will the money of admission be returned."

And those teams that did the responsible thing gave tickets to the fans as they exited. But teams found that the number of tickets given out would usually exceed the original sale.

The explanation was simply the fact that young fans were able to find their way into every game without paying, scaling walls or crawling through drainage ditches. Abner Powell, who played professional baseball from 1884 to 1886, is given credit with finding a solution to that problem.

After his playing days, Powell managed and owned several teams. In 1888, he devised the detachable rain check which acted as a receipt or proof of purchase once the game began. Additionally, it provided the holder of the ticket another opportunity to use the ticket if the game was rescheduled. But the practice was not universally embraced by every team until the early 1900s.

Powell is also credited with introducing Ladies' Day promotions and covering the infield with a tarpaulin so that after it rained it could be removed and the field would be playable.

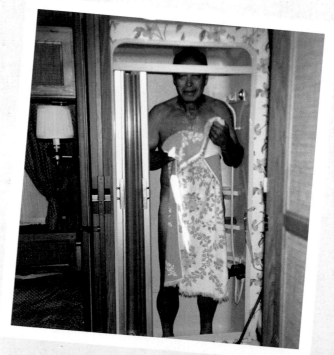

★ **A CHANCE OF A SHOWER**
Eddie Mathews drying off after a shower.
—*Judy Mathews*

# Forecast

Some players were born to play baseball in bad weather: Bob Hale (1955–1961, Orioles, Indians, and Yankees); Tim Raines (1979–2002, Expos, White Sox, Athletics, Yankees, Orioles, and Marlins); J. T. Snow (1992–2008, Giants, Angels, Red Sox, and Yankees); Ron Guidry, known as "Louisiana Lightning" when he pitched for the Yankees from 1975 to 1988; Jake Freeze (1925 White Sox); and Roy Weatherly, whose nickname was "Stormy" when he played for the Yankees, Indians, and Giants from 1936 to 1950.

### 1 ★ MAKING ADJUSTMENTS
From 1974 to 1985, the "Human Rain Delay" played baseball. First baseman Mike Hargrove earned the nickname by stepping out of the batter's box after every pitch, adjusting almost everything he was wearing, and thereby delaying the game. —*Madres*

### 2 ★ SNOWBALL
This is a keepsake of our family for over 50 years. It's a picture of Boston Braves pitcher Jim Tobin holding a snowball. When I looked up his record, I discovered that in one season Tobin lost 21 games. And when I mentioned that to friends who know baseball they all said the same thing, "You have to be good to lose 21 games." —*Ellen Cook*

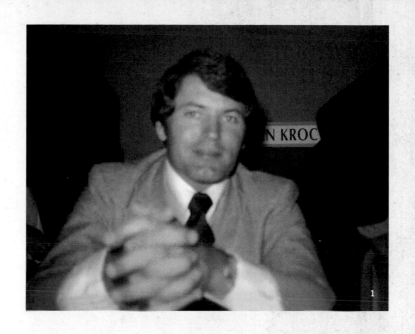

## Game Called Because of Sun

Baseball games have been canceled because of rain, wind, snow, wet grounds, floods, and once because of the sun.

The Reds were playing Boston on May 6, 1892, and the game reached the fourteenth inning without either team scoring. In those days there was only one umpire for a game. Jack Sheridan called the game because the sun was too strong in the eyes of the batters. Neither team complained.

Two years later home plate was moved to prevent a recurrence—and, as a result, the right fielder had to battle the direct sunlight. Soon most fields were laid out this way to protect hitters and provide uniform field conditions.

With the exception of indoor ballparks, most ballparks are now arranged with the right fielder in the glare of the east, the batter in the shadow of the west, and the pitcher standing with his left arm to the south. That's why left-handed pitchers are called southpaws.

# The Baseball Draft

In 1909, Mordecai "Three Finger" Brown of the Cubs thought he had stumbled onto a pitching gold mine the day he discovered a pitch he called the "curly cue." Thrown with his hand almost hitting his hip and with a jerky motion of the wrist, the ball curved in on right-handed batters with a nasty drop. It was tough to hit, but as Brown found out later to his dismay, it would only work when a southwest wind blew across Cubs Park.

Brown's discovery of the effect of air currents on pitches was confirmed one day by Al Orth of the Phillies. Up to the sixth inning in a game he was pitching, Orth was breezing along comfortably, his underhand thumb ball and sidearm curve working to perfection, when he suddenly lost control of his underhand pitch, which kept floating off the plate. He gave up walk after walk and staggered through the inning. On his way back to the bench, a puzzled Orth paused and was suddenly struck by an idea. He wet his finger and held it in the air. Then he grinned. He knew what had gone wrong. Al approached the manager, who had already ordered a reliever to warm up.

"Have them close the doors under the stands and I'll win this one easily," Orth instructed his manager, who thought his pitcher had gone crazy but did as he asked. The wide stadium exit doors, thrown open because of the heat, were shut. Orth, as promised, settled down and finished the game without further difficulty. He had correctly guessed that the heavy current of air welling up from under the grandstand and moving across the field was blowing his delicate pitch off course.

**1 ★ SNOW WHAT'S NEW?**
During a winter snowstorm, it's always hard to imagine that eventually warmer weather will arrive. And it's even harder to envision when Fenway Park is covered in snow.
—*Chip Moynihan*

**2 ★ A DIFFERENT VIEW**
When Candlestick Park originally opened it was windy and cold, but the view past centerfield was breathtaking.
—*Bill Klink*

**3 ★ OUTSTANDING**
Although the Boston Red Sox and New York Mets eventually finished playing this game at Fenway Park in May 2009, the Fenway grounds crew turned in perhaps the best performance of the game.
—*Charlie Vascellaro*

**4 ★ POETIC**
Warren Spahn and Johnny Sain (pictured) are the inspiration for one of baseball's most enduring poems. (See "Poetic Pitching" on page 103.)
—*Stan Lemke*

"You don't save a pitcher for tomorrow. Tomorrow it might rain."

## LEO DUROCHER

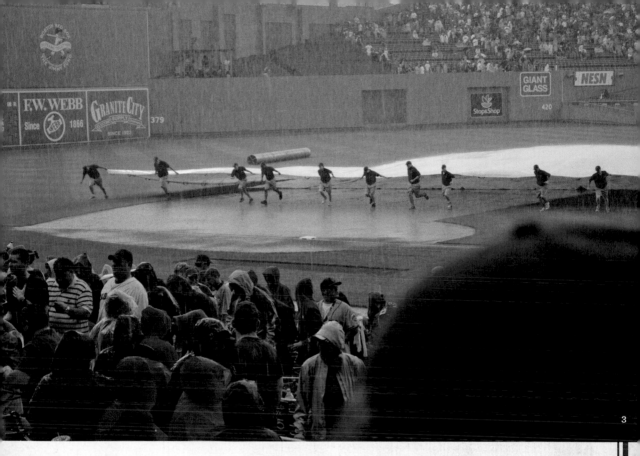

3

4

## Poetic Pitching

It became apparent to Gerald V. Hern, sports editor of the *Boston Post*, in 1948, that the Braves relied on two pitchers and inclement weather. He penned this poem for the September 14, 1948, edition:

*"First we'll use Spahn, then we'll use Sain. / Then an off day, followed by rain. / Back will come Spahn, followed by Sain, / And followed, we hope, by two days of rain."*

That year, Warren Spahn won fifteen games and lost twelve. Meanwhile Johnny Sain won twenty-four while losing fifteen and the team won ninety-one and lost sixty-two games.

# 12 Graves

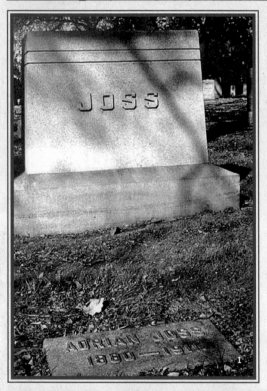

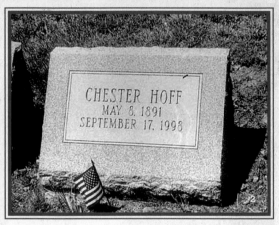

**1** ★ Adrian Joss's grave at Woodlawn Cemetery in Toledo, Ohio
—*Stew Thornley*

**2** ★ Chet Hoff's grave at Dale Cemetery in Ossining, New York
—*Stew Thornley*

# In Field Dirt

Cemetery surfers such as me visit graves for many reasons: genealogists trace their roots, scientists seek clusters of graves with a common death date that may indicate an epidemic, artists admire the monuments and epitaphs, travelers look to get off the beaten path, and others, such as myself, track down the final resting spots of notable people. Visitors respond in different ways to what they encounter, taking pictures, making rubbings, leaving offerings.

My usual visit consists of nothing more than taking a picture of the grave. The photo collection I've amassed provides a variety of contrasts. Sometimes the picture is only of a patch of grass, indicating an unmarked grave. Other photos show a simple flat-stone marker, bereft of any indication of the significance of the person beneath it. And sometimes the pictures, especially of elaborate monuments or those adorned by offerings left by previous visitors, tell stories.

Another contrast is shown by the dates on the graves of two baseball players—Addie Joss and Chet Hoff. One died young; the other didn't. Joss's grave, in Toledo, Ohio, indicates that the Hall of Famer was born in 1880 and died in 1911. In Ossining, New York, is a marker with this inscription:

> Chester Hoff
> May 8, 1891
> September 17, 1998

Unlike Addie Joss, Chet "Red" Hoff's status was not distinguished by his career (a total of eighty-three innings pitched over four seasons) but by his life longevity. Joss's career as a pitcher was tremendous but cut short by tubercular meningitis, which caused his death two days after his thirty-first birthday. Joss's election to the Hall of Fame was possible only after an exception was made to the minimum requirement of ten years as a player for those whose careers were cut short by illness, injury, or death.

BY STEW THORNLEY

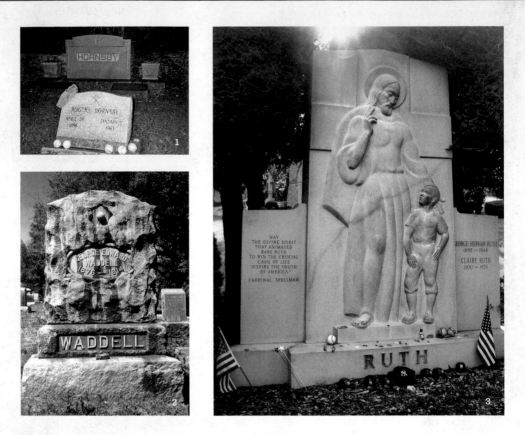

**1 ★ RESTING RAJAH**
Rogers Hornsby's grave at Hornsby Bend Cemetery near Austin, Texas —*Stew Thornley*

**2 ★ HEY, RUBE**
Rube Waddell's grave at Mission Burial Park South in San Antonio, Texas —*Stew Thornley*

**3 ★ BAMBINO**
Babe Ruth's grave at the Gate of Heaven Cemetery in Hawthorne, New York —*Arnie Cardillo*

Adding visual impact to the pictures are offerings left by fans. A small fire engine on Rube Waddell's grave is a testament to his eccentricities, which reportedly included leaving ballparks to chase fire engines passing by. Footwear on Joe Jackson's grave pays homage to his "Shoeless" nickname. Rogers Hornsby is buried in a private cemetery in Hornsby Bend, Texas, a few miles outside of Austin. The road to the cemetery is blocked by a gate with a prominent "No Trespassing" sign. Normally, it's prudent to observe such a directive, but the number of gloves and baseballs left around the Rajah's headstone indicates the determination of those who make the trek.

On my first visit to Babe Ruth's grave, in Hawthorne, New York, I was impressed by the number and types of things—baseball cards, balls, gloves, bats—left on his monument. I didn't have much to offer, but I ripped a sheet of paper from a pad and wrote "Babe, You're the best," along with my signature, a date, and an "NY" monogram, and tucked the note under a rock next to the grave. A few years later, I heard from a friend, who had seen this note in a window display at the Babe Ruth Birthplace Museum in Baltimore.

Many make journeys to the graves of the famous, infamous, and not-so-famous. All have probably experienced a quizzical look from those they have told of their hobby, but it is from one another that we cemetery denizens feel support and acceptance for what we do.

A complete list of the gravesites of Baseball Hall of Famers, including pictures of the graves, is available at *http://stewthornley.net/halloffamegraves.*

> "When Steve and I die we are going to be buried 60 feet, 6 inches apart."
>
> —TIM McCARVER—
>
> *Steve Carlton's catcher much of his career*

## They'll Manage

The only cemetery to have three Hall of Famers is New Cathedral Cemetery in Baltimore. The dearly departed honorees are Wilbert Robinson, John McGraw, and Joe Kelley.

### ★ CHARLEY HORSE

Joseph L. Quest (1852–1924) played for the White Stockings, Browns, Wolverines, Blues, and Athletics between 1871 and 1886. He never played more than 93 games in any season ('84) and his best year was 1880 when he hit .237, collected 27 RBI, had an on base percentage of .251 and a .276 slugging average for the White Stockings. That year, the Chicago team finished first with a record of 67–17. (In 1882, Quest was the first person to use the term "charley horse." The son of a blacksmith, he had noticed that certain muscle leg injuries reminded him of an old white horse, Charley, that resided in his father's shop.) In the spring of 2011, when I asked for the location of his gravesite at the Mount Hope Cemetery office in San Diego, I was given a paper with location details. I couldn't find it. A worker guided me to the coordinates, the exact spot, but, alas, poor Joe doesn't have a marker over his grave. With respect, I placed a used baseball over his grave and took a snapshot.
—*Andy Strasberg*

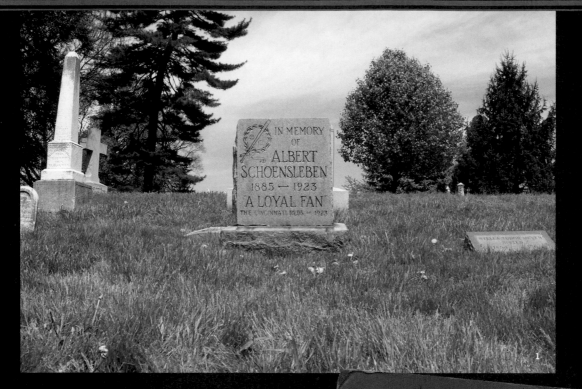

## A Tip of the Cap

"Here lies a man who batted .300."—What Cap Anson wanted on his tombstone; his lifetime batting average was .329. He died on April 14, 1922, and the inscription on his headstone reads "He played the game."

## #8 Is Retired

Cal Abrams died February 25, 1997, and was buried in Fort Lauderdale, Florida, in his Brooklyn Dodger uniform, number 8.

## A Card to End

Max Patkin, known as the Clown Prince of Baseball for fifty-one years, is said to have handed out his baseball cards from his hospital bed the day before he died.

**MAX PATKIN**

**THE CLOWN PRINCE OF BASEBALL**

### 1 ★ THE MILKMAN

On Dec. 21, 1923, in Cincinnati's St. Mary's cemetery, a monument was erected by the Reds in memory of a fan. He was Al Schoensleben, known as "Al the Milkman," and had died that summer. Al was considered the Reds' king of the bleachers. Players and the ball club raised enough money for the monument, which has a bat imposed over a wreath and the inscription, "A Loyal Fan." —*Bob Santoro*

### 2 ★ GOTCHA

Phil Masi was a catcher from 1939 to 1952. He is best known for a pick-off play attempted by Cleveland Indians pitcher Bob Feller and shortstop Lou Boudreau in the 1948 World Series. In the bottom of the eighth inning of Game 1, Masi pinch-ran for catcher Bill Salkeld. Mike McCormick bunted Masi to second on a sacrifice. Feller intentionally walked Eddie Stanky, who was replaced by Sibby Sisti. Feller then tried to pick Masi off second and Lou Boudreau appeared to tag Masi out, but umpire Bill Stewart called him safe. Tommy Holmes then singled Masi home with the only run of the game to give the Braves a 1–0 victory. Although this gave the Braves a 1–0 lead in games, the Indians bounced back to win the World Series in six games. Masi died in Mount Prospect, Illinois, at the age of 74. Upon his death, his will revealed that he really was out on the pick-off play. —*Gerald Hampton*

### 3 ★ A ROSE IS A ROSE

This is a display at the Louisville Slugger Museum in Louisville, Kentucky. It is a rose from Babe Ruth's casket. —*Bob Santoro*

Sept 1, 1948

Dear Jeff

This rose from Babe Ruth's casket was sent to Hillerich & Bradsby Co. by one of Ruth's friends in 1948.

In 1948, Babe Ruth died of a rare head and neck cancer at age 53. His body lay in state at Yankee Stadium, where more than 100,000 people paid their final respects.

## Great Hands

The grave digger with the best baseball stats has got to be Richie Hebner, hands down.

Career: 203 HR, .276 BA, 890 RBI, 3B/1B, Pirates/Phillies/1968–1985, bats left, throws right, shovels left.

*Graves*

# 13 Commissioners

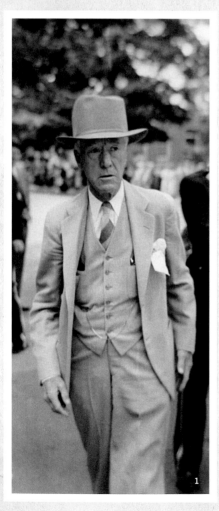

**1** ★ **GO TELL IT ON A MOUNTAIN**
The first baseball commissioner, Judge Kenesaw Mountain Landis, walks down Main Street in Cooperstown, New York in 1939.
*—Homer Osterhoudt*

**2** ★ **BURT & HAPPY**
Dodger manager Burt Shotton, on the left, is with baseball's second commissioner, A. B. "Happy" Chandler, during 1949 spring training.
*—Jan Friedman*

**3** ★ **BASEBALL'S BEST INTEREST**
Baseball commissioner number five was Bowie Kuhn, seen here holding infant Brian Appel on a Sunday afternoon. Kuhn would frequently make use of the term "in baseball's best interest" when making decisions.
*—Marty Appel*

**4** ★ **BASEBALL'S TABLE OF CONTENTS**
Baseball's sixth commissioner, Peter Ueberroth, and the Yankees' Don Mattingly are seated at the head of the table for the 1985 New York baseball writers' annual dinner. I am still shocked that Donnie Baseball is no longer a Yankee.
*—Carmine Cappaletti*

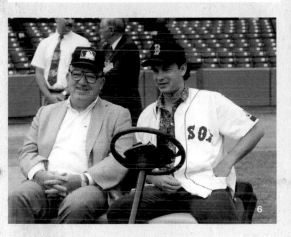

5 ★ SCHOLAR
Former Yale president
A. Bartlett Giamatti
became baseball's
seventh commissioner.
Here he visits with Dennis
Walsh. —*Tom Walsh*

6 ★ BY GUMP
Fay Vincent was baseball's
eighth commissioner. Here
he sits with Tom Hanks
before a Red Sox game.
—*Jim Healey*

7 ★ HEY BUD
Bud Selig is baseball's
current commissioner
and is seen here with Hall
of Fame umpire Doug
Harvey and his wife, Joy,
in 2010. —*Andy Strasberg*

# The Baseball Disclaimer

This book is for your private enjoyment only. Use only as directed. Batteries not included. No assembly required. Parental guidance suggested. Keep away from fire or flame. Any resemblance to real persons, living or dead, is purely coincidental. Use only in a well-ventilated area. Do not bend, fold, spindle, or mutilate. If mailing, the post office will not deliver without appropriate postage. Some of the trademarks mentioned in this publication appear for identification purposes only. The author and his heirs, friends, colleagues, and business associates are not responsible for direct, indirect, incidental, or consequential damages resulting from any defect, error, or failure as it pertains to this book. Furthermore, any rebroadcast, retransmission, reproduction, or other use of the pictures and accounts of this book without the express written consent of the Publisher is strictly forbidden. And NO PEPPER.

# 14
# *Statues and Monuments*

★ **STOIC BASEBALL FAN**
The Vivian Smith statue in Houston, Texas.
—*Desiree Guenther*

# Monumental Shots

I go to a lot of ballparks.

In 1985, just out of college, I set out to see every stadium. There were twenty-six teams then, and at a pace of two or three per year, I could complete my quest in ten to twelve years. Now, twenty-five years later, there are thirty clubs, and though I've seen forty-seven ballparks, I'm still not finished!

On Saturday, September 7, 1991, I hopped a flight from Chicago to Houston. In those pre-Internet days, I'd plan my visits when *Street and Smith's Baseball Annual* came out. I'd pick a weekend that worked and call the team box office. To my shock, on this night I was able to buy a single ticket in the second row behind home plate.

My ritual when touring each stadium includes two walks, an outside walk and an inside walk. These leisurely strolls are a cram course in local color and regional cuisine. There wasn't much to experience around the Astrodome—lots of parking lot, lots of concrete. Then I found myself face-to-face with the statue of one Vivian L. Smith.

Mrs. Smith stood alone in a plain dress and pulled back hair. The plaque nearby noted her birth and death dates (1908–1989) and the simple epitaph "She Loved the Astros." It was beautiful, mesmerizing, and touching. Here was this little old lady seeming to feed the birds, as thoughts of her beloved ball club coursed through her mind. I jotted all this down before I hustled in to watch the 'Stros defeat the Phils, 6–0, behind the late Darryl Kile.

I eventually learned that Mrs. Smith was a onetime minority owner of the Houston Astros and, along with her husband, instrumental in developing the Astrodome compound. She was one of the hard-cast immortals scattered around America's stadia. Back then, at other parks, there were only a few monuments, including Stan Musial crouched and ready to strike outside Busch Stadium, and Honus Wagner, once perched at Forbes Field, and then moved to Three Rivers Stadium (and now at PNC Park).

Today, statues have become a huge part of the look of the ballparks. They're a dime a dozen. The Tigers have seven sculptures at Comerica Park. At the new Busch, the Cardinals have twelve, including two of Stan the Man. A plethora of bronzes have descended like a plague upon the land.

But there's the one that will always stand out in my mind, one that is a cut above the rest. I can still see Vivian L. Smith, silently and benignly smiling to those who sought her out before they entered the ballpark, and hoping that maybe, just maybe, they'd love her Astros as much as she did. She stands strong, a fitting team tribute to a true fan.

BY JEFF KATZ

## Statuesque

This is the Bronze Age of baseball, where nearly every week someone unveils a statue of a player, but curiously, several franchises with storied histories—including the Los Angeles Dodgers, the Oakland Athletics, and the Baltimore Orioles—lack the statues to match. Most of these teams do justice to their former stars in other ways. Best among these alternative approaches, of course, is the Yankees' Monument Park. The Orioles have only one statue, of native son Babe Ruth; but they honor Jim Palmer, Eddie Murray, Earl Weaver, Frank Robinson, Brooks Robinson, and Cal Ripken, Jr., with four-foot-high monuments of their uniform numbers on Eutaw Street. It should be noted that a Brooks Robinson statue was finally added in October of 2011.

Baseball statues seem to carry hidden messages, like statues of soldiers on horseback. In the latter case, if one hoof of the soldier's horse is raised off the ground, the soldier was wounded in battle (perhaps mortally); two lifted hooves indicate that the soldier died in battle; all four hooves on the ground mean the rider survived the war unharmed. With baseball statues, if the player has both feet firmly planted on the ground, his peers considered him a clubhouse lawyer—someone who griped about missed calls, misinterpreted rules, and other injustices. If only one foot or just part of one foot is on the ground, the player was a clubhouse leader. And on those rare occasions when the player's feet are not on the ground, the player's team persona is now a bit of a mystery.

**1 ★ THE MAN IN BRONZE**
The Stan Musial statue at Busch Stadium 3. —*Tom Larwin*

**2 ★ MONUMENTAL TOUCH**
Andy Strasberg at the Babe Ruth Monument in centerfield at Yankee Stadium in 1963. Notice the batting practice baseball he caught in his back pocket. —*Gary Baker*

**3 ★ LIKE FATHER, LIKE SON**
Monument Park at Yankee Stadium in 2003, as seen by Randy Maris and his son Andrew Maris. —*Fran Maris*

## Bronze Plate Special

The unofficial record for most home plates in a city belongs to Louisville, Kentucky. If you walk down Main Street from Jackson Street, past Eighth Street, you will find fifty regulation-size home plates. Sculpted from bronze by artist Wyatt Gragg, the plates have been erected by the Louisville Slugger Museum to commemorate players who have notably used their bats during their career. Two home plates of interest include those of Dr. Dot Richardson, an Olympic softball hero, and Roger Maris, the only major leaguer so honored who is not enshrined in baseball's Hall of Fame. This "Walk of Fame" extends twelve blocks, and each home plate is accompanied by a replica of the actual model bat used by the player.

**1 ★ THE GREAT ONE**
The Roberto Clemente Bridge
and statue at PNC Park.
—*Rob Johnson*

**2 ★ THE DARK
DESTROYER**
The Jackie Robinson sculpture
in Pasadena, California.
—*Dan Ranken*

**3 ★ AT HOME**
Roberto Clemente bat and
plate, Louisville, Kentucky.
—*Bob Santoro*

**4 ★ HANDS ON HANS**
A Honus Wagner statue as a
work in progress. —*Anonymous*

**5 ★ FLYING DUTCHMAN**
Honus Wagner statue at Three
Rivers Stadium, Pittsburgh.
—*Pete Nunez*

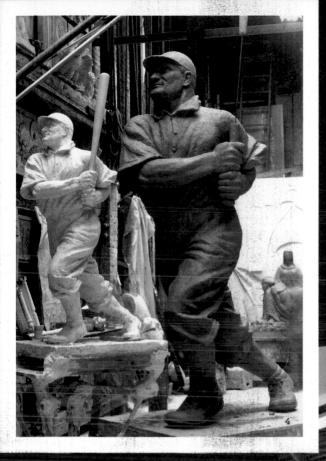

## Béisbol Estatua

Somewhere in Havana, there is (or was) a statue of the man who introduced baseball to Cuba. William Henry Steve Bellan, a Cuban who grew up in the United States, played in 1871 for the Haymakers of Troy, part of the first major league, the National Association. Bellan was an infielder and attended Fordham University. Returning to Cuba in 1874, he organized the island's first league. The statue was noticed by a visiting baseball team in 1910.

## Some Day ...

Anticipating that Mark McGwire was a sure thing for the Hall of Fame, the Cardinals enlisted sculptor Harry Weber, who was creating a statue of Ozzie Smith at the time, to also do one of McGwire. The Big Mac statue was completed but is hidden somewhere in Busch Stadium, just waiting for when the time is right.

5

# 15

# *Broadcasters*

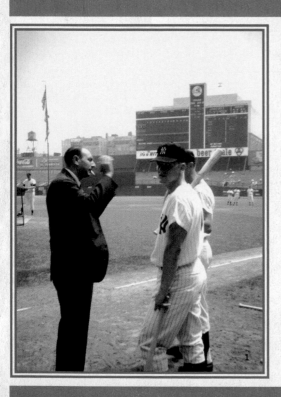

**1 ★ TELLING IT LIKE IT IS**
Howard Cosell, in the mid 1960s, is making a point with
Roger Maris during batting practice at Yankee Stadium.
Cosell made his living reporting on sports and said, "Sports
is the toy department of human life." —*Scott Keene*

**2 ★ SIGNING OFF**
The ever popular and iconic broadcaster Harry Caray signs
autographs. —*Madison McEntire*

# Of Mic and Men

Despite today's pervasive visual media on television and of course the Internet, fans may still not be familiar with the faces of their hometown baseball broadcasters. They don't appear on ESPN nightly, and they rarely appear directly on camera during a regular TV broadcast. In the pre-1960s years dominated by radio (still the best medium for baseball), fans could instantly recognize their favorites by the Voice: the Alabama twang of Red Barber for the Dodgers from 1939–1953 (and, later, the Yankees from 1954–1966, but originally for the Reds from 1934–1938), the distinct voice of Ernie Harwell for the Orioles and the Tigers, the cheerleading hometowners Harry Caray (Cubs) and Rosey Roswell (Pirates), and the mellow musings of Vin Scully, still going strong after beginning in 1950 for the Dodgers. Many fans may not even know that Jon Miller, who for years did ESPN's *Sunday Night Baseball*, is the regular broadcaster for the San Francisco Giants. Despite the presence of many stellar broadcasters on the air today, the color has faded a bit. No on-air broadcaster would today recite Longfellow's poem "The Song of Hiawatha" in its 115-line entirety, as Mel Allen did during a Yankee game. Nor would it be likely today that a broadcaster would set himself on fire with an errant cigar during a broadcast, as Twins broadcaster Halsey Hall did in the early 1960s (resulting in fans sending him fireproof asbestos jackets).

Radio broadcasters didn't exist until the 1920s, of course, and some teams failed to recognize the importance of radio as a medium to bring baseball to the fans—or fans to the park. The innovative Phil Wrigley of the 1920s Cubs "got it" and broadcast every game, proving that fans who listened would attend more games. In contrast, the three New York teams—Giants, Dodgers, Yankees—had an informal ban on radio broadcasts until the 1940s; incorrectly fearing that if fans could listen on radio, they wouldn't bother to come to the ballpark. Vin Scully remembers the early 1950s Brooklyn years when he could encourage fans to come out even after the game had started, as "lots of great seats are still available." The fans would come.

For many years teams provided the novelty of away game "re-creations." Until the 1950s, many teams wouldn't spend money to send their broadcasters on the road. The broadcaster would sit in a local hometown studio silently reading a Western Union telegraph feed of the game that arrived in a version of shorthand. He would use the information to bring the game alive on the radio. Former Yankees pitcher Waite Hoyt was famous for this long-abandoned art form. A broken or delayed telegraph feed forced the broadcaster to be creative: a rain delay, extra foul balls, an injury time-out; anything to kill time until the ticker resumed its feed.

It wasn't until TV really took hold in the 1960s that broadcasters had a "face" that local fans would recognize easily. Even today, most fans probably identify the voice before the face, and that's the essence of broadcasting.

BY JONATHAN FRASER LIGHT

## Megaphone Men

Before baseball had broadcasters, others had the responsibility to "announce" the batteries for both teams. This responsibility for a time was that of the home plate umpire, but that proved impractical—umpires can't be heard from the bleachers to home plate, especially when people are booing.

In the early 1900s, the problem was solved. Men with sturdy vocal cords walked in foul territory, using a megaphone to announce the starting pitcher and catcher for both teams.

Pat Piper was the Cubs PA announcer in Wrigley Field long enough to make the transition from megaphone to electric public address system.

1

"I hope he takes this job more seriously than he did the last one."

### EARL WEAVER

*on learning that umpire Ron Luciano had signed to become a sportscaster*

2

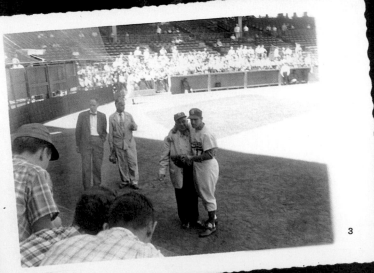

3

**1 ★ MIRACLE BROADCASTER**
Al Michaels, the 1972 Cincinnati Reds broadcaster, walks through the Cincinnati airport after another successful road trip with the team. —*Dave Lemox*

**2 ★ EVEREADY**
Dodger broadcaster Vin Scully (left) receives the 1960 Eveready Broadcaster of the Year Award from the Southern California Broadcasters Association. Making the presentation is association president Robert M. Light. —*Jonathan Fraser Light*

**3 ★ OISK & TEX**
Some pregame socializing with Dodger pitcher Carl Erskine and Tex Rickard. Rickard, the Brooklyn Dodgers' public address announcer at Ebbets Field, was as important a Dodger personality as some of the players. —*Lew Lipset*

**4 ★ ON THE AIR**
In cavernous DC Stadium, home of the Washington Senators, NBC broadcasters Tony Kubek and Jim Simpson interview outfielder Frank Howard. —*Greg Howell*

### 5 ★ VOICE SMILES

Bob Sheppard was the PA announcer for the New York Yankees from 1951–2007, which means his announcements spanned eras that included players Joe DiMaggio and Derek Jeter. Sheppard passed away in 2010 but can still be heard, via recording, announcing every at bat for Jeter. His visitor is Claire Doherty, who is all smiles with the legendary PA announcer. —*Paul Doherty*

### 6 ★ BROADCASTING BUDS

The St. Louis Cardinals broadcasters Jack Buck and Mike Shannon are seated in the Cards' dugout prior to the game. Cardinal games are not the same since the passing of Jack Buck.
—*Fu-chan Fujisawa*

### 7 ★ YAZ WATCH

Carl Yastrzemski at the Pro-Am golf tournament at La Costa Country Club in 1968. He had just won the Triple Crown the year before and the kids and media were following him everywhere. This picture of Carl and Joe Garagiola was taken at the ninth green, where Joe was interviewing him for a radio show. I remember Joe taking off his wristwatch and handing it to Yaz and saying, "Here, it's been about half an hour and you haven't won any awards yet." He got a great laugh from the crowd. —*Paul Joba*

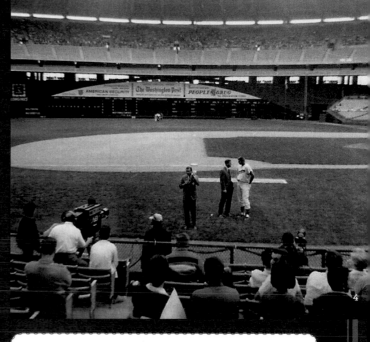

## The Language of Baseball

The first baseball game to broadcast in five languages happened on July 5, 1994, when the Dodgers played the Montreal Expos in Los Angeles. English was handled by a former player, Rick Monday; Spanish by Jaime Jarrin; French by Jacques Doucet; Korean by Richard Choi; and Mandarin by Steven Cheng.

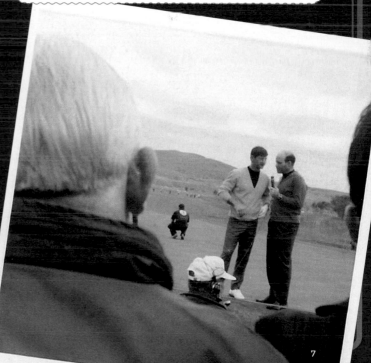

# Rizzuto/Barber
# Maris HR #61 Call

TV and radio are different animals, and a broadcaster must adjust accordingly when doing the play-by-play. Add to that their personality and broadcasting style, and a fan following a broadcast for the same event could have two different listening experiences.

Compare the historic calls of Yankee broadcasters Phil Rizzuto on radio and Red Barber on television on October 1, 1961, when Roger Maris hit his sixty-first homer to break Babe Ruth's single season home run record.

**Red Barber**: Fastball is wide. Lays off of it. Ball One.

**RB**: Low, ball two, crowd is reacting negatively. They want to see Maris get something he can swing on.
**RB**: There it is
**RB**: Sixty-one.
**RB**: $5,000 somebody.
**RB**: He got his pitch.
**RB**: $5,000.
**RB**: And here is the fellow with sixty-one.
**RB**: You are seeing a lot today.
**RB**: Well you haven't seen anything like this, have you?
**Mel Allen**: Nobody ever has, Red.
**MA**: Nobody has ever seen anything like this.

**Mel Allen**: Not much you can say. You just look and listen.

**Phil Rizzuto**: And here comes Roger Maris. They're standing up, waiting to see if Maris is going to hit number sixty-one. Here's the windup, the pitch to Roger— way outside, ball one.

And the fans are starting to boo.

Low, ball two. That one was in the dirt. . . .

And the boos get louder. Two balls, no strikes on Roger Maris.

Here's the windup.

Fastball hit deep to right! This could be it! Way back there! Holy cow he did it! Sixty-one for Maris!

**1 ★ HOLY COW**
Yankees broadcaster Phil Rizzuto, puts his arm around fan Brian Appel before broadcasting a Yankee game in the early 1990s. —*Marty Appel*

**2 ★ THE OL' REDHEAD**
Red Barber broadcasted baseball games for the Cincinnati Reds, Brooklyn Dodgers, and New York Yankees. His contract with the Yankees was not renewed after he acknowledged that a paid attendance of only 413 fans showed up for the September 22, 1966, game at Yankee Stadium against the White Sox. The Yanks were in tenth place and 29 games out of first place. Here he is walking around Vero Beach for the Dodgers spring training in the 1940s.
—*Robert L. Hennessy*

**3 ★ BIG D**
After his playing days, Don Drysdale's broadcasting career blossomed, as he did both network and team broadcasts. Here he is at the 1978 All-Star Game for ABC Sports. —*Bill Klink*

**4 ★ BASEBALL TONIGHT**
Two of ESPN's popular baseball broadcasters Karl Ravech and Peter Gammons discuss the 2000 MLB All-Star Game, which was held at Turner Field in Atlanta.
—*Tom Larwin*

# The Gipper Ad-Libs

In the 1930s, a future president of the United States was the radio broadcaster for the Chicago Cubs. During one game, Ronald Reagan was re-creating the action in a studio from wire service reports, the wire went dead. Reagan had to improvise for more than six minutes. He had players holding conferences, hitting foul balls, and tying their spikes before the service was returned and he could accurately report the game.

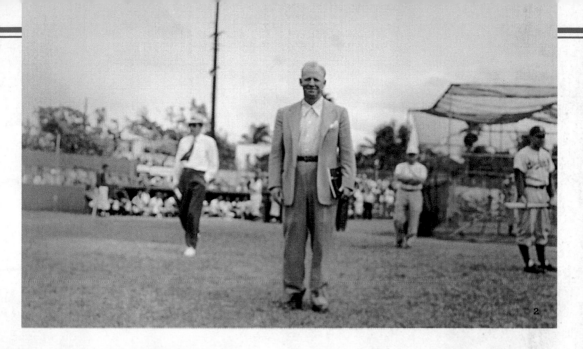

"When I first started broadcasting in Seattle, the team wasn't going so good and I was on the bus after a bad game in Milwaukee. One of the coaches on the Mariners staff was big Frank Howard, you know what a wonderful man he is and a gentle giant, but every once in awhile he had had enough. Hall of Fame broadcaster Dave Niehaus and his wife, Marilyn, were also on the trip, sitting on the bus. Hondo gets on the bus and he's going to air out the team and he screams at the top of his lungs, 'Are there any women on the bus?' Niehaus says, 'Why yes Hondo, my wife Marilyn is here.' And Hondo says, 'And what a lovely one she is, David!' and sat down."

## JOE SIMPSON,

*TV Broadcaster, Atlanta Braves*

## Radio Signal

A big "shout out" to pitcher Steve Arlin. Arlin played in the big leagues from 1969 to 1974 with little notoriety. His grandfather, however, was Harold Arlin, the first broadcaster to call a base-ball game on radio. On August 5, 1921, he called the Phillies against the Pirates at Forbes Field in Pitts-burgh. The Buccos won, 8–5. There were no commercial breaks, which may explain how the game was completed in only one hour and fifty-seven minutes.

1

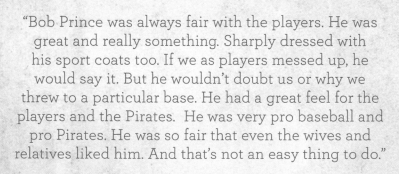

2

3

"Bob Prince was always fair with the players. He was great and really something. Sharply dressed with his sport coats too. If we as players messed up, he would say it. But he wouldn't doubt us or why we threw to a particular base. He had a great feel for the players and the Pirates. He was very pro baseball and pro Pirates. He was so fair that even the wives and relatives liked him. And that's not an easy thing to do."

— AL OLIVER —

**1 ★ REM DOG WORKING**
In some of the older ballparks it is possible to position yourself just right and take a picture of the team's broadcaster while they are on the air. Here's the Red Sox broadcaster Jerry Remy working in Fenway. —*Carol Ruatenberg*

**2 ★ A LEAD SINGER**
Harry Caray leads the seventh inning stretch song, "Take Me Out to the Ball Game," at HoHoKam Park during a Cubs spring training game. —*Tom Larwin*

> "My favorite broadcaster was Dizzy Dean because we were always very friendly towards each other and he would always come by my locker to discuss hunting . . . quail hunting especially. We played a lot of golf together too. We played tgolf about a week before he died. He was always friendly and I enjoyed talking about hunting with him and other things."

— BOBBY RICHARDSON —

### 3 ★ INFINITY
When John Kruk was asked why he selected "8" for his uniform number during his playing career, his answer was, "Because when I slide into second base my number changes from 8 to infinity." —*Madres*

### 4 ★ THE DEAN OF BASEBALL
Dizzy Dean was a great pitcher and then became a popular baseball broadcaster. It was Dean who said, during one broadcast, "He slud into third." —*Whitney Jackson*

### 5 ★ BRAVE HEARTS
After the Boston Braves moved to Milwaukee they returned to Boston to play the Red Sox. Unidentified players are interviewed on a rainy night for an exhibition game at Fenway Park. —*Don Mcnelsh*

## Players Time Line

Baseball broadcasters have been known to summarize an incredible amount of thought in just a few words. Such as this insightful Vin Scully observation: "It's a mere moment in a man's life between an All-Star Game and an old-timer's game."

# 16 Dugouts

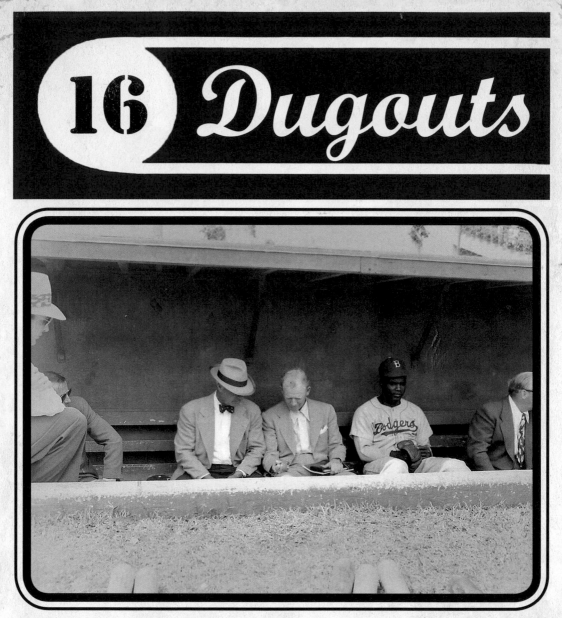

★ BENCHED
The writing on the back of this snapshot taken by my parents says:
"1949 Miami Field. Sitting in the dugout was Dodger manager Burt
Shotton, Dodger broadcaster Red Barber, and Jackie Robinson."
—*Robert L. Hennessy*

# Player Stables

Amid all the sights and sounds a stadium has to offer, three attributes of the ballpark experience repeatedly attract a fan's attention: the field of play, the scoreboard, and the dugouts. Of these, the dugouts hold a unique fascination.

The dugout is where players retreat to rest and recollect their thoughts between at-bats, between their turns on the diamond, between their moments in the sun or the bright lights. In the dugout, individual players agonize, teammates socialize, managers strategize, coaches analyze, batboys are utilized, and the rare pregame visitor is mesmerized.

Around the dugout is where eager souvenir seekers congregate during batting practice and between innings hoping to claim a quick autograph. Dugouts host some of baseball's most memorable moments. Cameras love to capture sprinting fielders who flip over railings and disappear headlong into the dugout as they race to catch a foul ball. And while dugouts swallow some players, they also spew them out. Think of George Brett, who erupted from the Royals' dugout during a July 1983 game against the Yankees when his home run was nullified because of too much pine tar on the bat handle.

In the dugout, emotions and personalities sometimes boil during tense games. Fans may recall Yankees manager Billy Martin and future Hall of Famer Reggie Jackson going nose to nose in the Fenway Park visitors' dugout during a nationally televised June 18, 1977, game against their rival Red Sox. All too often, careers, credibility, and an occasional water cooler are damaged beyond repair when a fuming player returns to the dugout, perhaps after a strikeout or an ejection, and unleashes his fury with bat in hand before disappearing down the tunnel into the clubhouse.

That mysterious passageway leading to the locker room is an example of how dugouts have evolved since the late 1800s. In early-era ballparks, before the advent of sunken and covered dugouts, an open-air wooden bench gave teams little protection from splinters, foul balls, bawdy fans, or the glaring sun. And there were certainly no hidden runways leading to air-conditioned clubhouses. Even the venerable Polo Grounds in New York, once home to both the National League Giants and the American League Yankees, had a second-floor clubhouse that hung high above the center field wall, requiring players to walk the length of the field from the dugout into an outfield nook where stairways led up to each team's locker room.

BY JEFF ARNETT

1 ★ PALE HOSE
The 1953 Hall of Fame
exhibition game had the
Chicago White Sox play
the Redlegs. The Reds
won by a score of 16–6.
This is the White Sox
dugout at Doubleday
Field.
—Homer Osterhoudt

2 ★ DO YOU
WANT TO KNOW A
SECRET?
Perhaps the most famous
occupants of the visitor's
dugout at Shea Stadium
were not the 1969 Atlanta
Braves as seen here, but
rather the Beatles. Their
concert took place on
August 15, 1965. John,
Paul, George, and Ringo
entered from the visitor's
dugout at 9:17 P.M., ran
out onto the stage set up
near second base, and
sent the Shea crowd into
a frenzy by opening with
"Twist and Shout."
—Don McNeish

3 ★ ANAHEIM HEAT
As was the custom in
baseball for years, the
starting pitcher for a
game would warm up
in front of the dugout.
Nolan Ryan is shown
continuing that tradition
when he pitched for the
Angels. —Tom Larwin

4 ★ TIN TOP
Connie Mack Stadium's
dugout probably was the
only dugout that had a
corrugated tin roof.
—Don Mcneish

5 ★ YOGI BANTER
Yogi Berra, as a member
of the Mets coaching
staff in 1966, walks into
their Shea Stadium
dugout. —Lew Lipset

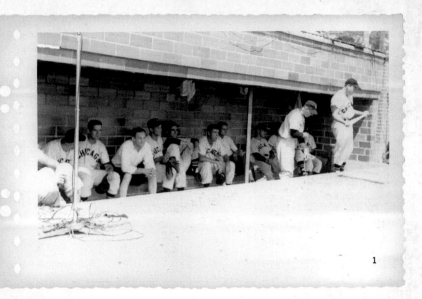

1

The geography of the dugout is also interesting. If your team is at home in Houston, for example, your dugout is along the first-base line, as it is for nineteen big league teams. If you're playing in Los Angeles or Chicago—whether with the Dodgers, the Angels, the Cubs, or the White Sox—the home dugout flanks third base, as it does for eleven major league clubs. Strangely, the Major League Baseball Rulebook is mute on which dugout a team should occupy, leaving it to the choice of the host club.

Whichever dugout a team occupies may also influence a fan's seat selection, where a perfect angle and a pair of binoculars can spy a favorite player clowning with his colleagues, perched on the top step, or sulking in the shadows. A quick survey of a team's dugout demeanor sometimes predicts the outcome of a game. Comedic broadcaster and journeyman major leaguer Bob Uecker joked of his playing days, "When I came up to bat with three men on and two outs in the ninth, I looked in the other team's dugout and they were already in street clothes."

Among other things, dugouts are home to rally caps, bat racks, sunflower seeds, and veteran skippers. Radio legend Ernie Harwell said, "A tall, thin old man waving a scorecard from the corner of his dugout. That's baseball," conjuring memories of Connie Mack, the Philadelphia Athletics manager for the first half of the twentieth century. Another icon, Casey Stengel, once barked at an incredulous rookie, "Sure I played, did you think I was born at the age of seventy sitting in a dugout trying to manage guys like you?"

The dugout's interior is a popular focal point for sponsors to promote their products, while the dugout's roof is where mascots dance, where ballgirls launch T-shirts from slingshots, and where teams chronicle their championships. Even those ballparks without a display of pennants welcome ticket holders to the friendly confines with greetings from atop the dugout. After all, it is the dugout where spectators frequently fix their game-time gaze, where the legends take shelter, and where fans stack their memories alongside all the bats, balls, and helmets.

2

3

## Not Dug Out

Candlestick Park, the former home of the San Francisco Giants, opened in 1960. It was the first ballpark with dugouts that were not dug out. They were on ground level with no steps.

4

5

## Bench Jockey

No one gives much thought to this today, but there are good reasons why players' benches came to be located in dugouts, out of the sight and sound of the fans. Before 1900, it was customary for the entire team—players, coaches, manager, batboy, mascot, and even pets (Honus Wagner's bulldog mix)—to sit on long wooden benches near the foul lines. And if those benches were close to the stands, which they were in the small ballparks, it was a recipe for problems. Lolling on the bench, players often indulged in familiarities with the patrons, which tended to degenerate into angry and uncouth repartee. Such ugliness took place as far back as 1885, when Fred "Dandelion" Pfeffer of the Chicago White Stockings rode a heckler in the stands so hard that the rowdy organized a mob that stoned the team after the game.

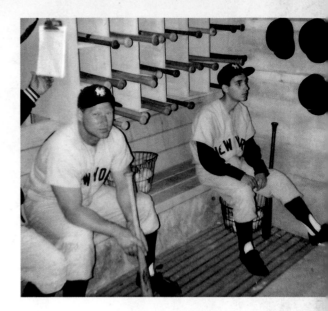

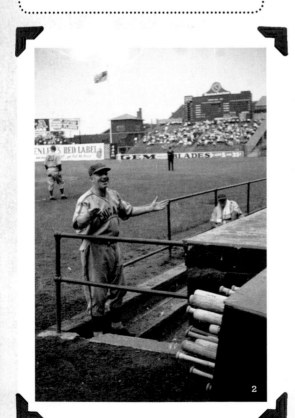

2

## Sounds Like Baseball

In 1912, new technology in sound recording had produced the dictograph, a device that picked up, magnified, and transmitted sounds of the spoken voice.

According to the testimony of an electrical company representative, seventeen dictograph recorders were discovered hidden under both the New York and visiting players' benches at the Polo Grounds. The wires led directly to the offices of the club owner, John T. Brush, and the manager, John McGraw. Baseball observers could only conclude that Brush and McGraw were able to listen in to the conversations of their opponents as well as their own men. It was the height of snooping, paranoia, and cheating.

**1 ★ MAKING THE SHOW**
In 2000, HBO recreated the 1961 baseball season when Mantle and Maris challenged Babe Ruth's sixty-home-run record. This is one of the recreated visitors' dugouts for a scene that includes two faux Yankee players. —*Dan Moore*

**2 ★ GABBING**
Gabby Hartnett of the Cubs laughs on the top step of the dugout at Braves Field before a game in the 1940s. —*Don McNeish*

## Location, Location, Location

Should the home dugout be on the first base or the third base side? The Major League Baseball Rulebook does not restrict the location. Even the two oldest parks still in use differ on this point: the Cubs sit on the third base side at Wrigley, while the Red Sox inhabit the first base dugout at Fenway. As for the Yankees, the dugout once was on the third-base side and now is on the first-base side.

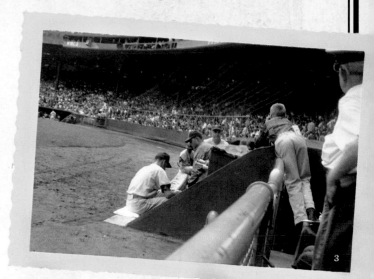

## Dugout Birth

The St. Louis, Cincinnati, and Chicago grounds in the late 1880s were the only ones spacious enough to afford seating for players at points remote from the spectators.

In 1895, Philadelphia tried the first experiment in hiding players from the crowds. All nonparticipants, except for the starters and coaches, were placed on benches under the grandstand.

Four years later, a new league rule stipulated that the players' bench had to be located at least twenty-five feet from the foul lines. That arrangement caused some fielding hazards with foul balls. Around 1902, most major league parks had moved the players to permanent accommodations under the stands and walled them in on three sides. Voilà, the dugout.

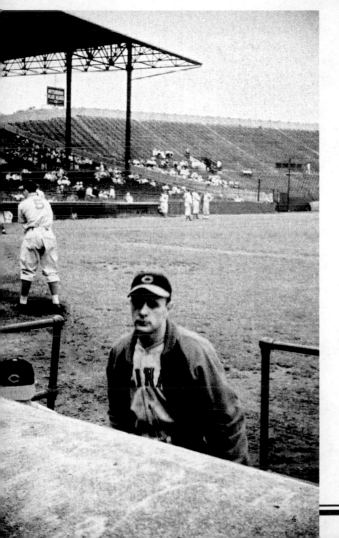

**3 ★ A PARK BENCH IN BROOKLYN**
The most magical dugout in all of baseball was the Dodgers' 1950s dugout at Ebbets Field.
—*Lew Lipset*

**4 ★ A NO NO**
Johnny Vander Meer, who pitched back-to-back no-hitters, heads into the dugout.
—*Don McNeish*

**1 ★ HOME AWAY FROM HOME**
Sportsman's Park (1920–1953) was
for years the home ballpark of the
Browns and Cardinals of St. Louis.
—*Steve Falletti*

**2 ★ LIP SERVICE**
This is the closest I could get to Leo
Durocher in the Cubs dugout.
—*Drew Donahue*

**3 ★ 1/10,232**
Just before Tony Gwynn got up to
bat for the first time in the major
leagues, I snuck down near the
dugout and shot this photo. It is
moments before he would go to bat.
I couldn't believe that the Padres
had drafted a basketball player
from San Diego State. Little did I
or anyone else realize that Gywnn
would go to bat 10,232 times and hit
his way into Baseball's Hall of Fame.
—*Fred O. Rodgers*

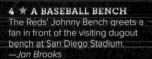

### 4 ★ A BASEBALL BENCH
The Reds' Johnny Bench greets a
fan in front of the visiting dugout
bench at San Diego Stadium.
—*Jan Brooks*

### 5 ★ HE'S A LEMON
Jim Lemon of the Washington
Senators pokes his head out of the
dugout in 1968. —*Greg Howell*

### 6 ★ I CAUGHT A PASS
After using someone else's press
pass to get onto the field, I took
this picture of Manny Ramirez on
October 2, 2005, after the Sox
beat the Yankees, 10–1, to clinch
the 2005 Wild Card. He's doing
interviews and signing autographs
while wearing a Red Sox shirt that
has "Guerrero" and #65 on the
back. Not sure what it's all about.
Chalk it up to Manny being Manny,
I guess! —*Jay Flemming*

### 7 ★ I'VE GOT A SECRET
Moe Berg finished his baseball
career with the Boston Red Sox.
Many believe that Berg served as
a spy for the United States when
he traveled to Japan for exhibition
games prior to World War II.
—*Raymond Davis*

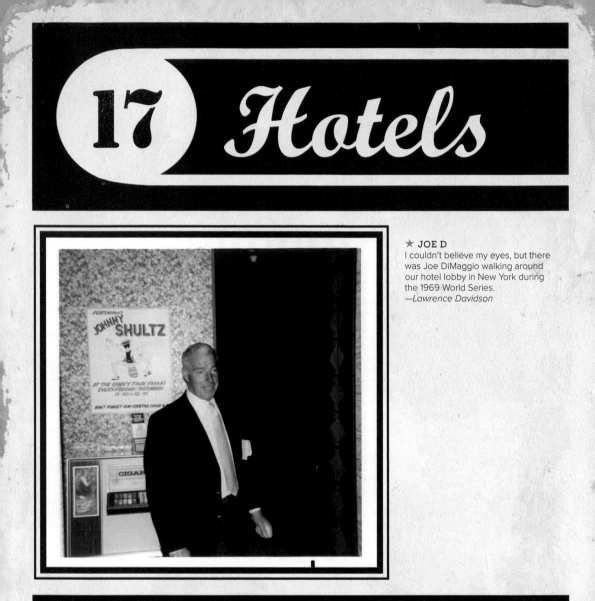

★ JOE D
I couldn't believe my eyes, but there was Joe DiMaggio walking around our hotel lobby in New York during the 1969 World Series.
—*Lawrence Davidson*

# Inn Ballplayers Room

Half a century ago persistent, camera-equipped fans could loiter outside the visiting team's lodgings in any major league city and be reasonably confident they'd be able to snag an out-of-uniform photo or two of a major league baseball-playing member of whichever team was in town to play the locals.

But times changed. Collective bargaining guaranteed every player a single room, and nearly every one of them began making enough money to use room service, thus eliminating the necessity of a player ever having to emerge from his den away from home. Fans lurking outside New York's Grand Hyatt two decades ago when the Chicago Cubs were in town would likely have gone away disappointed if they wanted photos of big-name personnel like Andre Dawson, Ryne Sandberg, Rick Sutcliffe, or skipper Don Zimmer. However, to true aficionados the chance to catch a shot of Steve Wilson, Kevin Blankenship, Marvell Wynne, or Paul Assenmacher was still a pretty sweet consolation prize.

Things are much different in the smaller cities that are home to a branch of Major League Baseball's Research and Development Department, otherwise known as a minor league team. During the summer of 1986 any patient and enterprising Salem (Virginia) Redbirds fans willing to wait outside Roanoke's Omega Inn when the Prince William Pirates were in town could likely have posed for photos with future big leaguers Bobby Bonilla, John Smiley, Jose Lind, Jim Neidlinger, Barry Jones, Jose Melendez, and maybe even a then-slender pro rookie by the name of Barry Bonds.

Today getting around security at the hotels of the visiting team for a glimpse of any big leaguer can be challenging. But imagine how many memorable photos of young future Hall of Famers an enterprising fan could obtain if he (or she) had an unlimited travel budget, a *Baseball America Directory,* and the gift of clairvoyance!

In 1984 the fourth starter for the Anchorage Glacier Pilots of the Alaska League was a six-foot-ten beanpole who hadn't any idea where his left-handed pitches were headed. But had some prescient fan known enough to lurk outside the barracks at Eielson Air Force Base, which was where visiting teams stayed when they were visiting the North Pole Nicks or the Alaska Goldpanners of Fairbanks, they could have gotten a photo of Randy Johnson *before* he was a 303-game winner!

BY ANDY YOUNG

## It All Happens Here

In addition to being where the visiting team stays, hotels have gained notoriety as a result of the site of where a player was shot in the chest and survived (Chicago's Edgewater Beach Hotel, Eddie Waitkus, June 14, 1949), a Baseball Hall of Famer died (Montreal, Quebec, Don Drysdale, July 3, 1993), a player committed suicide (Boston's Copley Plaza Hotel, Willard Hershberger, August 3, 1940), expansion franchises were approved, an owner got into a fight in a hotel elevator (both at LA's Biltmore Hotel, George Steinbrenner, October 28, 1981), a baseball legend had a residence (Boston's Somerset Hotel, Ted Williams), managers hired and fired, free agents signed, ghosts haunted the premises (Milwaukee's Pfister Hotel, according to players Trevor Hoffman and Mike Cameron), "nature-watching" is the best in the world (Washington, D.C.'s Shoreham Hotel, according to Jim Bouton), but to date no major leaguer has listed his place of birth as a hotel, although chances are one of the seventeen thousand major leaguers who have played might have been conceived in a hotel—but I'm guessing.

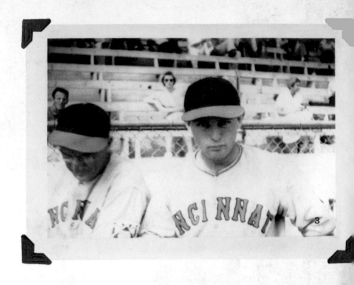

## Floored

Yankee pitching legend and Hall of Famer Lefty Gomez managed in the minors after his playing career. In 1947, while he piloted the Binghamton Triplets, the team lost thirteen in a row. The GM, Bill McCory, called Gomez's hotel to make sure he was OK. When McCory couldn't reach him, he called the front desk and asked what floor Gomez's room was on. "The second," was the response. "Oh well, I won't worry about him," the GM told the front desk. "He can't hurt himself jumping out of a second-floor window."

**1 ★ DEATHWATCH**
The Copley Plaza Hotel in Boston was the site of a tragedy. On Friday August 2, 1940, the Cincinnati Reds lost a doubleheader to the Boston Braves. Backup catcher Willard Hershberger was depressed, blaming himself for one of the defeats. He returned to his hotel room and took his own life.
—Chris Gamble

**2 ★ BOO!**
Bobby Mercer sits by the hotel pool in Texas. I was about to take his photo when Whitey Ford tried to scare me. He did, but I got the shot anyway.
—Marty Appel

> "Being with a woman all night never hurt no professional baseball player. It's staying up all night looking for a woman that does him in."
>
> — CASEY STENGEL

## "Murphy Money"

"Murphy Money" is a baseball term that has been around since the 1940s. The term refers to the money provided by the team to each player during spring training or when the team is playing games on the road. This per diem is meant to pay for players' incidentals, such as tips and food.

It is believed that the term originated with a Boston attorney, Robert Murphy, who tried to organize a players' union in 1946. One of the demands Murphy made on behalf of the players was that they would receive money for those expenses in addition to their salary. While the union didn't become a reality, the owners instituted certain concessions for the players, including a guaranteed expense account, which quickly became known as "Murphy Money."

**3 ★ LET'S PLAY 2**
The always positive Chicago Cub Ernie Banks stops for a moment in a hotel lobby to have his picture taken with a fan. —*Anonymous*

**4 ★ WINTER FEAST**
The annual New York Baseball Writers Association of America dinner was held at the Sheraton Hotel in midtown Manhattan in 1982. I was able to get close enough with my camera to take this picture of Yankee manager Bob Lemon, George Steinbrenner, and baseball writer Bill Madden.
—*Carmine Cappaletti*

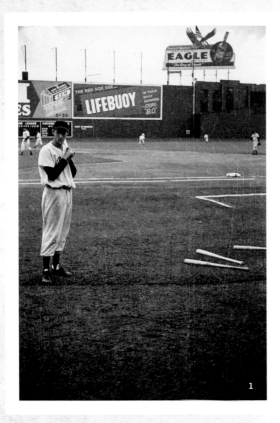

## Get Changed

In the early days there were no dressing rooms or lockers at ballparks. As a result, players changed into their uniforms at their hotels. In the American League, this continued until 1900, when all the ballparks were equipped with locker rooms. And by 1906, all National League ballparks except for the Chicago Cubs' West Side Park had locker rooms. Charles Murphy, the Cubs' owner, had a sound but selfish reason for being the exception. He preferred having his players driven to the park in carriages behind a team of gaily caparisoned steeds covered with blankets emblazoned with the team's playing record. Eventually other National League owners pressured Murphy into halting this bush league advertising.

In 1911, Washington manager Clark Griffith wrote American League president Ban Johnson, requesting that all teams have dressing rooms for the visiting club. He advanced two simple reasons: that players would no longer have to endure wet uniforms on their way back to their hotels, and that it would prevent hometown fans from spotting the hotel-bound visitors and heckling or fighting them.

**1 ★ HOTEL HABITAT**
Ted Williams lived in the Somerset Hotel rather than live in a house or apartment for many years during the baseball season. —*Don McNeish*

**2 ★ TWO SHAKES, NO TIES**
Lou Brock shaking hands with a couple of fans. —*Unknown*

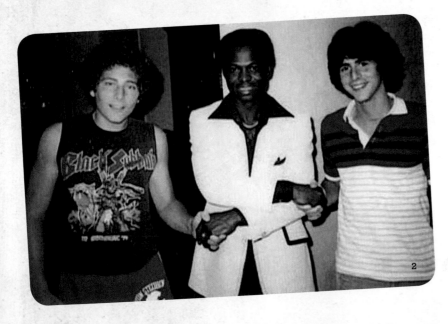

> "I don't room with him;
> I room with his suitcase."

### PING BODIE,

*quoted in Robert W. Creamer's*
Babe: The Legend Comes to Life

**3 ★ HOTEL SWEET**
We were staying at the same hotel as the Cubs in 1966. I saw the sweet swinging Billy Williams in the lobby and asked if I could take his picture.
*—Hank Bishop*

**4 ★ WAITKUS AND SMELL THE ROSES**
This photo was taken the day that Eddie Waitkus returned to the Phillies after being shot by a deranged female fan while the team was staying at Chicago's Edgewater Beach Hotel in 1949. *—David Greene*

> "The fullest, most expansive, most public talk is the talk in the lobby, baseball's second-favorite venue. The lobby is the park of talk; it is the enclosed place where the game is truly told, because told again and again. Each time it is played and replayed in the telling, the fable is refined, the nuances burnished the color of old silver. The memories in baseball become sharpest as they recede, for the art of telling improves with age."

### A. BARTLETT GIAMATTI,

*from* Take Time for Paradise

# 18 Seats

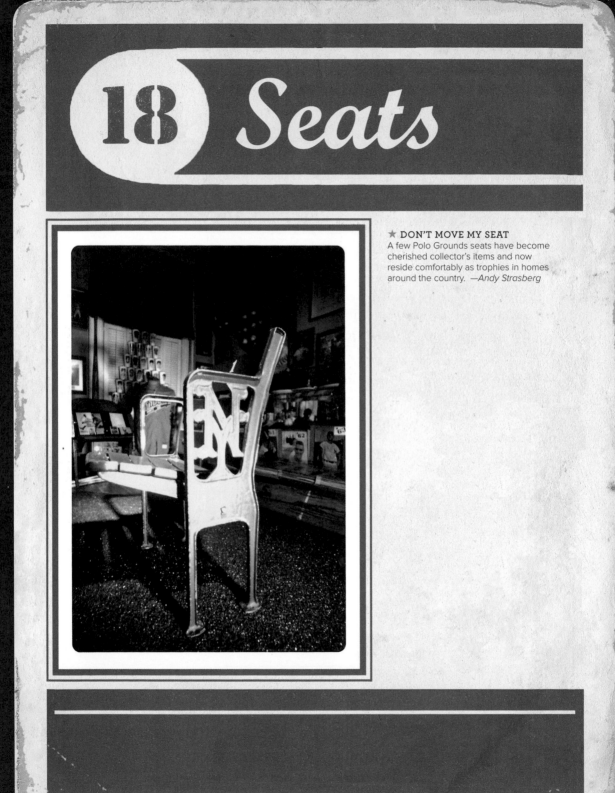

★ **DON'T MOVE MY SEAT**
A few Polo Grounds seats have become
cherished collector's items and now
reside comfortably as trophies in homes
around the country. —*Andy Strasberg*

# Butt Wait

Although it's the national pastime, baseball is still a business, and the critical objective for any professional baseball team today is to sell tickets and fill the seats.

My obsession with ballpark seats began very innocently. After the Dodgers left Brooklyn, a friend went to Ebbets Field and took a chair that had been used for box seat holders and was being discarded . . . or at least that was the story I got. In 1959 my friend gave me that chair, and as a result I have become a baseball park seatoholic.

The Ebbets Field seat has been with me for more than a half century now. It began its presence in my life proudly positioned in the corner of my bedroom. In time, it became the centerpiece of my den. Eventually, needing company, it attracted other seats and even provided great baseball memories that did not involve an actual game.

## POLO GROUNDS

The venerable Polo Grounds was being demolished in 1965. Many of the ballpark walls were down and there were no security guards or posted signs, so anyone could just walk in, rummage around the field that was littered with seats, and take home a piece of history. Like Crusaders of the Middle Ages in pursuit of the Grail, my pal Jimmy Gold and I took the usual bus routes and subways to get to the old ballpark that at one time had been the home field of the Giants, the Yankees, and then the upstart Mets. We knew exactly what seats we wanted and we were determined they would be the best of them all. Near what would have been third base, a glint of sunlight reflecting off its green paint, we found the goal of our quest, a pair of end seats with the cast iron stylized NY initials of the New York Giants on the sides. We dusted them off and checked to make sure they worked, and off we went, oblivious to the curious looks of our fellow passengers and neighbors as we retraced our routes home, lugging those stadium seats.

BY ANDY STRASBERG

**1 ★ HOUSTON WE HAVE LANDED**
This is the seat where Doug Rader's 1970 tape measure homer landed in the Astrodome.
—*Andy Strasberg*

**2 ★ TV MT SEATS**
Fox Television staged a home run contest between Cecil Fielder and Jose Canseco at the height of their careers. The empty seats at Dodger Stadium were the backdrop as umpire Doug Harvey made his way to home plate.
—*Andy Strasberg*

# YANKEE STADIUM

In the late 1960s, the Yankees were changing their old bench seats in the bleachers from wood to fiberglass. The new bleacher benches would be just as hard, but more than likely more durable and, most importantly, devoid of those irritable splinters that could penetrate even the thickest of corduroy pants.

It was January, cold and snowy and desolate, when I drove by Yankee Stadium to see if per chance those old bleacher benches were now outside the ballpark. Yes sir, just as I had hoped. It was obvious the old relics had been purposely placed there so a fan like me could drive back at 3 A.M. and cram a twelve-foot plank in the backseat of his car, both ends hanging out the windows, resembling a poorly designed airplane. That wooden bleacher bench would be housed and preserved forever. And it too will be celebrating its golden anniversary in my possession soon.

# CONNIE MACK STADIUM

When Connie Mack Stadium was being razed, I took a chance and wrote management a heartfelt plea that I wanted to add a couple of their seats to my collection. I was happily surprised to get a response that indicated the bearer of that letter (me) would be afforded the opportunity to take two seats from Connie Mack Stadium at no cost. An understanding friend drove me down to Philadelphia on a Tuesday afternoon. Equipped with a crowbar and hacksaw, which would have made me conspicuous in most other neighborhoods except this one surrounding Connie Mack Stadium at the time. After circulating the exterior of the ballpark, I spied a door marked "Security." I entered with all the confidence in the world because I had a letter permitting me to extricate a couple of seats at no cost. I proudly handed the

letter to the security guard, who read it, adjusted his hat, and pointed to the ballpark with the gentle admonition, "OK, son, go knock yourself out."

I damned near did. There were no end seats visible, but I took my time. I brought with me my 35 mm camera and took shots at every angle. This was a deceased ballpark that had a glorious past, and I wanted to memorialize it in photos. My buddy Dave Wright and I walked around the entire field. We sat in the dugout, stood on the mound, leaned up against the left field fence, and at one point found a rubber ball on the patchy infield grass. My eyes darted everywhere, looking for something like a broomstick so that I could hit a fungo in the old ball park. It was not a Louisville Slugger, but I told Dave to swing first. I stood behind him as he tried to knock it to the seats in right. Whew, he crushed it. We retrieved the ball and now it was my turn. I took some stickball practice swings and made that stick *swish* sound. I stood where Phillies shortstop Larry Bowa would have stood in deep short with Hank Aaron at the plate and Art Mahaffey on the mound for the Phils. Dave was holding the camera, and I was hoping that he would capture the moment on film. I threw the ball up with my left hand, grabbed the broom handle in one motion, and as the ball came down, I connected. My tonk went zooming into the left field seats about nine rows up. Or at least that's my story. Fortunately for me Dave, caught me as I was about to connect.

It was now work time, and we found a pair of seats that needed just a little encouragement to unbolt from their concrete pad. We each carried one end of the seats and walked back out through the security gate waving thanks to the guard who was on duty. On the ride home I could not stop thinking about our great and unique experience. About forty miles from home I realized I still had that permission letter for two seats in my pocket. Over the next couple of months I went back five more times, my official letter in hand, and fortunately never ran into the same security guard on any of my forays.

★ **SAY "CHEESE"**
Andy Strasberg takes a break while looking for a Connie Mack Stadium seat to add to his collection in 1971
*—Dave Wright*

## Ted's Red Seat

The lone red seat in Fenway Park's right field bleachers (Section 42, Row 37, Seat 21, pictured below) signifies the landing spot of the longest measurable home run ever hit there. Ted Williams hit the home run on June 9, 1946, off Fred Hutchinson of the Detroit Tigers. The shot was measured at 502 feet. After every Red Sox game, fans line up to take pictures of the seat or just sit in it and look toward home plate and imagine that clout.

### 1 ★ OPENING LINE

This is the seat where President John F. Kennedy sat in DC Stadium on April 9, 1962, for the Washington Senators' Opening Day game. It was the first and only game played in the American League that day. The Senators beat the Tigers. and it was reported that as JFK left DC Stadium, he said to the Senators owner Pete Quesada, "I'm leaving you in first place." —*Andy Strasberg*

### 2 ★ MARKED & NOTED

A seat painted white among the yellow-painted seats in the upper deck at RFK Stadium in Washington, D.C., to honor a Frank Howard tape measure home run. This snapshot was taken on August 31, 2007. —*Jeffrey Saffelle*

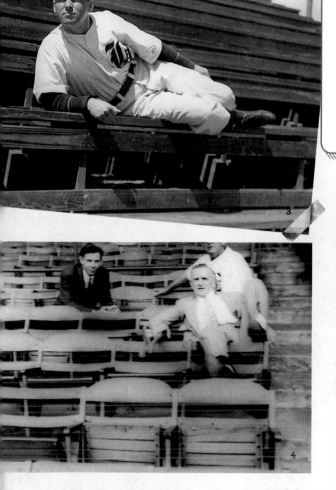

## Reds Sell Their Seats

The Cincinnati Red Stockings, organized as the first professional baseball team in 1869, didn't lose a game their inaugural season. In 1870, they lost only six of the eighty they played, but attendance declined. Talk about fair-weather fans. When the management needed to meet outstanding bills, they sold the grandstand seats to a lumberyard after the season's last game.

## Seat Location Change

Crosley Field is the only major league ballpark to be brought back to life. It was resurrected by Larry Luebbers, a Reds fan and seat collector from Union, Kentucky. When parts of Crosley were auctioned off in 1970, Luebbers went to buy two seats as souvenirs. But . . . "I got kind of carried away," he said. "Before I knew it, I had the walls and the scoreboard too."

Luebbers decided that his new Crosley treasures would fit nicely in his two-hundred-acres-plus backyard. He spent thousands of dollars clearing and leveling his property. Over a two-year period, he had the sixty-five-foot scoreboard repainted; rebuilt a sixty-foot flagpole that had cracked into three pieces; sawed the ticket office in half so it could be moved across a bridge spanning the Ohio River, and then nailed it back together.

Luebbers also liberated the old popcorn stand, the Reds locker room, the WCKY-WLW broadcast booth, a sign advertising "The New 1970 Dodge," the bat rack, and the pitching rubber. For a while, he invited local baseball teams and spectators to use the field. Fans sitting in the four hundred Crosley Field seats got to enjoy Union's Knot hole League team play there, and patrons had their names inscribed on seats for a mere $25.

**3 ★ THERE'S NO PLACE LIKE HOLMES**
Braves outfielder Tommy Holmes relaxes in the bleachers just before the gates are opened. —*Gerald Hampton*

**4 ★ BRAVES POW WOW**
Just before the gates of Braves Field opened, this snapshot was taken in 1943. That was the season that Casey Stengel was hit by a taxicab that broke his leg (note crutches to the right of Stengel). Bob Coleman, a coach with the team, stepped in and managed 46 games while Casey recovered. Coleman did such a good job he got the mangers job on a permanent basis for 1944. Seated left to right: John Quinn (Braves GM), Casey Stengel (manager), and Bob Coleman (coach / manager) —*Gerald Hampton*

# 19

# The Wit and Wisdom of the Players

## Horsehide Chatter

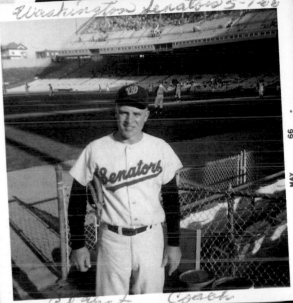

Gerald Hampton

Leo Huffman, Sr.

"Baseball is like church. Many attend but few understand."

**WES WESTRUM**

*Washington Senators 5-7-66*

*MAY 66*

*Ed Yost Coach*

"He threw me his arms, his elbows, his foot and his wrist, everything but the ball. The next thing I knew he threw the ball … to my surprise."

**EDDIE YOST**
*on facing Satchel Paige*

Gerald Hampton

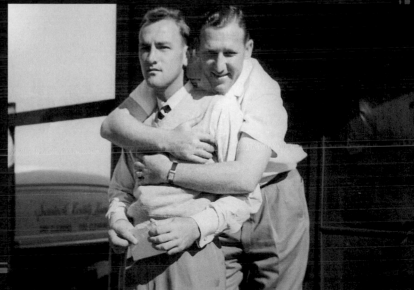

"Possibly there have been greater shortstops in the league since Honus Wagner, but it's unlikely."

*A 1940s National League write-up on*
**EDDIE MILLER**
*(right, with Jim Tobin)*

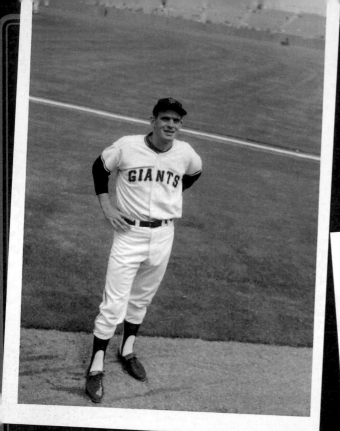
*Ted Cantor*

"The trouble with baseball is that it is not played the year round."

**GAYLORD PERRY**

*Al Prince*

*Gary Westlake*

"You gotta be a man to play baseball for a living, but you gotta have a lot of little boy in you."

**ROY CAMPANELLA**

"I just want you to know one thing. When you get to be my age, there are no routine ground balls."

**JIM FREGOSI,**
*at age thirty-five and feeling his age.*

*Leo Huffman, Sr.*

"My main aim was to win. I was more tired than nervous. All I know is that we lost. What's so historic about that? Didn't anyone else ever lose a thirteen-inning shutout?"

**HARVEY HADDIX**
*after he had pitched twelve no hits, no runs, no errors innings and then lost the game in the thirteenth inning, on May 26, 1959.*

*On why he was accused of throwing too close to batters and thereby acquired the nickname "Sal the Barber":*

"When I'm pitching I figure the plate is mine, and I don't like anyone getting too close to it."

**SAL MAGLIE**

*Craig Kellerman*

> "This is the only town where women wear insect repellent instead of perfume."

## RICHIE ASHBURN

*after playing a game in Houston for the Mets in 1962*

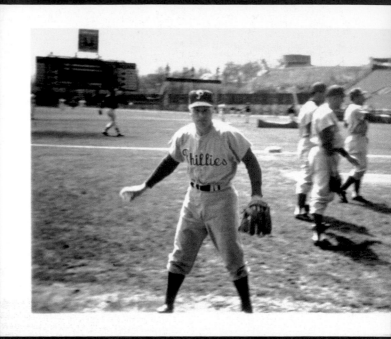

Pete Wagner

> "I'm a major league third baseman. If you want to go play in a parking lot, I'm supposed to stop the ball."

## BROOKS ROBINSON'S

*response before Game 1 of the 1970 World Series and playing on synthetic Astroturf for the first time instead of grass*

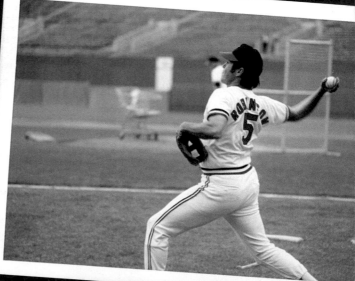

Andy Strasberg

## CASEY STENGEL

*won ten American League pennants in twelve years of managing the Yankees. After losing the World Series to the Pirates in 1960, he was fired by the Yankees for being too old to manage. When asked for his response, he said,*

"I'll never make the mistake of being seventy again."

Lew Lipset

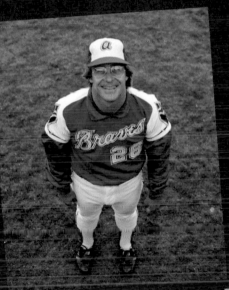

Andy Strasberg

"The next thing I remember, I'm at home plate, giving the ball to Henry. I said, 'Here it is, Hammer.' He said, 'Thanks, kid.'"

**TOM HOUSE,** *relief pitcher for the Atlanta Braves, recalls catching* **HANK AARON'S** *record-breaking 715th career homer in the bullpen.*

"The difference between the old ballplayer and the new ballplayer is the jersey. The old ballplayer cared about the name on the front. The new ballplayer cares about the name on the back."

## STEVE GARVEY

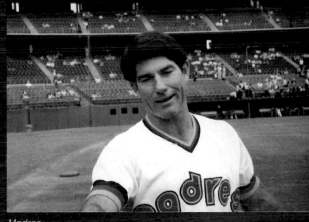

Padres

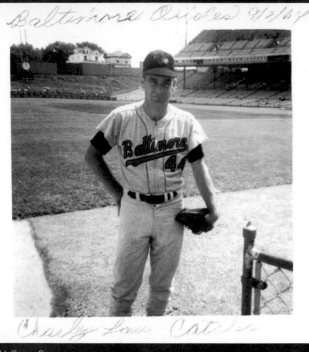

Baltimore Orioles 9/7/67

Charly Lau Catcher

eo Huffman, Sr.

"There are two theories on hitting the knuckleball. Unfortunately, neither of them works."

**CHARLEY LAU**

"Mike Ivie is a forty-million-dollar airport with a thirty-dollar control tower."

**RICK MONDAY**

"I don't even try to fool anybody. I just throw the knuckleball 85 to 90 percent of the time. You don't need variations, because the damn ball jumps around so crazily, it's like having a hundred pitches."

**HOYT WILHELM,** *in 1969*

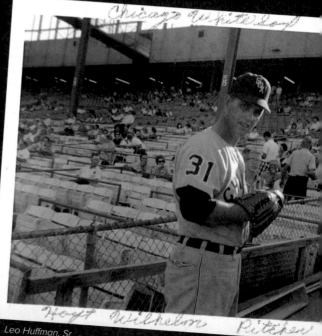

Chicago White Sox

Hoyt Wilhelm Pitcher

Leo Huffman, Sr.

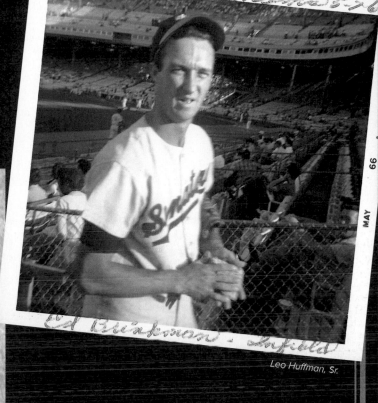

Washington Senators 5-76

MAY '66

Ed Brinkman - Infield

Leo Huffman, Sr.

*Washington Senators manager*
**SAM MELE** *complimented*
**EDDIE BRINKMAN** *once,*

"A contending club could
carry Brinkman for his glove
and not worry about his bat."

Madres

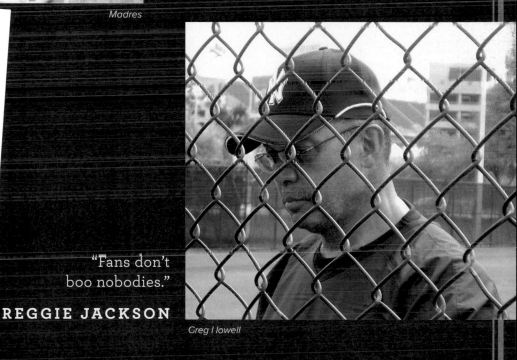

"Fans don't
boo nobodies."

**REGGIE JACKSON**

Greg Llowell

Elten Schiller

"What you lack in talent can be made up with desire, hustle, and giving 110 percent all the time."

## DON ZIMMER
*(he and his wife, Soot, were married at home plate on August 16, 1951)*

Dick Rivas

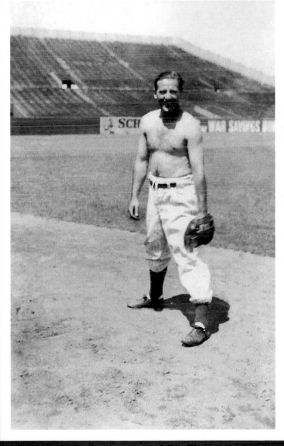

*Jason Berry*

"... and now, I welcome Dave Winfield, the greatest Yankee to enter the Hall of Fame as a Padre."

*New York* **GOVERNOR PATAKI'S** *welcome remarks at the 2001 Baseball Hall of Fame induction ceremony*

*Upon being asked by Pope Pius XII what his vocation was,* **JOE MEDWICK** *replied,*

"Your Holiness, I'm Joe Medwick. I, too, used to be a Cardinal."

"Hitting is an art, but not an exact science."

**ROD CAREW,**
*from the book* Heavy Hitters *by Bill Gutman*

"If it hadn't been for the pine tar game, then I'd only be known for hemorrhoids."

**GEORGE BRETT,**
*in* Baseball Digest, 2000, *referring to the unfortunate condition he suffered through in the 1980 playoffs*

*Gerald Hampton*

# 20 Ballparks

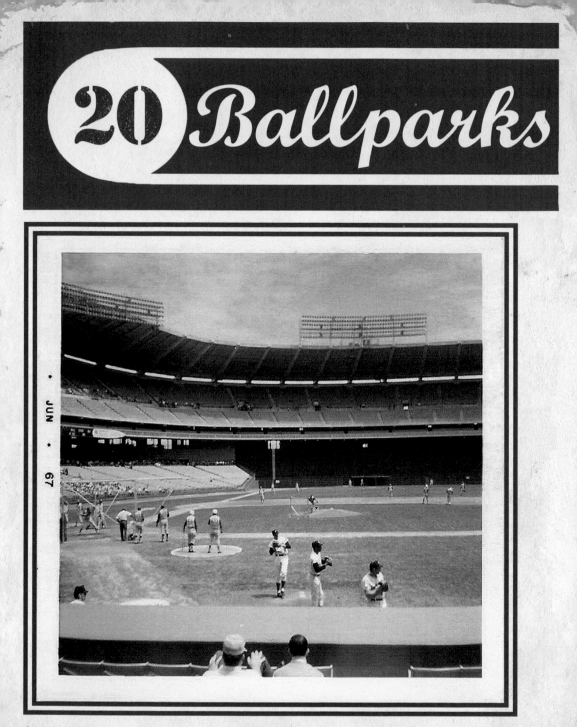

JUN • 67

★ **WAFFLE HOUSE**
DC Stadium was the original name of what would later be named Robert F. Kennedy Memorial Stadium. It was aptly described in Philip J. Lowery's book *Green Cathedrals* as looking like a waffle whose center stuck to the griddle because of its curved, dipping roof. Players in white uniforms warming up are Ken McMullen, Paul Casanova, and Ken Harrelson of the Washington Senators. *—Greg Howell*

# 50 Yards

*"The 1-1 pitch. It's swung on and driven . . . High and Deep . . . Left Field . . .*
***WAAAAY BACK! Going . . . And . . . GONE!! INTO THE UPPER DECK!! The Yellow***
***Seats of Section 533!*** *A Titanic Clout by Zimmerman! His eighth home run of the*
*year and the game is tied!"*

On June 3, 2007, Dave Jageler, radio broadcaster for the Washington Nationals,
bellowed out that call, announcing the longest home run hit by any player at Robert
F. Kennedy Memorial Stadium, at any game, since major league baseball returned to
the nation's capital after a thirty-three-year hiatus. Nats all-star Ryan Zimmerman's
blast off the San Diego Padres' David Wells reached the yellow seats, the top tier of
the circular ballpark's famous upper deck.

Opened in 1961 as District of Columbia Stadium (changed to RFK in 1969 after
the assassination of the 1968 Democratic presidential candidate), the East Capitol
Street complex was the first of the cookie-cutter ballparks, the multipurpose stadi-
ums that allowed cities with professional franchises in both baseball and football—
even soccer—to share the same facility. Unique originally to Washington, D.C. (but
later copied by the municipalities of Atlanta, St. Louis, Philadelphia, Cincinnati,
and Pittsburgh for their new ballparks) was the baseball configuration.

Since movable box seats positioned along the third base line were rotated out
to left field on gliding rails for football games, there were no bleacher seats at RFK
Stadium for baseball—just a barren wall before which sat each team's bullpen, the
scoreboard, and the home run fence. The only way any fan could catch any home
run ball at RFK Stadium was by purchasing a seat in the Upper Deck—a long, long
distance away.

The right and left field foul lines at RFK Stadium were 330 feet. Center field
measured at 410 feet, the Power Alleys at 380 feet. Considering there was a fifty-foot
wall from ground level to the Mezzanine Seats (an early version of suites), a com-
plete Outfield Lower Reserved Section (400-level), and even a walkway before the
Outfield Upper Reserved Section (500-level) situated behind all that, any home run
hit by any batter into the Upper Bowl 500-level yellow seats was a legitimate shot.
A clout of great strength and significance.

And when the Montreal Expos transferred to Washington, D.C., and became the
Washington Nationals, hundreds of players—visiting or home—tried valiantly to
accomplish the feat to reach that level during batting practice. The upper deck was
a target. A badge of honor to be gained and worn proudly if accomplished.

BY JEFFREY LYNN SAFFELLE

**1 ★ MY FRONT YARD**
I grew up in Yankee
Stadium. I knew all the
nooks and crannies
of the place that was
accessible to the public.
It was my "safe place"
and never felt big to me.
—*Andy Strasberg*

**2 ★ TWO ANGELS**
Betty Pierce & Billy
Hamlin, June 11, 1977,
on their way to see
the Angels play the
Indians. The site of the
ballpark was at one time
four farms; 39 acres of
orange and eucalyptus
trees, 70 acres of alfalfa,
and 39 acres of corn.
—*Madres*

In the three years the Nats called RFK their home before moving to Nationals Park in 2008, sluggers like Albert Pujols, Barry Bonds, Mike Piazza, Carlos Lee, Ryan Howard, and Andruw Jones were just a few of the many major leaguers who all sat back on their heels during BP to swing away at the distant target. Some were successful in reaching the mark, though very few did so during an actual game.

Why?

RFK Stadium was considered a "Pitcher's Park" in the late 2000s. A place were home runs came to die. Time after time, game after game, for three seasons, big league hitters complained about how difficult it was to hit one out there. The Old Ballyard on East Capitol Street was not built like the newer hitter-friendly parks of today with smaller dimensions. That's why Zimmerman's blast off Wells in 2007 was so memorable.

Yet back in the 1960s and early 1970s, when the Washington Senators played their home games there, when baseball was a different game, when starting pitchers many times went the distance and not just five innings to get the "quality start," when there were few "closers" and not one "designated hitter," RFK Stadium was considered a Hitter's Park. "Very fair," as recalled by their legendary slugger, Frank Howard. "Hondo" played seven seasons in the nation's capital. Twice, this six-foot-seven, 275-pound jovial giant of a man led the American League in home runs. Once, the "Capital Punisher" led the Junior Circuit in strikeouts.

Wearing a Senators uniform, this "all or nothing" slugger socked out 237 home runs. One hundred and sixteen of those shots were at RFK Stadium, twenty-four of which made the upper deck seats. And three of those were confirmed as actually landing in the yellow seats of the 500-level—blasts that were so renowned for their distances hit and for Howard's feared power that the District of Columbia Stadium Authority painted white the actual yellow seats where Hondo's launched baseballs came down from orbit in RFK's Upper Bowl: Section 535, Row 5, Seat 17; Section 538, Row 4, Seat 19; and Section 542, Row 3, Seat 3.

A tribute to a Herculean feat repeated at least three times by a former star player with prodigious strength, from a long gone team, in a different era, who still calls the Washington, D.C., area his home. A man who wasn't swinging from his heels. An accomplishment today's players and fans still look back on in awe. Admiration that Frank Howard never feels he's worthy or comfortable of receiving.

Now retired after fifty years in professional baseball, and living in Northern Virginia, Frank Howard works the speaking engagement circuit and grants one-on-one interviews telling stories of his five decades of experience in the game. That's how I reconnected with My Favorite Player of All Time when, in 2007, Hondo invited me over to his home to chat about his long career in the game. What I learned right away was that everybody else was always a better player—according to Big Frank. "I just came out there to win and do my best every single day," stated Frank.

If you listened to Howard and didn't know much about his excellent big league career, you might never gather he was a four-time all-star, hit 382 lifetime homers, and was the 1960 National League Rookie of the Year for the Los Angeles Dodgers. Every tale he tells is self-deprecating. Every story spins the joke back on him, few better then how Frank Howard recalls those white painted seats on East Capitol Street.

Question: "Looking back, how honored are you to still have people ask you about those upper deck home runs at RFK Stadium?"

Frank Howard: "Well, it's nice, but let me tell you. All those white seats represent my home runs. All those yellow seats represent my many strikeouts!!"

That's funny and that's how Frank Howard always recalls his days in baseball playing at RFK Stadium. Even upon being complimented, "Hondo" will never take credit for completing a task so few others accomplished. A feat he managed three times, officially—home runs to the upper deck seats at RFK Stadium that always thrilled players and fans and broadcasters alike.

*"Here's the 3-1 to Ward . . . Swing . . . and a **DRIVE TO DEEP RIGHT FIELD!! DOWN THE LINE . . . HOOKING . . . TOWARD THE CORNER . . . AND THIS ONE IS GOOOOONE!! GOOD-BYE . . . AN UPPER DECK SHOT FOR DARYLE WARD!!** Daryle Ward with a tremendous pinch-hit home run that adds an insurance run for the Nationals. It's Washington 3 and Houston 1 . . . Ward's third home run of the year . . . **A TITANIC BLAST** down the right field line landing near seating Section 550. The Yellow Seats!!"*

Washington Nationals broadcaster Charlie Slowes's radio call of Daryle Ward's May 23, 2006, "Moon Shot" at RFK Stadium against Russ Springer of the Houston Astros. A now extinguised era of baseball in the nation's capital where every single baseball hit into the yellow seats needed to be cherished forever.

**3 ★ YOU'RE IN THE NEIGHBORHOOD**
Wrigley Field is the only remaining Federal League ballpark. The last time a World Series Champions flag flew over it was . . . never. The last time the Cubs won the World Series was in 1908 and they played in the West Side Grounds, which was also known as West Side Park. —*Tom Larwin*

**4 ★ THE CORNER**
Tiger Stadium was known as Navin Field from 1912–1937, Briggs Stadium 1938–1960 and Tiger Stadium 1961–1999. The ballpark's nickname was "The Corner," because that's where Michigan Avenue and Trumbull Avenue meet. One of the last purposes of the ballpark was to stand in for Yankee Stadium in 2000 for the HBO movie *61*\*.
—*Thomas Hagerty*

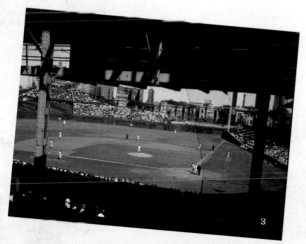

"Ballparks have their own distinctive smells—stockyards (extinct Phoenix ballpark), meat packing plant and sulphur springs (extinct Sulphur Dell ballpark in Nashville), scent of plumeria and pikake on the trade winds (extinct Honolulu Stadium), rain (see Phoenix, Nashville, and Honolulu). Vaseline; ammonia water; Cramer's Atomic Balm analgesic ointment, a spicy cinnamonlike smell—I wonder whether some players became hooked on this odor (superstitious player who won't let the clubhouse man wash his sweatshirt)."

— DAVE BALDWIN —

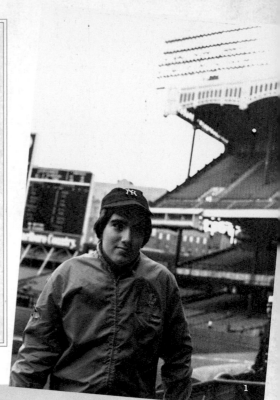

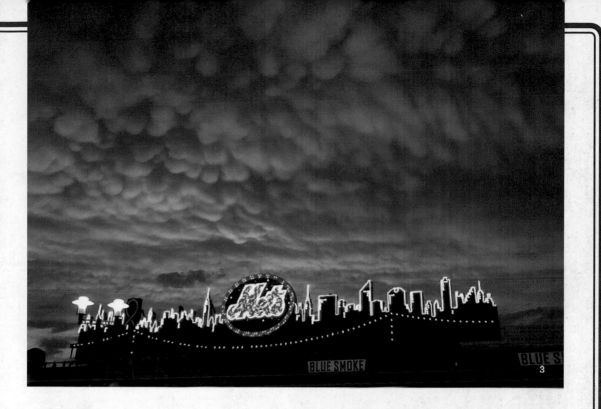

**1 ★ COUNTOWN**
This is exactly what it looks like—my dad's best attempt to get a photo of me, In a "Yankee Uniform" for a baseball card, on a rainy night, in a desperate effort to get it done before the old place closed in 1973, and evidently just before puberty took full effect. —*Keith Olbermann*

**2 ★ BETTER RED**
The Cincinnati Riverfront Stadium scoreboard in deep center field acknowledges a triple play. —*Peter Nunez*

**3 ★ TRULY AMAZIN'**
Aside from family, I cherish two things in life, the New York Mets and a beautiful sunset. As the threat of a hurricane approached Citi Field on the evening of June 26, 2009, I was left awe-struck when my two passions collided to present the most amazing skyline I had ever witnessed. —*Charlie Cipriano*

**4 ★ A REAL SPORT**
Sportsman's Park was the home of the St. Louis Browns from 1909–1953. It was the site of the only at bat for the smallest player (3 feet, 7 inches tall) Eddie Gaedel to appear in a major league baseball game. On August 19, 1951, Gaedel walked on four pitches thrown by Bob Cain. This snapshot was from the Browns vs. the Yankees game on June 7, 1941. —*Steve Falletti*

> "Baseball smells? At old Comiskey it was mold, must, and stinky-stanky stuff, and at Fenway, the smell of exterminator fumes when coming back from a road trip."

— CARLTON FISK —

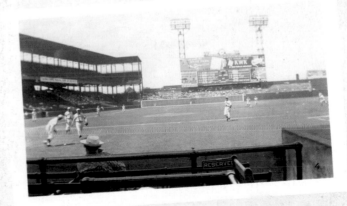

# Infield Nuptials

In my early years of dating, it was often a dilemma to figure out the best place and situation for a first date. Taking the analytical approach, I concluded that movies, while providing a measure of safety from awkward conversation, did not provide an atmosphere to determine if my date had a winsome personality and could piece together a real conversation. I also determined that going to dinner was a potential hazard, and so the chance of us having a *Lady and the Tramp* scene with a strand of spaghetti was fairly remote. And besides, eating with someone else watching me, as I suspected would occur, made me extra nervous, and my stomach would indubitably rebel. The social genius in me concluded I should go someplace safe, where I knew the environment and the activity, a place I could be a charming conversationalist with my vast knowledge of the subject. The only logical place for me was the ballpark. Unfortunately, my logic was not always shared by the persons I sought to entertain.

Upon arriving in California, I began working in a camera store in Cerritos. When I asked a coworker out to a California Angels game at the Big A, her unequivocal no was more than just deflating. She added that she did not like baseball because it was too boring. That inauspicious beginning did not deter me, and I compromised my principles and we instead saw a movie at the drive-in. What the heck, a girl I asked out was not expected to know how many stitches are in a baseball, or what is the meaning of a frozen rope, what position Harry Steinfeldt played, or how to calculate an earned run average for a pitcher. But not liking baseball and telling me it was boring could have spelled instant doom to any long-term rapport. Three years later, following my second season with the Padres, on a beautiful Indian Summer afternoon, the girl for whom baseball was boring, Patti Hampson, and I were married by Judge Leland Nielsen at home plate in San Diego Stadium.

"When I was twelve or thirteen years old, back in 1956 and 1957, I remember the smell coming from the coffee plant located only a few blocks from Buff Stadium in Houston. My uncles who lived nearby would take me to see the games of the Double-A Houston Buffs. I had really never thought about that smell until Opening Day in April 2000 at Enron Field (now Minute Maid Park). That same smell wafted through the ballpark and I realized that forty-five years later, the Astros were playing only about one mile west of that same coffee plant (I believe it is now Maxwell House). It brought back very positive memories of the first professional games I attended."

**MILTON JAMAIL,**
*baseball writer*

## Baseball Players' Favorite Ballparks

| PLAYER | FAVORITE |
|---|---|
| Aramis Ramirez | Wrigley, Chase/Minute Maid |
| Steve Carlton | Dodger Stadium |
| Larry Doby | Griffith Stadium |
| Billy Williams | Dodger Stadium |
| Bob Feller | Comiskey Park |
| Jay Bell | Busch Stadium/Wrigley |
| Brian McRae | Camden Yards |
| Nate McLouth | PNC |
| John Lackey | Yankee Stadium/Safeco |
| Nick Swisher | Fenway/U.S. Cellular |
| Hunter Pence | Minute Maid |
| Cole Hamels | Wrigley/Fenway/Citizens |
| Justin Morneau | Fenway/Chase |
| Johnny Estrada | Dodger/Coors |
| Scott Kazmir | Fenway/Yankee |
| Brian McCann | Fenway/Yankee |
| Roy Oswalt | Wrigley/Turner |
| Carl Crawford | Yankee/Camden |

**1 ★ I DO, I DO**
Andy Strasberg and Patti Hampson are married at home plate at San Diego Stadium on Oct. 9, 1976.
—Roberta Collins

**2 ★ TWISTED**
Connie Mack managed the Phillies from 1901 to 1950. The ballpark was named Connie Mack Stadium in his honor (1953–1976). Prior to that, it was called Shibe Park (1909–1953).
—Bill Klink

**3 ★ FUNGO**
It was 1971 and my college buddy Dave Wright and I got into Connie Mack Stadium after the Phillies moved over to the Vet. We found a stick and a rubber ball. I challenged Dave to Fungo one into the RF stands. He did.
—Andy Strasberg

# First Impression

My father was an incredible and knowledgeable baseball fan. He loved to brag to me that at one time he worked as a security guard for the New York Giants at the Polo Grounds. He took me to my first baseball game at the Polo Grounds in 1957, and it was life changing, but I didn't know it at the time. I remember walking through the streets of Harlem and arriving in front of a big building. My dad went up to the ticket window and came back with our tickets in hand. I remember walking through a dark runway under the stands and then coming out to a wide open ballpark with a field of green green grass. I have never been able to describe the color of the grass that day with only one green. I was also affected by the smells at my first baseball game. It was an interesting odor combination of beer, cigar smoke, hot dogs, and cut grass. That smell will never be duplicated again because fans can't smoke in ballparks anymore.

I remember how visually striking the contrast was of the New York Giants wearing the whitest uniforms against the green grass. The Giants played against the Phillies, whose gray uniforms had oversize red numbers on the back. Robin Roberts pitched for the Phillies, and I think the reason I remember his name was the way it sounded—Robin Roberts.

The highlight of the game didn't happen on the field. It took place in the third inning when my dad left me alone sitting in the upper deck behind home plate. I was sure that he was going to buy me a souvenir. A few minutes later he's waving at me from the bottom of the section. He wants me to come down from where we were sitting. I'm thinking, We're going home? How could that be? The game was only in the fourth inning. When I reached my dad, he took my hand and walked down the ramps behind the seats to a couple of box seats just past first base on the field level. He "tipped" the usher and that was it. We were now about twenty feet from the field. My heart was pounding. I couldn't believe that we were this close. The sounds were different sitting there. They probably weren't, but they sounded louder. I remember that all my senses were in overload—sight, sound, the taste of the hot dog, and it was there that the smell of grass entered into the olfactory equation. Whoa.

Baseball prides itself on its consistent rules. In every ballpark, it's ninety feet between the bases and each team has only three outs to score runs. But every field has its own personality and each ballpark has its own ground rules. Prior to each game, when the managers give lineup cards to the umpires, the specific ground rules are reviewed and explained. This process of explanation gets shorter and shorter as the teams are familiar with the specifics, but the rules are printed on the reverse side of each lineup card.

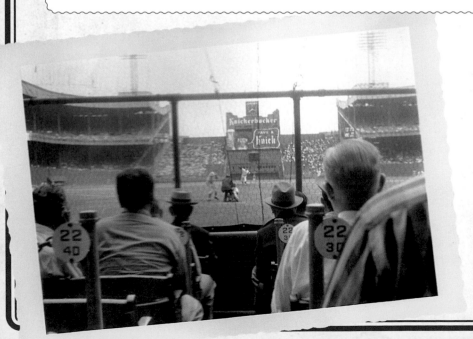

★ NO POLO
Legend has it that the only sport not played at the Polo Grounds was polo. It was the home park for the Giants, Yankees, and Mets and in its time, it was the only ballpark that you could sit in (home plate upper deck) and see another ballpark— Yankee Stadium.
—Lew Lipset

> "Candlestick Park in San Francisco was built on the water. It should have been built under the water."

## —ROGER MARIS

> "You know it's summertime at Candlestick when the fog rolls in, the wind kicks up, and you see the center fielder slicing open a caribou to survive the ninth inning."

## —BOB SARLATTE

## The Sweet, Sweet Smell of Home (Plate)

Every ballpark has its own smell. There are some basic ingredients, but the smell recipe for the stands, dugout, bullpen, and clubhouse are unwritten secrets kept by team officials and handed down from one generation to another.

Springtime is a great season for smelling memories. Baseball—from Little League to major leagues—is built on the remembrance of things past. Perhaps the most tradition-minded of sports, baseball relies on nostalgic odors to stir fans and players year after year.

APR 1960

4/12/60

★ **WEATHER OR NOT**
I attended the 1960 Giants opener at Candlestick Park with my best friend, my dad, and my mom who took the snapshot. It was a perfect day. The ballpark got its name after the long-billed curlew candlestick bird that had trouble catching flies. (I made up the catching flies part but it would make sense based on all the misjudged flies at the ballpark.)
—Bill Klink

"It was 1976, '77, or '78 and I was scheduled to pitch on Saturday so I asked Elrod Hendricks to meet me at Fenway so I could do my throwing. It was Thursday and no game scheduled. I was stretching in right center field at around 3:15 P.M. in late August where the air was crisp and clean. No one was in the ballpark and as I looked out towards the 'Green Monster,' I really smelled Fenway. It's different when the fans are not there and they aren't cooking hot dogs, or drinking beer. It's an antiseptic pure baseball smell that you can't find or experience anywhere. The conditions have to be ideal. The smell is overwhelming and memorable to this day."

—JIM PALMER—

"There it sat, in kind of a dilapidated neighborhood, like a jewel. It was sort of an oasis. You'd walk up through the portals to the seats. The sight of that bright-green grass would hit you, and you'd think you'd walked into another world."

**—PAUL SOMMERKAMP,—**

*Crosley Field public address announcer*

**1 ★ A MISTAKE**
Cleveland Municipal Stadium was lovingly known as "The Mistake by the Lake" because of the wind and chill from Lake Erie. —*Tom Larwin*

**2 ★ STREETBALL**
The Kingdome was the home of the Mariners and the site of the 1979 All-Star Game. After opening in 1977, the best stat considered by many is that this ballpark was imploded on March 26, 2000. —*Peter Nunez*

**3 ★ PAINTING THE CORNERS**
Braves Field is perhaps best known for the April 16, 1946, home opener when 5,000 fans left the ballpark because green paint got on their clothing as a result of the freshly painted seats from that morning, which had not dried. The Braves beat the Dodgers, 5–3, behind Johnny Sain who pitched all nine innings. —*Don McNeish*

"My boyhood memory of baseball smells is the smell of exhaust from idling cars as I made my way through the parking lot to the far reaches of the Dodgers left field pavilion seats."

**GEORGE LOPEZ,** *comedian*

> "Wrigley Field was my favorite because the stadium dimensions suited my style of hitting, and that was one of the reasons why I had a high average for so long in my career."

## AL OLIVER

> "Other than home games at Yankee Stadium, I loved to play at the old ballpark in Detroit because they had a dark green background and I could see the ball well there. I could also reach the left field seats in Detroit!"

## BOBBY RICHARDSON

**1 ★ CONNIE MACK WAS FIRED!**
After the Phillies left Connie Mack Stadium, the upper deck behind home plate caught fire and all that remained was twisted steel.
—*Bill Klink*

**2 ★ HOLEY BAT, MAN**
The oversize Babe Ruth bat standing next to Yankee Stadium was where it seemed like everyone met before the game.
—*Tom Larwin*

**3 ★ HIGH CEILING**
The baseball term "High Ceiling" took on a different meaning once the Astros started playing in the Astrodome.
—*Andy Strasberg*

**4 ★ SOLO**
Stayler Hernandez stands alone in center field during a Tuesday afternoon game between Sancti Spíritus and Havana Industriales, Feb 16, 2010. —*Geoff Silver*

"Crosley Field was the best. It was nice and thick and soft and cushiony, the best place I ever played in my life. When you walked out onto that field, you were in high cotton."

— JIM GREENGRASS —

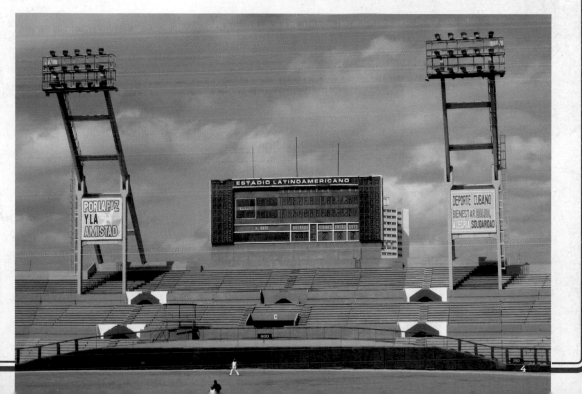

# 21 Baseball Cards

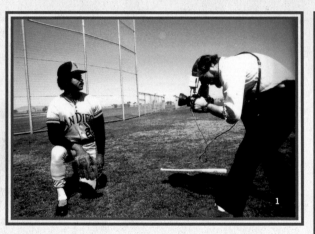

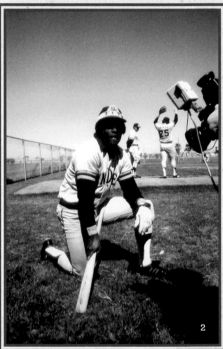

**1 ★ SMILE**
Not every photo taken by a Topps photographer becomes a baseball card. Here's Bobby Tolan kneeling for his close-up. —*Andy Strasberg*

**2 ★ DON'T KID ME**
Prior to joining the Padres, Tito Fuentes played for the Giants, and after a near beaning was quoted as saying, "They shouldn't throw at me. I'm the father of five or six kids." —*Andy Strasberg*

# Topps in the Field

Since 1886 baseball cards have been a part of the baseball picture. The first ones were actually photographs of players taken in studios and then inserted into tobacco products. The posed action shots usually consisted of a player appearing to slide into a base, but in actuality the guys were stationary on a rug. The other favorite pose was of a player attempting to catch a fly ball ... which really wasn't in motion, but suspended on a string.

Over the years baseball cards have come in many different sizes and formats, including photographs and artists' paintings, but they've always been included as a premium with a wide variety of products. It wasn't until the mid 1950s that the size of a card was standardized and that reproduced photos were used consistently (and a stick of questionable bubble gum was included—and eventually dropped in 1992).

When a player's image finally appears on a baseball card, he knows that he's arrived in the big leagues. It's the confirmation of making it because practically every major leaguer has, as a young boy, purchased baseball cards with the hopes of someday having his picture on that ubiquitous piece of two-by-three-inch cardboard. I had the good fortune of helping to realize the dreams of many players, when for twenty-three years I was the official Topps baseball card company photographer.

My "Fantography" journey began in 1950 when I was twelve, after the local baseball cards of the Pacific Coast League's Oakland Oaks stopped being issued. My neighborhood friend Dick Dobbins and I decided we should go to the ballpark with our cameras and make our own "picture cards" of the PCL players. We'd go to the first game of each series, shoot our photographs of the players, and then take them to Low Cost Drugs in Berkeley, where they would develop and print them for us. Eventually, we'd return to the ballpark and get the photos autographed. It was great fun, and the players got to know us. Also, that summer I was given a subscription to *Sport* magazine for my birthday. I loved all the full-page color pictures of athletes and took note of the name of the photographer whose baseball pictures I liked the most. His name was Ozzie Sweet. I was entranced with how beautiful and clean his pictures were, and for years I collected and cut them out. They covered one wall of my bedroom—floor to ceiling—wall to wall. (I had a very understanding mother.)

BY DOUG McWILLIAMS

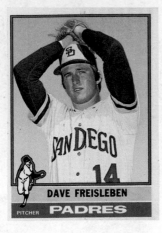

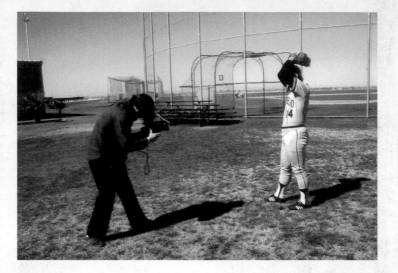

★ **SHOOT THE SHOOTER**
Topps photographer Doug McWilliams shoots Padres' pitcher Dave Freisleben in Yuma, Arizona, in 1975 for his baseball card. I shot him the moment he shot Dave and here's his baseball card and that photo. —*Andy Strasberg*

By 1954, my photography skills were, excuse the pun, "developing." I was getting some pretty good images, and a few of the players asked to purchase copies of their photos. *Sports Illustrated* had just begun, and I thought that being a sports photographer, like Ozzie Sweet, might be an interesting career. In 1955 I started college in the journalism department at the University of Kansas, but eventually I talked my dad into letting me transfer to the Brooks Institute of Photography in Santa Barbara, California. During the 1960s, I graduated from school, got married, was drafted, joined the Army National Guard, had children, and worked at three jobs in photography in Los Angeles, Oakland, and then back home in Berkeley, at the University of California. I was very happy and very busy.

In 1968, the Kansas City A's moved to Oakland, and one fateful day in 1969 I went to a "picture day" at the Coliseum. It was fun and reminded me of those earlier days at the Oaks ballpark with my childhood friend Dick. Once again, I was reeled in by baseball. And just like when I was a kid, I started regularly taking pictures of the players from the stands. One of the players with the A's was a pitcher whom I had photographed back in 1956 when he was with the Pacific Coast League's San Diego Padres. His name was Jim "Mudcat" Grant, and he remembered me even though fourteen seasons had passed. In September of that year, the A's called up a youngster who stayed with Mudcat at his apartment to play for that last month of the season. He wanted some pictures to give to his family back in Louisiana, and Grant recommended me. The nineteen-year-old rookie was Vida Blue. Then not much later, Mudcat was traded away to Pittsburgh but surprisingly reacquired by the A's the next year. The club asked him to have new PR photos done by their team photographer, but he refused, saying that only Doug McWilliams was going to do his pictures! They of course said, "Who?" but I was given a day photo pass and took Grant's pictures. I then asked how I could obtain a photo pass to shoot players and games in the future, and they told me I had to "publish." I asked how could I publish if I couldn't shoot? Around and around we went . . . until Vida Blue surfaced once more in my life.

In 1971, the baseball world belonged to Vida Blue, who was on his way to win the Cy Young and MVP awards. His popularity exceeded the sports pages as he quickly

became the cover boy of a lot of major magazines. Vida came to me and asked if I would create some postcards for him to send out to his fans. I asked if he'd need a hundred or two, and he said, "No, I need *thousands*. I'm getting over a hundred letters a day asking for autographed pictures." Eventually sixteen thousand postcards of Vida Blue went out all over America with my name and address printed down the center on the back of the card. Needless to say, things changed for me.

A friend I traded baseball cards with, Bill Haber, lived in Staten Island, New York. He worked writing the back copy for Topps baseball cards. He took the Vida Blue postcard I had shot and showed it to his boss, Sy Berger. Sy has been known as the father of modern baseball cards, having worked at Topps since the early 1950s. He liked my work and decided to give me a tryout at the Arizona spring training sites. It was 1972, and the Oakland A's were coming together as one of the major franchises of the seventies. I was in a good place. I passed my audition "photographically," and I was with Topps for twenty-three seasons.

My work with Major League Baseball was wonderful, and I made many lasting friendships. On the days I didn't work for Topps, I worked for myself and for the players personally. I did their weddings, their kids' bar mitzvahs, family group shots, as well as images of the players in their uniforms as they changed from team to team.

During spring training, life as a photographer could be hectic. I had to take the same five posed images of everyone in camp: players, managers, and coaches. That generally meant about sixty people to shoot. A few years, some teams had up to a hundred people that I had to photograph in a single day. It was also my responsibility to identify all the players that I photographed, and I did a pretty good job, but it wasn't easy, since everything happened so fast.

In the summer of 2010, the National Baseball Hall of Fame accepted my life's work in baseball photography, both amateur and professional—a total of more than twenty thousand images. It represents minor leaguers (1951 through 1957 and the mid seventies) and major leaguers (1969 to the present), but I still shoot, sometimes even from the stands. It's in my blood. I love baseball and I love photography. It's a double-play combination that has provided a lifetime of enjoyment.

★ SHOOT THE SHOOTER II
As Padres' third baseman Dave Roberts poses for Doug McWilliams. I also took a photo, but from a different perspective.
—Andy Strasberg

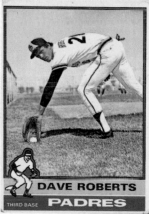

DAVE ROBERTS
THIRD BASE  **PADRES**

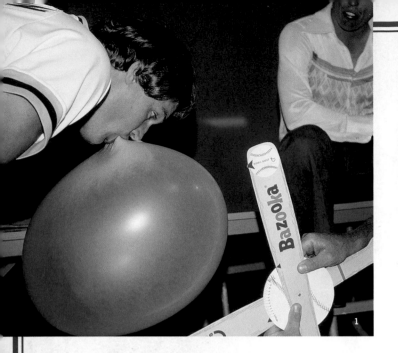

# The Legend of the Missing Maury Wills Card

Long ago, the general practice at the Topps Baseball Card Company was to have minor league players sign contracts giving the company exclusive rights to reproducing the player's image on a card once they made the major leagues. Topps officials would give the minor leaguer a $5 check to seal the deal. These checks became known as "steak money" because the fee would pretty much cover the cost of dinner. Rather than sign every minor league player, Topps asked the teams' scouts which players had the best chance to make the big leagues. The scouting reports on Maury Wills, who spent nine years in the minors, were not strong. Therefore, Topps didn't offer him a contract.

Wills not only made it to the big leagues, in 1959, he made it in a big way. In 1962 he broke Ty Cobb's single season stolen base record of 96, setting the new record at 104. Wills was a baseball celebrity, and every kid went looking for a prized Maury Wills baseball card. But in the Topps 1962 set of baseball cards, Maury Wills was missing. Realizing that Topps was unable to take advantage of Wills's popularity, a competing baseball card company did. Wills signed a contract with the Fleer Baseball Card Company. Fleer, which had produced a set of Ted Williams cards in 1959, decided in 1963 to build a set of cards around Wills. Instead of selling packs of cards with pink slabs of bubble gum, cookies were inserted into the packs. The set consisted of sixty-six cards, but card number 43 of Maury Wills spurred sales. It was the only card produced that season of baseball's new stolen base king.

**1 ★ BY GUM**
In 1975, the Topps Bubble Gum company had a contest among the players as to who could blow the biggest bubble. An unidentified Padres player is blowing a bubble while Padres coach Whitey Wietelmann measures it. The National League champ that year was Johnny Oates and the American League champ was Kurt Bevacqua. Bevacqua then beat Oates for the title as the MLB best bubble gum bubble blower.
—Andy Strasberg

**2 ★ UP CLOSE**
Jorge Bell is all smiles while a photographer takes his photo during spring training.
—Larry Carpa

## Picture Perfect Error Cards

Baseball card companies have made a few errors. These are a few of the most interesting photo mishaps:

*Topps*

**1956 #31** The picture of "Hank Aaron" sliding into home plate is actually Willie Mays.

**1957 #20** Hank Aaron is shown batting left-handed because the negative was reversed.

**1959 #440** Lew Burdette posed wearing his glove on the wrong hand and his first name is misspelled.

**1961 #332** The photo of "Dutch Dotterer" is really his brother Tommy, a minor leaguer.

**1964 #279** Shortstop Joe Koppe has his glove on the wrong hand.

**1966 #586** Claude Raymond's zipper appears to be open.

**1969 #209** Larry Haney appears to be a left-handed catcher because the negative was reversed.

**1969 #465** Tommy John is in the follow-through position, but the ball is still in his glove.

**1969 #653** The photo of "Aurelio Rodriguez" is really of the Angels' bat boy.

**1970 #282** Steve Huntz is shown with a batting glove on his throwing hand.

*Fleer*

**1989 #616** Billy Ripken's bat knob has "F**k Face" written on it.

"I know when my career was over. In 1965, my baseball card came out with no picture."

— BOB UECKER

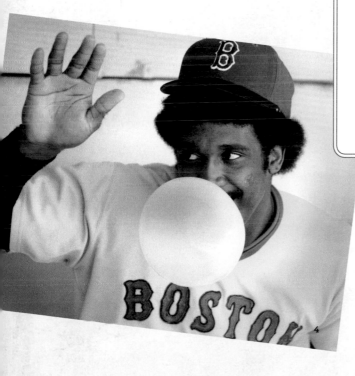

**3 ★ CARDBOARD SIGN**
Phillies pitcher Cole Hamels participates in the 100-year-old ritual of autographing his baseball card for an admirer. —*Andy Strasberg*

**4 ★ RICE BUBBLE**
Boston Red Sox outfielder Jim Rice blows a bubble for the fun of it in 1976. —*Andy Strasberg*

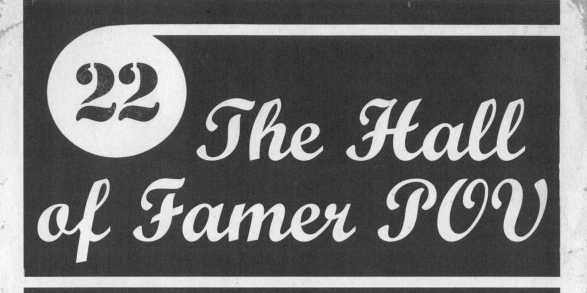

# 22 The Hall of Famer POV

Larry Carpa

Andy Strasberg

★ In 2002, my one final back flip in front of the Hall of Fame.

★ While playing golf

# World of "Ah's"

I am flattered that over the years I have been recognized by baseball fans. I get a kick out of elderly ladies who come up to me waving their finger and saying, "I know who you are. You are that baseball player who does flips on the field."

I also enjoy those people who recognize me but are not able to connect the name with the face. "Hey, there's Ozzy Osborne." Or "Aren't you Ozzie Davis?" And the most asked question by far is "Can I get your autograph?" The second most question asked: "Can you still do a flip?"

I consider it an honor and a privilege that I am recognized and asked for an autograph. Growing up, I idolized Roberto Clemente and never had the opportunity to meet him, but for me the ideal keepsake of meeting a player is having a picture taken with him. Think about how many autographs have been signed by players and the similarities of each one. But a picture is very personal. It has no value to anyone other than the person who takes it. A picture states that for this moment in time I was with my favorite player . . . and this is the proof.

As a result of having my picture taken by and with fans, I have a collection of "Can I have my picture taken with you?" mishaps. The mishaps are very similar. The fan asks someone who is not familiar with the camera to shoot the picture and usually points out that all the person has to do is "press here," pointing to a button on the top or the side of the camera. More often than not, nothing happens. And/or most of those times, the flash never works, and the fan asks me apologetically if we can try it again. And once again, the button doesn't work or the flash doesn't go off. So what would normally take a few seconds turns into what feels like an eternity for the fan, the other fans, and the player. The stall tactic excuse is "It worked before." I'm old enough to remember that the solution used to be someone suggesting, "You have to advance the film," but those days are gone. In fact now with cell phone cameras, the photo opportunities have increased to the point that no matter where I am there is always a chance that someone will ask for a photo.

In 1997, the year after my retirement, I attended World Series Game 3 in Cleveland and sat with National League president Len Coleman. It was cold and the game was a slugfest, with the Marlins winning, 14–11. The game took over four hours to play. During that time, I had been drinking a lot of coffee to keep warm, and by the eighth inning I had to go to the bathroom. It is in these situations that being recognized is not necessarily a good thing. I was wearing a fedora hat and had it pulled down low with my overcoat collar up when I arrived at the bathroom entrance, where there was a line waiting to get in. Like everyone else, I waited, and when I was about to enter the bathroom, someone noticed me and started the line of men chanting "Ozzie, Ozzie, Ozzie." This continued as I approached the urinal, and it exploded into applause once I was finished and turned to leave. But one fan with a booming voice asked, "Hey, Wizard, can you still do a flip?" My response was loud enough for all my bathroom brethren to hear: "Not intentionally." And as I left, I thought how lucky I was that nobody asked to have their picture taken with me.

BY OZZIE SMITH

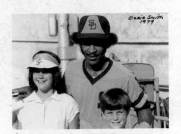
★ Me with Laurie and Tom Larwin Jr.

★ 1980 Padres Welcome Back Lunch

★ Doubleday Field, Cooperstown, New York, close up

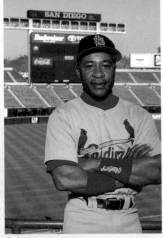
★ My last visit as an active player to Qualcomm Stadium in 1996

★ Dennis Quaid

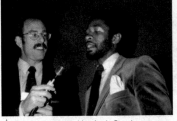
★ Being interviewed by Andy Strasberg at a Madres luncheon

★ Waldorf Astoria Hotel bookstore

★ Jeff Meredith and his son Conor

★ Spring training, Yuma, Arizona

★ Bronson Arroyo at 2006 All-Star Game

★ Tailgating with a couple of ladies (Madres)

★ NPR's Carl Kasell

★ Satellite Media Tour

★ Pittsburgh dinner, 2006

★ Warren Spahn

★ Sean J. Kinyon

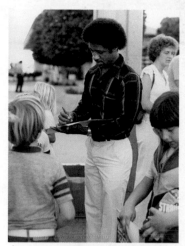
★ Signing autographs at a 1980 Padres Winter Caravan stop

★ NASCAR

★ Otesaga Hotel, Cooperstown, New York

★ Dugout with Fu-chan Fujisawa

★ Laughing interview

★ Spike Lee

★ Radio Shack, New York City

# 23

## Non-Uniform Ballpark Personnel

★ **RED HOT**
A 1976 Tiger Stadium hot dog vendor in the center field upper deck seats.
*—Thomas Haggerty*

# The Unsung Utility Players

Here's an all-star trio even many diehard fans might not recognize:

Debra Jane Sivyer
Stanley Kirk Burrell
Dale Petroskey

None of these three is listed in any baseball encyclopedia or has seen his or her name in a box score, but all worked hard to make sure that fans enjoyed their trips to the ballpark. Later, each found fame and success in other fields.

Sivyer worked as a ball girl for the Oakland A's in the 1970s. After marrying a man named Randy Fields, she changed her name to Debbi Fields. In 1977, the couple opened a few stores that sold freshly baked cookies in Palo Alto, California. You might be familiar with her as Mrs. Fields.

Stanley Kirk Burrell also worked for the A's in the 1970s. The players called this ball boy MC, for master of ceremonies, and added Hammer because he resembled Hank "The Hammer" Aaron. You might remember a little song he did called "U Can't Touch This."

Dale Petroskey wiped seats as an usher in the early 1970s at Briggs Stadium, home of the Detroit Tigers. Eventually Dale would serve as assistant White House press secretary (1985-1987) to President Ronald Reagan.

Such is the power of baseball that this sport attracts people who have very little else in common. Two examples from the world of broadcasting:

In the 1980s, the Kansas City Royals had a new ballpark, a great team, and a talented front office whose staff included a brilliant member of the promotions department, Rush Limbaugh.

And in the early 1970s, I worked at a start-up baseball card company alongside a precocious teenager. He had a photographic memory, a sharp sense of humor, fantastic writing skills, and knew everything imaginable about baseball players, current or retired. I wonder whatever happened to Keith Olbermann?

BY ANDY STRASBERG

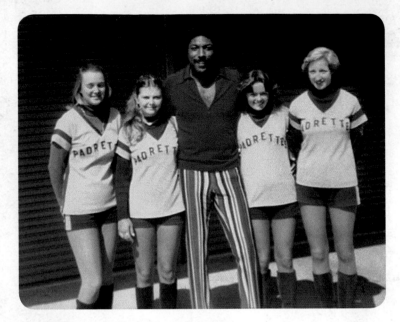

**1 ★ BIG MAC AND ALL THE TRIMMINGS**
Willie McCovey poses with the San Diego Padrettes in 1975 before a game. —*Jim Eakle*

**2 ★ FOR A RAINY DAY**
This is the Braves Field grounds crew who, like other ground crews, could make the difference in saving the field from a downpour. These guys were very good. —*Fred Williams*

**3 ★ BOSOX FRIENDS**
That's Ted Williams getting out of car at Fenway for a ball game. And the person dressed in white is Red Sox clubhouse man Johnny Orlando, who was said to have given Ted one of his nicknames, "The Kid."
—*Nick Weaver*

When I went to work for the Padres, I recognized that some of the most important people in a baseball organization are the "part-timers" who work during the games. Prior to every season, the stadium operations director would meet these game-day-only employees to discuss the team's game operation policies and procedures. As the person responsible for marketing the team, I would explain their role in the eyes of a fan.

This group sets the mood for fans attending a ball game. All it took was a smile, a friendly hello, and a helpful attitude. I would explain that we were fortunate because in San Diego we had control over the entire baseball experience (except for the final score and the weather. And our weather during the baseball season is pretty good, although I think the temperature did fall into the sixties. Once). I would explain that all fans attending the game would not have the opportunity to talk to the players, but they could chat with a parking attendant, ticket seller, ticket taker, usher, or concessionaire. As long as the hot dogs were hot and the cold beer was cold, we could enhance their Padres ball game experience.

But I realized that many of these people worked at jobs at the ballpark that I had never held. So I took advantage of my position with the team and worked their jobs for one game. I learned how to yell "PEANUTS," how to make a ticket buyer comfortable and feel like he made a great choice with bleacher seats that were the best he could afford, hauled hoses and raked the infield and applied chalk to the baselines as part of the ground crew. I got to enter the balls and strikes on the scoreboard and operate the team's third base camera. I rubbed up the shiny baseballs with secret mud for the umpires and handed out Padre replica hats on cap night. I was even the team mascot for a couple of innings and worked in the Padres gift shop. Somewhere in the recorded archives, you can even hear my voice announcing one batter on the public address system.

They were all great experiences and gave me a better appreciation for everything these part-time all-stars do to ensure that every fan has a great time at the ball game.

Ted Williams

## Ring-a-Ding-Ding

For more than one hundred years, players in spring training have said that when the bell rings they'll be ready. How did that expression originate? Long before ballpark announcers, a man in the press box pulled a cord, ringing a bell to indicate that it was time for the visiting team to take the field for practice. Two rings of the bell meant that the game was to begin.

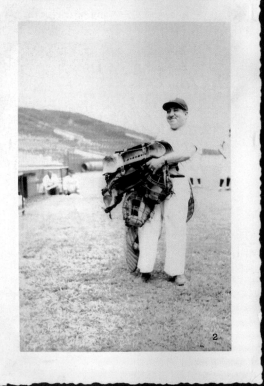

## One Good Nut

He was known as Peanut Jim Shelton, and he was as much a part of the Crosley Field experience as the Reds players. Dressed in stovepipe hat and tails, he sold roasted peanuts from his pushcart well into his nineties, having followed the Reds from Crosley Field to Riverfront Stadium in 1970.

**1 ★ INDIAN FANS CAN'T BE BEAT**

It seems like John Adams has been beating his drum in the outfield seats at Cleveland Indians' games forever. It all started in 1973. When the Indians played at Cleveland Municipal Stadium in 1972, we sat next to him for the entire game. I said, *we sat next to him for the entire game.* —Matthew Ruben

**2 ★ A YOUNG MAN**

Shorty Young was the Boston Braves clubhouse custodian who handled the equipment for the team in the 1940s. —Gerald Hampton

## Get Your Cold Beer Here

In the last few years, Major League Baseball has invited vendors from around the country's major league stadiums to the All-Star Game. Like the players, the best and most popular vendors work the game.

**3 ★ SEAT LOCATORS**
It's the 1943 Boston Braves ushers. The best in the business! —Alan Burns and Kathy Alexander

**4 ★ TAKE A STAND**
The ballpark smell of years ago included cigars and beer. Here's the 1977 Tiger Stadium concession stand where you bought those items and could also order a hot dog.
—Thomas Haggerty

**5 ★ TUBAMAN**
Jim Eakle loved the Padres and rallied the fans in the stands playing his tuba. In the 1970s, he was the unofficial Padres cheerleader.
—Elten Schiller

3

5

# Contributing
## Writer Biographies

**MARTY APPEL** has forty years of experience in communications, public relations, and writing. He has won an Emmy Award and a Gold Record, and has written award-winning books. His eighteen books include collaborations with Larry King, Bowie Kuhn, Tom Seaver, Lee MacPhail, umpire Eric Gregg, and Thurman Munson; the definitive collection of Hall of Fame biographies in *Baseball's Best*; and the award-winning biography *Slide, Kelly, Slide* about a nineteenth-century baseball star. Marty's autobiography, *Now Pitching for the Yankees*, was named best New York baseball book of 2001 by ESPN; his *Munson* was a *New York Times* best seller in 2009; and *Pinstripe Empire* (2012) is the first narrative history of the Yankees in almost seventy years.

**DR. JEFF ARNETT** is the former director of Education and Public Programs at the National Baseball Hall of Fame and Museum. He is presently the chief communications officer for a large public school district in the Chicago suburb of Barrington, Illinois.

**DAVE BALDWIN** is the only geneticist to have ever played major league baseball. From 1966 to 1973 he pitched for the Washington Senators, the Milwaukee Brewers, and the Chicago White Sox. Dave earned his PhD in genetics at the University of Arizona and is an accomplished painter. He authored the baseball book *Snake Jazz* in 2008 and writes poetry under the name DGB Featherkile.

**TALMAGE BOSTON** is a commercial litigator with the law firm of Winstead PC in Dallas. He has been named a "Super Lawyer" in *Texas Monthly* magazine every year from 2003 through 2011. Talmage authored *Baseball and the Baby Boomer* and *1939: Baseball's Tipping Point,* and is a media member of the Texas Baseball Hall of Fame.

**JEFF FIGLER** has authored over 250 published articles about sports collecting. He is a former sports columnist for the *St. Louis Post-Dispatch, STL Today,* and his articles have appeared regularly in the *Journal of Antiques and Collectibles, Collectors Journal, Autograph Magazine*, and other magazines in the collectibles field. Jeff's radio shows have been heard both nationwide and around the world.

**JEFF KATZ** is a retired Chicago options trader who relocated to Cooperstown and authored *The Kansas City A's and the Wrong Half of the Yankees.* Jeff also blogs about rock history (*Maybe Baby, or You Know That It Would Be Untrue*) and the ups and downs of raising an autistic son (*Mission of Complex*).

**DAVID KENT** is the director of the Village Library of Cooperstown and a columnist for the *Cooperstown Crier.*

**TOM LARWIN**, a professional transportation engineer, was general manager of the San Diego Metropolitan Transit Development Board (MTDB) for twenty-four

years, and was president of the San Diego Ted Williams Chapter of the Society of American Baseball Research (SABR). He has authored numerous baseball player biographies and research articles that have appeared in various publications.

**JONATHAN FRASER LIGHT** graduated magna cum laude in history from UCLA in 1978 and is a graduate of the UCLA School of Law, where he was a member of the Law Review. Jonathan has been a management-side employment attorney for thirty years and is the author of two editions of the nationally acclaimed and award-winning book *The Cultural Encyclopedia of Baseball*.

**DOUG MCWILLIAMS** was the official Topps baseball card company photographer for twenty-three years. Doug has shot more than ten thousand baseball photos, all of which he has donated to the National Baseball Hall of Fame.

**DALE PETROSKEY** served as president of the National Baseball Hall of Fame and Museum from 1999 to 2008. From 1988 to 1999 he was a senior executive with National Geographic, and from 1985 to 1987 he served as assistant White House press secretary to Ronald Reagan.

**ROGER RUHL** was the vice president of marketing for the Cincinnati Reds during the team's Big Red Machine era. In 2000, after thirteen years as vice president of the Greater Cincinnati Chamber of Commerce, he established a marketing communications consultancy.

**JEFFREY SAFFELLE**, a White House–credentialed cameraman and editor for nearly thirty years, has covered the world as a television photojournalist for virtually every major international news organization, including the BBC and Global TV-Canada. Jeffrey and his wife, **SOHNA SALLAH-SAFFELLE**, immediately embraced the Washington Nationals upon the team's transfer from Montreal to Washington, D.C., in 2005 by purchasing full season tickets. Sohna has yet to miss a single played inning since Nationals Park opened in 2008. Jeffrey and Sohna run the very successful baseball blog www.nats320.blogspot.com, covering the Nationals both on and off the field of play.

**OZZIE SMITH** played shortstop for the St. Louis Cardinals and San Diego Padres (1978–1996) and is a member of the National Baseball Hall of Fame. Ozzie is considered to be among the one hundred greatest baseball players ever. He has coauthored *The Road to Cooperstown*, *Wizard*, and *Hello Redbird!*

**STEW THORNLEY** has authored more than thirty-five books, twenty of which are award-winning books about baseball. Stew is the "go to" person for baseball player grave information and has been proclaimed the "Sultan of Cemeteries." He is also one of MLB's official scorers for Minnesota Twins home games.

**DEAN WHITNEY** is a semiretired music producer and publisher. He authored the novel *Pinch Hitter*.

**TIM WILES** is the director of research at the National Baseball Hall of Fame and Museum's library in Cooperstown, New York. He coauthored *Baseball's Greatest Hit: The Story of Take Me Out to the Ball Game* and *Line Drives: 100 Contemporary Baseball Poems*.

**ANDY YOUNG** is an English teacher at Kennebunk High School, in Maine. He spent fourteen years as a radio play-by-play announcer in minor league baseball, and currently writes a column for a small newspaper in southern Maine.

# Author Biography

**ANDY STRASBERG** takes pride in the fact that the July 17, 1948, diary entry of his father, Sidney Strasberg, noted the unthinkable departure of Leo Durocher from the Brooklyn Dodgers to helm the rival Giants. The concluding line of that entry also succinctly observed, "My son, Andrew, was born today." Andy grew up in the shadow of Yankee Stadium and spent most of his formative years waiting for the ballpark gates to open. The national pastime became his lifeblood, and he was indelibly imprinted when he had the good fortune of attending Ted Williams Baseball Camp at the age of fourteen and making the camp's All-Star team. Andy's transition from fan to baseball professional occurred when he was hired by the front office of the San Diego Padres, where he served for twenty-two years between 1975 and 1996. Shortly after leaving the Padres, Andy established his own consulting firm, All-Star Corporate Marketing Enterprises (ACME), offering a wide array of services, including strategic planning, problem solving, corporate development, and identity branding. His clientele is diverse, encompassing the baseball profession, as well as individuals and entities outside the sports world. Andy has been privileged to provide professional assistance to five members of the Baseball Hall of Fame, a baseball broadcasting legend, and even a chicken. He consulted for Billy Crystal's HBO movie *61\**, staged a baseball exhibit at the Lincoln Center Library for the Performing Arts, and proposed the issuance of, and then consulted on, the 2008 U.S. Post Office stamp for "Take Me Out to the Ball Game." Andy is the coauthor of the book *Baseball's Greatest Hit: The Story of Take Me Out to the Ball Game*, and the poignant first-person account of his close personal relationship with Roger Maris, which began as a boyhood devotion, is featured in *Chicken Soup for the Baseball Fan's Soul*. Andy regularly donates his time, talents, and baseball treasures to the National Baseball Hall of Fame and is the current vice president of the San Diego chapter of the Society for American Baseball Research. He has attended MLB games in fifty-two ballparks and still has the first MLB foul ball he caught in 1960.

*This book is dedicated to baseball fans of yesterday, today, and tomorrow.*

*Despite the constant changes that evolve for a team over a lifetime—the ups and downs of winning and losing seasons, players who come and stir interest and then go, a rotation of managers, and changes in front offices and ownership— the loyal fan is still there at the beginning and end of each season.*

*I think the true feelings of the fans are best exemplified in the eclectic, candid photos they take when they're at the ballpark or when they encounter a favorite player. . .and then again when they graciously share them with Fantography.*

*You are very much part of the game. You are the reason baseball thrives and this book exists. You're the hero today. Pull up a seat. This is your turn in the spotlight.*

ANDY STRASBERG

Andy Strasberg

Do you have a personal and poignant baseball snapshot that you would like us to consider for the next baseball Fantography book? Send it to Fantography at www.Fantography.net.

# Acknowledgments

★ Whoever wants to know the heart and mind of America had better learn baseball, the rules and realities of the game..." - Jacques Barzun noted American historian with Tim Wiles of the National Baseball Hall of Fame Library.
—Tim Wiles

"**W**hoever wants to know the heart and mind of America had better learn baseball, the rules and realities of the game..."
-Jacques Barzun
*God's Country and Mine, 1954*

An acknowledgment page can sometimes get out of hand, becoming too pluralistic, as often happens when the writer thanks such notables in their life as a seventh-grade homeroom teacher, Mr. Zacharie Clements, a college advisor, Mrs. Hadassah Winninger, or perhaps a niece, Julie Kappers, her husband, Richard, their children, Jefferson and Sydney, or even my cousin, Tony Beryl, and his son, Louis.

Some authors avoid acknowledgments altogether, typically when there is a measure of fear about forgetting someone. Finding the balance between the two extremes is like trying to move a runner over by hitting behind him and not grounding into a double play. For me, naming all who have helped and contributed to this book is well worth the risk.

While working for the San Diego Padres beginning in the mid-1970s, Padres owner Ray Kroc was made aware of a plan devised by the front office to publicly thank fans for their *support* in an ad. Ray was immediately upset. A proud man and the successful founder of the McDonald's restaurant chain, Ray said, "I don't need anybody's support." In reply to my look of surprise, he continued, "Let's thank them for their participation." This made an enormous amount of common sense and a lasting impression on me. So, with that introduction, indulge me as I express heartfelt appreciation to the following people, many of whom fit in more than one category.

For their *confidence and love*: Patti Strasberg, Hazel (our canine daughter), and my younger sister, Bobbi Collins.

For their *inspiration*: Fred Obligado, Arthur Leipzig, and Harvey Tuttle.

For their steadfast *faith* in me and the project: Ted Giannoulas, Steve Smith, John Boggs, Randy Maris, and Andrew Maris.

For their *guidance*: Art Berke, Bill Goff, Arnie and Debra Cardillo, Jim Holtzman, Dean Lambros, Drew Schlossberg, Chris Capen, Flynn Johnson, Jeff Light, and Mary Appel, who began guiding me since he first heard of the Fantography concept in 1997.

For their unwavering and consistent *friendship*: Jim Gold, Dick Freeman, Elten Schiller, Dan Moore, Amanda and Gary Hammels, Belinda Garcia, Bill and Alice Habeger, Jeff Prescott, Kathy Johnson, Doug and Joy Harvey, Debra Dennler, Dave and Cheryl Lemox, Eric and Cherie Cirlin, Ernie Kovacs, Dave Wright, Jim and Janice Healey, Rob Friedman, Susan Mendolia, Larry McNaughten, Larry Cancro, Lloyd Kuritsky, Bob Watkins, Rob and Cindy Johnson, Joe Milchen, John Rebella , Billy Crystal, Don and Linda Benson, Paul Menard, Tony Morante, Aracely Rivas, Sean Kinyon, and Jeff Meredith.

For their *encouragement*: Bob and Anna Lee Serrano, Peter and Joyce Briante, Ron and Christy Seaver, Richard, Madeline and Paul Schuster, and Richard Johnson.

For their hands-on *participation*: Tom Larwin, Doug Gilmore, Duane Dimock, Daniel M. Novis, John Rooney, Terry Cannon, David Kent, Daniel Gilmore, Howard Frank, Alex Seaver, Pete Meisner, Robert Warmack, Catherine Greene, Doug Allen, Diane Murbach, Ana Newton, Greg Funk, and Mike Metger.

For their *endorsement*: Bob Costas, Andy McCue, John Zajc , Faye Vincent, Peter O'Malley, Fred Claire, Anne Jewell, Hugh Wiley, Ross Greenburg, Steve Greenberg, Peter Bavasi, Rob Wilson, and Judy Leitner.

For providing their *expertise* before a publisher was secured: Bob Santoro, Jeff Marrien, Li-An Leonard, Michael Maguire; the contributing authors, John Myatt, Russ T. Nails, Rodney L. Moore, Larry and Nancy Kuntz, Don Gibson; my book agent, Jeff Silberman of the Literary Group, who like a great baseball-team manager pushed me when I thought I had nothing left in my tank and then pulled me when I needed to be pulled; and David Cashion, Abrams editor, whose talent and patience, mixed with abundant encouragement and diplomacy, helped ensure everything was done correctly.

To the dedicated and talented Abrams All-Star team of Marty McGrath, Bob Levatino, Claire Bamundo, Kerry Liebling, David Blatty, and Kara Strubel, whose design wizardry made this one book you can actually judge by its cover and then be delighted when you turn each page.

To my friends at the National Baseball Hall of Fame, dating back to 1967 with Howard Talbot and Ken Smith. I particularly want to thank Jeff Idelson, Baseball Hall of Fame president; former Baseball Hall of Fame president, Dale Petroskey; Tim Wiles, director of the Giamatti Research Department; Jim Gates, head librarian; and Tom Shieber, senior curator.

I also thank the many members of the media, who when contacted by Marty Appel and John Mooney, made print, cyberspace, and airwaves available to the project. In particular, I want to acknowledge the dedicated folks at Phoenix Communications: Joe Podesta, Geoff Belinfante, and Rich Domich; Larry Himmel, Bruce Patch, Sandi Banister, Jeff Kolpak, Ron Kaplan, Jason Owens, Wayne Hagin, Willie Weinbaum, and Tom Baker.

For the talented wordsmiths who contributed: I wish there was a better word than "thanks" for the incredible assistance Jack McCabe, Tim Katzman, Peter Rowe, and Kyber Oser provided. These men lent their writing skills when I often needed wording enhanced, sentences reconstructed, and paragraphs moved and edited so there would be continuity in my written thoughts.

Early Fantography contributors who provided me with their extensive photo collections included: Bill Klink, Dorothy Klink, Larry Carpa, Gary Holdinghausen, The San Diego Madres, Homer Ousterhoudt, Ron Draper, and Bill McNeish.

My navigation through this project would have been far more difficult without the baseball reference masterpieces that I consider the essential tools for any baseball writing project: *The Cultural Encyclopedia of Baseball* by Jonathan Fraser Light, *Dickson's Baseball Dictionary* by Paul Dickson, *Green Cathedrals* by Philip J. Lowery, *Curveballs and Screwballs* by Jeffrey Lyons and Douglas B. Lyons, and *When Baseball Was Young* by Gerard S. Petrone.

Last in this long litany of persons deserving my gratitude, but certainly not the least, are all of you fans who sent me your incredible personal and poignant baseball snapshots. From the outset, my goal was to share the baseball experience from the perspective of you, the fan, as seen through your camera lens finder. I wanted to shine the spotlight on all of you. There was something important enough about your baseball experience that caused you to bring your camera to a game, take pictures, and then develop and preserve them as part of your family history. Thank you for sharing those memories and experiences with me, and now with the readers of this labor of love.

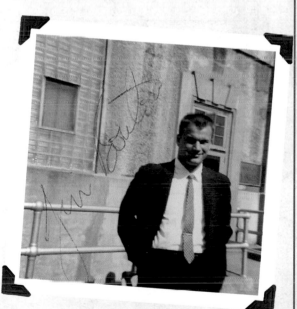

★ "You spend a good piece of your life gripping a baseball and in the end it turns out that it was the other way around all the time."
—*Jim Bouton Ball Four, photo by Mark Chiarello*

Editor: David Cashion
Designer: Kara Strubel
Production Manager: Jacquie Poirier

Library of Congress Cataloging-in-Publication Data:

Strasberg, Andy.
  Baseball fantography : a celebration in snapshots and stories from the fans / Andy Strasberg.
      p. cm.
  Summary: "Baseball Fantography is a celebration of baseball through the eyes of fans via photos they've taken of players, ballparks, and related subjects over the past nine decades, along with essays, sidebars, and quotes"—Provided by publisher.
  ISBN 978-1-4197-0213-6 (hardback)
  1. Baseball. I. Strasberg, Andy. II. Title.
  GV867.S87 2012
  796.357—dc23

                                 2011039993

Text and photographs copyright © 2012 Fantography LLC

Published in 2012 by Abrams Image, an imprint of ABRAMS. All rights reserved. No portion of this book may be reproduced, stored in a retrieval system, or transmitted in any form or by any means, mechanical, electronic, photocopying, recording, or otherwise, without written permission from the publisher.

Printed and bound in the United States
10 9 8 7 6 5 4 3 2 1

Abrams Image books are available at special discounts when purchased in quantity for premiums and promotions as well as fundraising or educational use. Special editions can also be created to specification. For details, contact specialsales@abramsbooks.com or the address below.

THE ART OF BOOKS SINCE 1949
115 West 18th Street
New York, NY 10011
www.abramsbooks.com